THE STORY OF TOMORROW FUTURE SYSTEMS

MARTIN PAWLEY

FUTURE SYSTEMS

THE STORY OF TOMORROW

PHAIDON PRESS LIMITED
2 KENSINGTON SQUARE
LONDON W8 5EZ

FIRST PUBLISHED 1993
SECOND EDITION 1993
REPRINTED 1994
© 1993 PHAIDON PRESS LIMITED

ISBN 0 7148 2767 3

A CIP CATALOGUE RECORD FOR THIS BOOK IS AVAILABLE
FROM THE BRITISH LIBRARY

DESIGN: FUTURE SYSTEMS

PRINTED IN HONG KONG

CONTENTS

All the clashing elements of mid-century technology fused into a single art of architecture. An architecture that embraced the precision of the armaments industry; the lightness, structural rigidity and strength-through-shape of aircraft construction, and the compactness and performance of the automobile.

The story of Future Systems is the story of Jan Kaplicky and the people who have worked with him over the last 25 years. All of them figure in this story, but without Kaplicky there would be no story to tell. His compelling images make possible a new belief in the creative potential of advanced technology architecture at a time when most architects have fled from the leading edge into irrationality or the imagined safety of the past.

Kaplicky's vision of a technological architecture is unique. It is a complicated product of heredity and environment that comes from his own genius and his country's history. Part of it is drawn from the memory of an earlier technological architecture, the legendary Czech Functionalism of the inter-war years that had been disowned by the rulers of post-war Communist Czechoslovakia by the time he became aware of its existence. Another part of it comes from the witness that he bore in his childhood to the Promethean technology of the last great European war: and yet another part comes from the images of America that he imbibed first from rare copies of *Life* magazine and, later, from two brief but significant visits to the USA.

freedom, then from freedom into another oppression only recently overthrown. And then, when finally freed from the last tyranny, they entered immediately into a new crisis of national identity. For such people there can be no confidence in the certainties of the past that is not mocked by a deep knowledge of how easily and suddenly it can be wiped out. That is the meaning of a true sense of history – as opposed to the futile worship of all things old.

The unique radicalism of 20th century Czechoslovak industrial history, pushed to Modern extremes amid the mountains and fairytale castles of old Bohemia and Moravia, surrounded Kaplicky as he grew up. From it, subconsciously at first, he drew a philosophy of design. In his mind all the clashing elements of mid-century technology fused into a single art of architecture. An architecture that embraced the precision of the armaments industry; the lightness, structural rigidity and strength-through-shape of aircraft construction; the compactness and performance of the automobile; the aesthetic and the economy of the purposeful machine in every context. And over all of it floated the proud banner of Czech Functionalism, the revolutionary architecture of the years of the pre-war Republic.

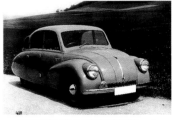

I N T R O D U C T I O N

Between them, all these influences gave Kaplicky an absolute and guiltless faith in the culture of technology. A true culture that is knowledgeable of, yet immune to, the lure of the past while at the same time remaining utterly fearless of the future. Within the personality of Kaplicky, belief in this culture of tomorrow is reinforced by the folk memory of the transient nature of its opposite – the world of traditions, laws, rules, frontiers, bureaucracies and ideologies – that all Czechs of his generation carry in their bones. They are a people who, repressed for 300 years, in a mere 80 years passed from colonial rule to freedom, then from freedom into slavery, then from slavery into

Kaplicky absorbed all these influences in his youth and early manhood. In the drawings that he began to make of the buildings of the the future, he saw them as complex, but self-sufficient pieces of equipment standing in a landscape. And in seeing this he realised an insight that Le Corbusier had put into words a decade before his birth: 'The useful objects of our time; our furniture, our tools, our motor vehicles, our buildings, have freed all slaves. They have themselves become our slaves, valets and servants. We sit on them, we work on them, we work in them, we work them. And once they have outlived their usefulness we dispose of them.' Thus it is to be with the architecture of tomorrow.

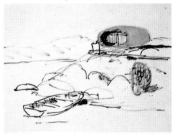

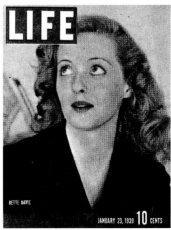

Martin Pawley
London, June 1992

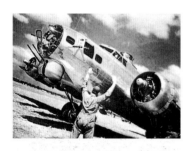

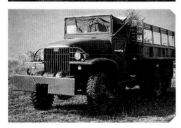

Jan Kaplicky was born in Czechoslovakia on 18 April 1937, the first and only child of Josef Kaplicky (1899–1962) and Jirina Kaplicka (1901–1984). Josef Kaplicky was a sculptor, landscape architect, and an interior and furniture designer of some note. His career was to survive the war and become the subject of a major exhibition in Prague after his death. Jirina started out as an art teacher in a high school and then became a professional painter of plants and flowers. She, too, survived the political upheavals of the war and its aftermath and published more than 20 books of watercolours after 1945, her career continuing far into old age until her eyesight failed.

At the time of his birth, Jan Kaplicky's parents were of mature age. His father was 38 and his mother 36. They lived in a district of Prague called Orechovka, a well-to-do suburb of large villas now hidden by trees, as close to the centre of the city as Hampstead is to the centre of London, and as desirable a place of residence. Adolf Loos' Muller house was built in Orechovka in 1928 and the famous Czech Functionalist Baba housing scheme was erected nearby a few years later. Unlike Hampstead, Orechovka had no great history. Like Czechoslovakia

To be Czech is to be a true child of the 20th century, a child of a country that has repeatedly flickered into life and died again. From the birth of the Republic in 1918 a bare 20 years elapsed before it was partitioned and occupied by Germany. Because of this national fragility, and the whirlwind of conflict that was already gathering strength at the time of his birth, the survival of the house in Orechovka, Josef Kaplicky's garden and Jan Kaplicky's birthday tree, is a kind of miracle. Living in Prague, in the eye of a European hurricane of catastrophe, the young Jan Kaplicky led a charmed life. From an early age he made models of aircraft, ships and vehicles, developing a great dexterity and feeling for shape and form that was to burgeon later in his career.

Kaplicky remembers disconnected vignettes of his school-days during the war. In 1943, with the German army already on the defensive in Russia, he was enrolled at the implausibly named English Elementary School where, in addition to compulsory German, English was still taught clandestinely by the staff in defiance of German regulations – an act of courage that was to end with the arrest of the school principal and his death in a German concentration camp. The English lessons were

'IT WAS LIFE AND DEATH'

itself, a republic created out of two parts of the old Austro-Hungarian Empire, it was a creation of the years between the two great European wars of the 20th century.

During those years Orechovka, with its large middle-class houses, accumulated an architecture of some distinction. Its gardens, too, were remarkable, and it was there that Josef Kaplicky particularly made his mark.

During the 30 years of his residence in Orechovka, the sculptor not only carried out alterations and enlargements to the Kaplicky family house, and designed and constructed all the furniture inside it, but he also turned its garden into a work of art. He laid lawns, made terraces, planted trees and buried fragments of millstones like reinforced grass. On 18 April 1937, the day Jan Kaplicky was born, Josef planted a special Japanese maple tree in the garden. Against all the odds the tree has survived. On her first visit to Prague more than 50 years later, the English architect Amanda Levete was shown this tree and told the story of its origin. She fell in love with Jan Kaplicky and became his wife.

important. Kaplicky remembers being taught English verbs in the school air raid shelter while American bombers droned overhead. He remembers seeing an American 4 x 4 Universal truck, captured by the Germans from the Russians – a massive vehicle that struck him as quite different from the German Horches, Hannomags and Büssings. And he recalls the arrival of the Red Army in Prague in May 1945.

Then, in 1946, came Kaplicky's first close-up view of an American aircraft: a shockingly uncamouflaged, natural aluminium-finish Boeing B-17G flown into Prague for an air display. To this day, Kaplicky can remember the impact this dazzling, flush-rivetted machine – with its ball-turret, blister domes and enormous turbo-charged, twin-row radial engines – made on his aesthetic senses. It seemed to him all of a piece with the copies of *Life* magazine that his parents used to receive before the war and which had just begun to reach his home from America again. America, that impossible place of limitless wealth and unrestrained technology, that paradise of design and

engineering freedom that was so far away as to belong to another world. Then, in 1948, came the Communist seizure of power.

In Kaplicky's high school the effect of the Communist takeover was muted. He remembers language lessons again, this time in Russian. He remembers youth organisations and 'voluntary work' at weekends. Heavy doses of Soviet propaganda featured in history and citizenship lessons throughout the school. For the children of middle-class parents, like himself, the 'political correctness' of the time was particularly onerous. Bourgeois tendencies, once detected, could lead to a strong reaction from certain members of the staff that might block the way to higher education.

In the whole of war-ravaged Europe at that time, rationing and an almost complete absence of consumer goods were the normal conditions of life. In 1950 Kaplicky's father purchased his first-ever car – a battered ex-Wehrmacht Volkswagen jeep in which Jan himself learned to drive a few years later. This canvas-topped machine served as the Kaplicky family car for seven years until Christmas 1957, when an equally implausible vehicle, a new Ford Anglia imported from England, was purchased at a price lower than that of the contemporary Skoda.

In 1955 came another educational threshold. Kaplicky remembers being surprised when he was selected for the gymnasium school where he won his baccalaureate. 'In a way that people who have not undergone it cannot understand, it was a matter of life or death,' he says at a distance of 40 years, of the tightrope walk that was required to comply with the official requirements of the Communist education system without sacrificing all individuality. A step too far and a child could be excluded. A step short and he or she would fall under suspicion.

In the year he was awarded his baccalaureate and left the gymnasium, Kaplicky sought admission to the Department of Architecture at the Technical University, but his application was rejected on the grounds that he did not come from a suitable background to represent the socialist realist principles of the Communist regime. Instead he was obliged to work for the government.

As a junior draughtsman in the State Design Office, Kaplicky led an arduous and unrewarding life. His working hours were from 6.15am to 2pm weekdays and a half day on Saturday. Each morning he had to punch a time clock on arrival at the office. Of his work he can remember nothing except that it was dull, boring and without creative challenge of any kind. All that he discovered about himself was that he had extraordinary ability with a draughting pen and pencil, the capacity to achieve a lucid uniformity in technical drawing that advanced it towards the status of art.

Kaplicky's rejection by the Technical University had forced him to take up the work of a draughtsman, yet he knew that, unless some miracle intervened, there was worse to come. In 1956 he would be eligible for military service and only a recognised university course could gain him respite from two years with the Czechoslovak Army, a force considered so loyal to Moscow that, unlike other Warsaw Pact countries, Czechoslovakia had no Soviet forces stationed on its soil to ensure obedience.

In desperation, and with very little hope of success, Kaplicky applied for admission to the School of Applied Arts and Architecture in Prague. This venerable establishment was much smaller than the giant Technical University of Prague and its six-year architecture course seldom contained more than 10 students in any one year. But apart from its small size, the real advantage of the School of Applied Arts was the fact that its graduates could become members of the Society of Artists, the state organisation formed by the Communist government in 1948 from an amalgamation of all the pre-war arts clubs and institutions. Members of the Society of Artists were recognised as licensed entrepreneurs by the Communist hierarchy and they were allowed to work for themselves in the minuscule private sector of the economy. Architect graduates of the School of Applied Arts could also become members of the Society of Artists. They received the title 'Academic Architect' and, in return for an annual subscription, membership cards and the right to practise as private architects, even though their fees were fixed by the government scale and had to be paid directly to the government for the deduction of tax. Such was the structure of the Communist state in Czechoslovakia at that time that nine out of ten architects worked for the government. Among the minority of free-thinkers in the profession the status of 'Academic Architect' was jealously guarded, for with it went access to foreign magazines, books and newspapers, and even occasional opportunities to travel abroad.

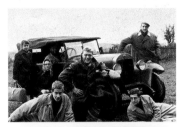

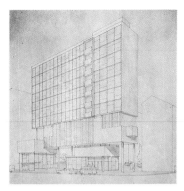

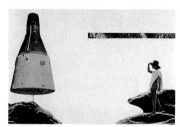

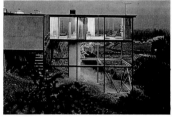

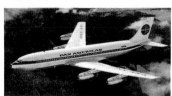

By great good fortune, and his own evidence of a powerful, creative talent, Kaplicky was admitted to the six-year course at the School of Applied Arts. Almost immediately he prospered, not only academically but by taking the first steps toward a professional career. The modest degree of freedom he was able to exercise during his student years was expressed in different ways. He and two colleagues clubbed together to buy an ancient, 1923 Laurin & Klement open tourer – a Czech vehicle whose manufacturer had long since been absorbed into the giant Skoda manufacturing concern. This vehicle, with its central accelerator pedal and wooden artillery wheels that creaked and groaned in warm weather, served them well as group transport. Similarly, part of Kaplicky's parents' house was converted into the nucleus of a small office where he could begin to practise. There, in 1958, he designed and furnished a loft conversion for a friend, transforming the derelict roof space of an ancient Prague townhouse into a small, modern flat. Two years later he designed a concrete summer house in the style of Le Corbusier for another client, but the project never went ahead. Nevertheless, these two experiences set the pattern for the level of architectural practice, with small private jobs, that was to be his salvation until he left Czechoslovakia.

In 1962, the year he graduated, Kaplicky had little time to savour the pleasures of independence. The shortage of housing in Czechoslovakia was so grave that shared dwellings were still the norm and, even aged 25, there was no chance that he could move away from home. He was still living in Orechovka, sharing his parents' house, when his father died after a long illness. The burden this placed upon his mother was not eased by the end of his own long deferment from military service. Two months after leaving the School of Applied Arts and Architecture he was required to report to the barracks of an infantry regiment to begin his basic training.

Despite his fascination with technology and his unquenchable interest in aircraft, motor vehicles, ships and advanced engineering of all kinds, Kaplicky did not enjoy his military service. Twenty-five years old when most of his fellow recruits were only 18, he chafed under the repetitive tasks and pointless discipline. When his basic training was over he managed, with the assistance of contacts in the architectural profession, to get himself transferred to a small army department dealing with the design of military exhibitions and recruiting displays. He remembers designing a demountable, tubular-aluminium, exhibition frame and then, still subject to army discipline, an 'army museum', which progressed at glacial speed during office hours and was finally completed years after he had left the army. At weekends, and whenever he was allowed out of barracks, he worked frenziedly on architectural competitions, but his efforts never met with success.

Finally, in 1964, his military service came to an end and he returned to his family home, which had now been converted into one apartment for his mother and another for himself – with separate quarters in his own section adapted to serve as his office. He began to resume his modest architectural career, but this time with a difference. Now that he was free of the army he devoted much time to applying to USA universities for grants and fellowships. In Prague his first post-military service project reflected this new determination. It was another weekend cabin, this time by no means Corbusian, but designed for welded-steel construction in the style of Mies van der Rohe and Craig Ellwood – influences brought to him in the steady diet of American magazines that had been his creative lifeblood since the late 1940s. The sheer simplicity and elegance of this project, and its early use of tension cables to brace a long, projecting balcony, mark out the scheme as the very first in which both the supreme draughtsmanship and the unique minimalist design style of the mature Kaplicky can be seen clearly.

If America was a decisive influence upon Kaplicky in his youth, there was a specific reason for it. His godfather, a doctor of medicine named Josef Brumlik, had left Prague in 1939 at the beginning of the German occupation and, after a perilous journey across Hitler's Germany, had reached Portugal, where he obtained a visa for the USA and took ship weeks before the outbreak of war. With skills that were in demand, Brumlik was soon established in practice in New York, and once the war was over it was he who renewed the supply of *Life* magazines for the growing godson he had never seen, as well as American books on boats, motor vehicles, aircraft and Modern architecture. Now, in 1964, Kaplicky was to meet Brumlik for the first time since his infancy. A chance win in the national lottery gained him a rare place on a guided tour of the USA's eastern states.

Kaplicky sought admission to the Department of Architecture at the Technical University, but his application was rejected on the grounds that he did not come from a suitable background to represent the socialist realist principles of the Communist regime. Instead he was obliged to work for the government.

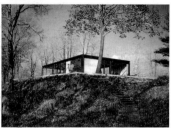

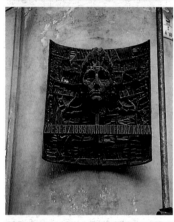

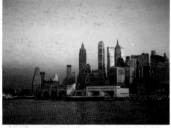

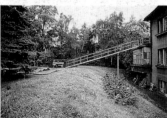

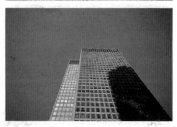

When the Air India Boeing 707 landed at Heathrow on the way to New York, the tour passengers were transported into central London for 24 hours. Kaplicky spent one night at a hotel opposite the Victoria and Albert Museum. He took the opportunity of a bus tour around the city but chiefly remembers its giant posters and commercial illuminations. The immense colour prints used on the advertisement hoardings amazed him. Nothing of that kind existed in Czechoslovakia. The following day the tour party returned to the airport to catch the plane for the short flight to Shannon, where there was a refuelling stop before crossing the Atlantic. Finally, nearly four days after leaving Prague, they reached Idlewild airport and were taken by bus to their hotel in Manhattan.

For Kaplicky, the days spent in America were a revelation. He knew exactly what he wanted to see and, armed only with his camera, his schoolboy English, and the argot he had painstakingly gleaned from the forbidden broadcasts of the American Forces Network and Radio Luxemburg, he took the tour bus to Washington DC and spent as much time as he could in the Smithsonian Museum, marvelling at the technological and scientific exhibits. Back in New York, he sought out Mies van der Rohe's Seagram building, Lever House and Union Carbide buildings; Frank Lloyd Wright's Guggenheim Museum and a dozen other major buildings. He was, he remembers, overwhelmed by the solidity and quality of the great American skyscrapers. He was astounded, more than in London, by the even-greater size of the advertising billboards and illuminated displays. While he was in New York he visited his godfather Dr Brumlik. It was a reunion that was to have a sequel.

Back in Prague, there were more small jobs for him to do. He designed a memorial plaque that was affixed to the rounded corner of a building on the site of Franz Kafka's birthplace. Deftly the plaque curved in the opposite way to the corner, enfolding a narrow bust of the great writer – an early example of the inherently strong formal sense that later was to emerge in Kaplicky's work more fully. At this time he also designed a memorial to a great flood, and designed a large competition-winning concrete tablet to commemorate the peasant victims of a 1644 uprising, in a style somewhat reminiscent of that of his father. The Kafka memorial and the peasant uprising *bas relief* still exist on the walls of the buildings where they were

erected in 1965 and 1966. More challenging still was a commission from a singular client, a successful film-scriptwriter named Jaroslav Dietl, who had met Kaplicky on the American tour and become a close friend.

In addition to being successful, Dietl was a dedicated follower of fashion. He owned the first Charles Eames chair to reach Czechoslovakia and he enthusiastically commissioned Kaplicky to remodel his house in the American style and design him a mini golf course to go with it – as well as devising a means to reach it expeditiously from the first-floor balcony. The ramp Kaplicky designed to serve this last purpose remains, after the passage of 30 years, one of the most beautiful and economical structures he has ever conceived. Fabricated from welded-steel angles painted white, it executes a daring cantilever, ending millimetres clear of the house where a less adventurous spirit would have sought an anchorage. By the same kind of miracle as attended his birthday tree, this structure also survives, though in different ownership.

From now on, beyond the parade of small jobs that sustained him in practice as an 'academic architect' in Czechoslovakia, Kaplicky was in the grip of a dream of America. The stultifying isolation and regulation of life in Communist Czechoslovakia became more and more oppressive to him and he conceived a plan to emigrate to the USA. Dr Brumlik played an important part in this scheme by providing not only the promise of support in New York that allowed Kaplicky to obtain a USA visa, but paying for his airline ticket as well. In September 1966 Kaplicky flew to New York for the second time.

On this occasion he stayed in the USA for three months. Dr Brumlik had arranged for him to stay with a family near Newark, Delaware, where he spent several weeks endeavouring to find a job in an architects' office or enrol in a school of architecture. For some reason neither effort was successful, even though Kaplicky pursued both vigorously. Living off his steadily dwindling financial reserves, he travelled to Boston, Baltimore, Philadelphia and Chicago, looking at buildings, taking photographs, but making no headway either in applications to universities to study for a masters degree, or in attempts to get a job in an architects' office. Suddenly, in late November, aged 29, he decided to quit and used the second half of his ticket to return to Czechoslovakia. There he resumed

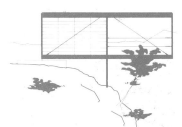

his old life. Subsequently he was to make one more unsuccessful application to the Harvard Graduate School of Design, but that was his last throw. Although America remained a powerful influence on his approach to architecture and design in general, he never again attempted to emigrate to the country that had so powerfully influenced him for so long.

Back in Prague there were further competition entries and small architectural jobs. His records list six projects between his return from the USA and his final departure from Czechoslovakia two years later. Without much energy or optimism, he worked on a family house and studio for one client, and a house for another that was built in concrete. Then, in 1967, he designed Project 12. This Cliff Cabin is the first of a series of structures intended to stand as autarkic pieces of life-support technology on steeply sloping or cliff-top sites, in isolated, almost abstract locations in untamed nature. This theme, to which he was to return repeatedly in later years, was to undergo enormous development. Yet in the first, 1967 version, despite its trabeated form and elementary structure, the seeds of all the main elements of its successors are present. Unfortunately, events were even then conspiring to ensure that Kaplicky's evolution as a designer was to be seriously impaired by Cold War politics.

The slow liberalisation of the Communist regime, which had been one of the reasons for his return to Czechoslovakia from the USA in 1966, had begun to accelerate in 1967 and in 1968 began to amount to open defiance of the USSR. In the early spring of that year Alexander Dubček, the leader of the Czechoslovak Communist Party, announced that press censorship was to be removed and the victims of the Stalinist seizure of power in 1948 were to be rehabilitated. On 9 April 1968 Dubček promulgated a reform programme entitled 'Czechoslovakia's Road to Socialism', promising open borders, an end to the suppression of political opposition, and a new national defence doctrine, less dominated by Soviet interests. It was anticipated that all these measures would be voted into effect at the 14th Party Congress in September, but it was not to be. By early summer, the threat of these political changes, allied to the prospect of a mixed economy with a strong free-market sector financed by Western investment and loans, had jolted the Soviet Union into action. In July, the Czech

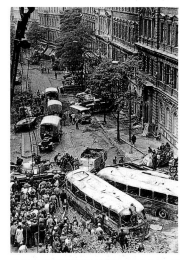

cabinet was ordered to attend talks with the whole Soviet Politburo at a border railway station. But the talks ended inconclusively and the process of Czech liberalisation continued, with passports and exit visas easier to obtain than they had been for 20 years. Then suddenly, on 20 August, Soviet troops, aided by units from East Germany, Poland, Hungary and Bulgaria, swept into Czechoslovakia.

In the chaotic days that followed, when passive resistance to Soviet tanks in the streets of Prague became part of the unforgettable kaleidoscope of images that made up the year 1968 in European history, Kaplicky, like hundreds of thousands of other young Czechs, had to make a final decision. It was no longer a question of emigration by stealth, or seeking admission to foreign universities. In the midst of the violent disorder of the capital, he and an architect friend Jaroslav Vokoun obtained exit visas, burned the personal papers and belongings they could not take with them, and fought their way onto one of the packed trains leaving for Vienna.

Practically penniless, they arrived in the Austrian capital and were treated with the utmost kindness. After two days spent begging and cajoling the consulates of West Germany and Belgium into giving them transit visas, they boarded a train for London. Kaplicky had borrowed $100 from one of his clients when he left Prague; apart from the bags he carried with him, that was all he had. To this day he can remember the sleepless night in the train and the despair with which he gazed at the back gardens of the miles and miles of mean, terraced houses lining the railway on the way into London at the end of their long journey across Europe. They arrived at Victoria Station on the boat train, on the evening of 12 September 1968.

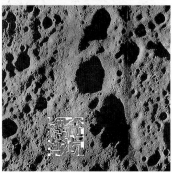

The only person Kaplicky knew in London in 1968 was an artist named Anthony Hill, whom he had met the year before in Prague. With no alternative presenting itself, he and Vokoun found their way to Hill's tiny flat in Charlotte Street and the Englishman, when he had overcome his surprise, took them to Schmidts restaurant across the road. The restaurant was famous but it is now demolished. At that time it was, Kaplicky says, as though he had not left Vienna.

In the weeks that followed, he and Vokoun moved into a shared flat in Prince of Wales Drive, Battersea and tried together to get jobs. Kaplicky remembers buying the *Architects' Journal* week after week, direct from the publisher in Queen Anne's Gate so as to be first to see the classified advertisements. Then he and Vokoun would repair to a bench in St James's Park to pore over them. At that time it was the correct form to reply to these by letter and then await a written invitation for an interview. This was a time-consuming process that was trying on the patience. Kaplicky remembers little of the trickle of nondescript offices he was invited to visit, except that they invariably employed a retired army officer to run the office library. This person appeared to Kaplicky, with his uncer-

drawings for pitched-roof single-family houses. This menial work sustained him for a time but, convinced he could do better, he left after three months. Again luck turned against him. This time he was unemployed for three months. His money ran out while he wrote hundreds of letters begging for interviews. In the end he wrote to Foster Associates three times: each time Norman Foster regretfully replied in the negative, but each time he did reply.

Suddenly, another job turned up – this time with Garnett Cloughley and Blakemore (GCB), the fashionable architects of the Chelsea Drug Store and Stop the Shop in the King's Road, who worked out of a fine house in Queen Anne's Gate. Again Kaplicky served a menial draughting role at GCB while the flamboyant Patrick Garnett appeared on television and in the colour supplements, and drove around in a Ford Mustang while designing hotels in Spain. GCB was always a wayward firm, awash with glamorous clients and bad debts. After three months Kaplicky was fired during one of the office's periodic cash flow crises. But this time he found another nondescript job in a nearby Kensington office quite quickly. In the middle of this half-gypsy period he and Vokoun entered the competition to

PART 2 'YOU MUST DO SOMETHING OR YOU WILL BE WAITING FOR EVER'

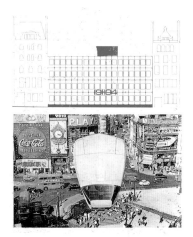

tain perception of English ways, to behave as though he were the senior figure in the partnership, although events always proved this not to be the case. It is, he recalls, one of the most difficult things in a foreign country to work out who is important and who is not.

For obvious reasons, Kaplicky lacked a portfolio of full-size drawings, although he had brought photographs to London of his 'little jobs' and competition entries. After a time, however, he began to suspect that the architects he showed them to at his interviews did not believe that he had drawn or built the concrete house or the steel ramp himself. 'I suppose,' he reflects now, 'that they thought we lived in mud huts in Czechoslovakia. Certainly none of them knew where the country was. They always seemed surprised when I said it was next to Austria.'

Kaplicky finally got a job with an architect in Tottenham Court Road who paid him £16 a week to prepare working

design a new school of architecture for the Architectural Association, then supposedly about to move from its Bedford Square premises to join London University's Imperial College of Science and Technology in South Kensington. Their entry was unplaced and, of course, the new school was never built.

Abruptly things took a turn for the better. His friend Vokoun landed a job in a real office at last, working for Denys Lasdun on the National Theatre. By assiduous networking, Vokoun got Kaplicky an interview and he, too, was invited to join Lasdun's office. For many months the pair of them, both experienced in Czech concrete construction, executed in some disbelief highly detailed, quarter-inch drawings of concrete shuttering.

Looking back on his modest role in the creation of the National Theatre, Kaplicky remembers the 'boss and troops' organisation and the enormous size of the office

at that time, and the vast number of balsa wood models and drawings that were produced. As far as concrete finishes were concerned, he says simply: 'They concentrated on all the wrong things. They never seemed to make any sort of contact with the outside world. There was never any shortage of time. We simply drew an immense number of working drawings and details. Details that were far too exacting for the practical site tolerances of in-situ concrete work.' But at the time the National Theatre was what everybody conceded to be real architecture. A major civic building that was to bring its architect a knighthood from the Queen and then be denounced as 'a nuclear power station in disguise in central London', by her son the Prince of Wales.

Kaplicky worked on the National Theatre for nearly two years. In that time he had only two conversations with Denys Lasdun: the first was at his job interview, and the second when he announced that he wished to leave. It was not a meeting of minds. More significant was a chance encounter with Eva Jiricna, a fellow Czech *émigrée* architect whom he had known slightly in Prague. They became friends and lovers. The close relationship between them was destined to last for 10 years.

When he left Lasdun's office in March 1971, Kaplicky moved directly to the office of Richard Rogers, recently established in Misha Black's Design Research Unit (DRU) building in Aybrook Street, Marylebone. Rogers' staff had refurbished the building themselves following the break up of the Team Four partnership with Norman and Wendy Foster. Kaplicky had been introduced to Rogers by Pierre Botschi, who had worked for the practice himself and who knew that Rogers wanted a replacement. Rogers was in fact looking for someone to take over the last phase of the DRU job, the addition of a large penthouse to the flat roof. It was with some trepidation that Kaplicky attended the job interview but he need not have worried. Three years after his arrival in England, Rogers was the first potential employer to show any interest in the work he had done in Czechoslovakia. He swept aside the concrete details and nondescript working drawings executed in England and concentrated on the photographs of the Czech houses and the spectacular Dietl ramp: it was after all an *oeuvre* only slightly less impressive than his own at that stage of his career.

At that time, in March 1971, there were only four people working with Rogers at the DRU: Rogers and his wife Su – whose marriage was in the process of breaking up – and two associates, Marco Goldschmied and John Young. Kaplicky joined this team and eventually became job architect for the penthouse.

The DRU roof extension was principally John Young's creation. It called for a large, open-plan space covering the entire roof and enclosed by 18 lightweight 3 x 9m long-spanning grp sandwich mouldings with a phenolic-resin core. In addition to its adventurous use of materials the roof was a tricky engineering problem handled with skill by Anthony Hunt, who became friends with Kaplicky's at that time and has remained so ever since. Hunt was of great assistance when the project fell foul of new building regulations governing the use of structural grp that made it impractical. Between them Young, Hunt and Kaplicky designed a second version using neoprene-jointed, 3m-wide profiled aluminium sandwich panels, this time resting on internal tubular-steel portal frames. The outer aluminium panel skin was powder-coated in a bright 'yellow submarine' colour characteristic of the time. Difficult to define in conventional terms, the DRU penthouse was best encapsulated by a Kaplicky photomontage of the time that is still reproduced to this day. It shows a green Volkswagen Beetle on the flat roof of the building, connected to it only by an umbilical cord of coiled cables.

1971 was a fateful year for Rogers' career for it marked his joint victory with Renzo Piano in the Paris competition for a 92,900m² arts and cultural centre to be built on a site long-occupied by a temporary car park at the Plateau Beaubourg near Les Halles. This competition was a mammoth effort involving a rapidly put together multinational design team more than 30 strong of which Kaplicky became a part. Coincidentally, it was at this time, in the early summer of 1971, that Kaplicky moved out of the room he had occupied in the Battersea flat since his arrival in London in 1968. He and Eva Jiricna negotiated the tenancy of a fifth-floor apartment on top of a modern office building in Praed Street, near Paddington Station, and moved in together.

Then, in August 1971, the astounding news came that Piano and Rogers had beaten nearly 700 international architectural practices and won the commission to design the new arts building for the Plateau Beaubourg, hence-

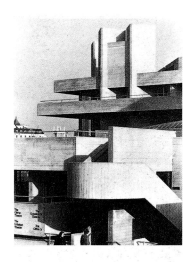

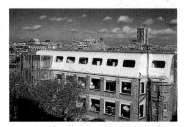

DRU invite you to a party to launch their new fourth floor. Help us get it off the ground on 28 October 1972 from 8.30pm

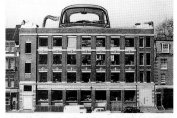

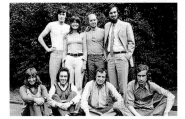

Richard Rogers was the first potential employer to show any interest in the work he had done in Czechoslovakia. He swept aside the concrete details and nondescript working draw-ings executed in England and concentrated on the photo-graphs of the Czech houses and the spectacular Dietl ramp.

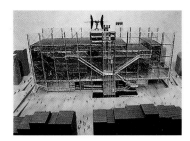

forth to be called the Centre Pompidou after the French president. The entire Rogers office immediately decamped for the awards ceremony and victory celebrations in the French capital. Kaplicky was included in this triumphant progress thanks to a special United Nations' refugee passport that Rogers secured, which enabled Kaplicky to be admitted to France.

In the excited atmosphere of the time, Kaplicky was drawn into a joint Piano/Rogers scheme to convert a barge into a floating office on the River Seine. Before this idea had evolved into the design of an inflatable office to serve the same purpose, he returned to London. Having just moved into a new apartment, he had no desire to join the new office being set up in France, so he continued working on the last stages of the Aybrook Street penthouse. Perhaps inevitably, the opening of this extension at the end of 1972 was an anticlimax, entirely overshadowed by the shower of publicity attending the spectacular Pompidou project.

After the Pompidou win, the Rogers organisation changed its character for ever. With the senior partner now a global figure and the centre of his activities temporarily shifted to France, no more jobs came into the skeletal London office. Consequently, there was little for Kaplicky to do. During this hiatus he and Jiricna entered the competition for a new building to house the Burrell art collection in Glasgow. Their submission was unplaced but it took a form that was both precursive of some later Future Systems designs, and bore traces of Kaplicky's early Czechoslovak work. The art gallery they proposed is an earth-integrated top-lit structure surrounded by big earth berms. The roof of the gallery forms the car park and is reached by a long ramp somewhat in the style of the Dietl house. The identity of the building is made clear by the enormous letters 'BC' on the single glass-clad wall not obscured by an earth berm. Entry and exit on foot to the lower level is through a flat wiring-shaped, inflatable tube.

By the beginning of 1973 it had become clear that Kaplicky no longer fitted into the new scheme of things at Rogers' office and, with characteristic thoughtfulness, it was Rogers himself who resolved the problem. When work on the Aybrook Street penthouse finished, he telephoned to ask if there might not be an opening for Kaplicky in the offices of Foster Associates. Foster invited Kaplicky to

present his portfolio and, early in 1973, Kaplicky left for the grey-tinted glass facade of the Fitzroy Street offices of Rogers' former partner.

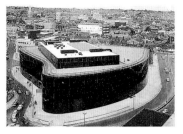

On his arrival, Kaplicky was put to work detailing the aluminium suspended ceilings of the Willis Faber Dumas insurance building in Ipswich, and was later employed preparing finished design drawings for the building, some of which are still reprinted to this day. Kaplicky was immediately impressed by the quiet and disciplined organisation of Foster's office compared to the impetuous course of events at Rogers' by now far-flung empire. But, more than this, he deeply admired the Willis Faber & Dumas project: a glass-clad deep-plan structure that follows the irregular plot line of the medieval streets of Ipswich and shows only reflections of its historic neighbours. This building, Kaplicky maintains, with regard to the technology capabilities and public acceptance of avant-garde architectural concepts of the time, is the most advanced and revolutionary ever designed by Foster Associates. Compared to the general level of architectural design in the early 1970s, it marks a number of entirely new departures. It is innovative in its frameless, precise, suspended glass cladding, in its lightweight construction and its multifunctional open planning. But, above all, it is innovative in the level of staff amenity represented by its atrium, staff restaurant, swimming pool and roof garden.

In all probability Kaplicky would have continued to work at Foster Associates indefinitely had it not been for a telephone call he received in the autumn of 1973. Like Rogers two years before, two young unknown English architects named Robin Spence and Robin Webster had won a major competition against tremendous odds: this time for a new parliamentary building to be erected on a large site opposite the Palace of Westminster in London. Far from resembling the modestly contextual redevelopment of the Bridge Street part of the site for parliamentary purposes, which has subsequently taken place, the Spence and Webster scheme contrasted sharply with the Gothic Revival Houses of Parliament and the undistinguished Edwardian houses in Bridge Street. In fact, it called for a complete clearance of the site bordered by Bridge Street, Parliament Street and Richmond Mews before construction could commence. The proposed building took the form of an uncompromisingly modern space-frame structure, soaring out over a vast, public,

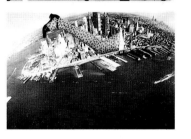

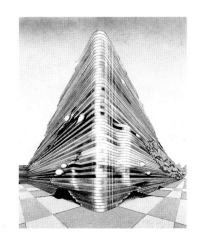

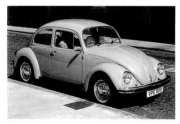

open space dedicated to free interaction between citizens and politicians.

Spence and Webster were direct in their approach to Kaplicky. They were familiar with his work and wanted him to leave Foster Associates and join their project team along with a later Foster protégé named Richard Horden. With initial expenditure on its design already authorised by the Edward Heath administration, the project appeared to offer several years of highly interesting design work on what was, undoubtedly, the most challenging commission in the country. In any case, to make the proposition even more attractive, Spence and Webster were prepared to offer Kaplicky a significant increase in salary.

After some thought, Kaplicky accepted and left Fitzroy Street after only nine months. He and Jiricna, who was now working for Louis de Soissons on the huge Brighton Marina project, left their apartment in Praed Street and purchased a new balcony-access flat in a discreet housing association complex in Bayswater. This apartment was transformed in the coming year and converted in to a species of utopian architects' dwelling, with an elliptical conversation area on the living-room floor; yellow walls (the same colour as the Aybrook Street penthouse); rubber flooring; cable-tray shelving, and doòrs labelled 'B', 'L1', 'B1', 'B2' and so on, like lettering on the plan of a house. While this was going on, in the back of their minds, all those associated with the great Parliament House commission knew that it was in trouble.

The abandonment of the Spence and Webster Parliament building is one of the great lost opportunities of post-war British architecture. As an event set against the backdrop of the Yom Kippur War, the Arab oil embargo, the three-day week, the great inflation and the two general elections of 1974, it is perhaps not surprising that this ambitious project is now all but forgotten, but in retrospect it can be seen that the strategy pursued by Spence and Webster themselves did not increase its chances. Unaccountably, instead of establishing an office within lobbying distance of parliament, they removed themselves to Hampstead. Then, as the political and economic climate grew worse, they found themselves drawn into a desperate battle to keep the project funded. After the general election of February 1974 when the Conservative government lost power, Spence and Webster's prospects diminished with each passing day. In October, when the minority Labour government was confirmed in power by a second general election, a period of financial stringency began in earnest. Under these desperate circumstances any £200m project for a new parliament building was doomed. In January 1975 Spence and Webster ceased working on the project and Horden and Kaplicky were given notice.

What followed began as a near-replica of the two periods of unemployment that had plunged Kaplicky into depression years before. Although he quickly began to act as a freelance outworker for the architects of the Brighton Marina project, he stayed at home, drawing in a kind of voluntary isolation. It was at this time, out of the depths of his depression, that he came to understand that he no longer wished to work for other architects in the way that he had before. As he put it in 1992: 'In those months I came at last to understand that nobody was ever going to come to me and ask me to design them a house as long as my identity was submerged in that of a better-known architect. I realised that what had really happened to me between 1968 and 1975 was that I had virtually stopped designing. Even the things I had designed were not associated with my name. It was time for me to start again before it was too late.'

From then on, while Kaplicky continued to do draughting work for the marina during the week, at weekends he began to draw a series of highly personal projects that were utterly unrelated to the day-to-day task of making a living. The first of these is numbered Project 001, a designation that differentiated it from Kaplicky's earlier Czech projects by the use of an extra digit, in the same way as the later series of Future Systems projects (already numbering 97 at the time of writing), is differentiated from this series by the use of the prefix '1'.

Project 001, which was drawn in April 1975, marks a turning point in Kaplicky's development as a designer. The scheme, called Cabin 380, brought together for the first time everything that he knew about aircraft, boat, motor vehicle, construction plant and spacecraft design. But more than that it brought forth from him a new engineering style of general arrangement drawing in place of the traditional architectural draughtsmanship he had employed as recently as four years before in the Burrell Collection competition entry. Combined with his fine eye for detail and capacity for precision rendering, this shift in

drawing style gives the project an extraordinary authority. With no key, no legend, no written information at all, it nevertheless conveys all the data necessary to visualise a pure form of domestic machine architecture.

Cabin 380 is a 5m-long, glass-fibre living capsule, cylindrical in shape with rounded ends and a diameter of 2m. Its interior is day-lit through a 2.5m, aircraft-style cockpit cover, which rises on gas-filled struts like the hatchback of a car, and can be covered over at night by the use of a retractable exterior blind working like the night-flying enclosure on a flight simulator. Entry into the capsule is via an externally hung, bulkhead door, which is reached by a lightly constructed profiled steel bridge. The dwelling stands upon a steeply sloping site that is only gesturally indicated. Its undercarriage – for the term 'foundation' is hardly appropriate – is an adjustable tripod of about the size and strength necessary to support a light anti-aircraft gun. Its interior is robustly furnished with rubber flooring; an upholstered sofa-bed occupies one end, in the space beneath the cockpit cover; there are two fitted tables, one combined with a triangular kitchen sink and cooker, and a separable shower room and lavatory.

Apart from its tenuous connection with the ground – excluding its tripod, the dwelling is only attached to the surrounding world by one end of its walkway and a bundle of flexible telephone, water and electricity lines – the most remarkable thing about Project 001 is the uncompromising fashion in which it presupposes a single- or two-person household in an almost socially abstract living pattern devoid of any remnant of historical context, even furniture. As Kaplicky says today: 'I always thought that the greatest weakness of the second generation of Modern houses was their failure to develop the interior at all. All the Modern architects of the 1960s and 1970s ended up using Barcelona chairs, just like their forefathers.' In this respect too, the fitted ergonomic interior of Project 001 marks an important beginning.

Surprisingly, Kaplicky's second and third personal projects, 002 and 003 – drawn respectively in December 1975 and April 1976, more than six months and more than one year after Cabin 380 – abruptly address the whole question of urban and historical context so deliberately eschewed by their predecessor. With exquisite economy of line and absolute confidence, Project 002, House 26, shows a 5m-wide glass-clad facade inserted into a gap in a terrace of three-storey 19th-century town houses. With its transparent facade based on the use of six large silicon-jointed glass panels, sealed against the surrounding brickwork by means of rubber gaskets, the house makes no concessions to the appearance of its neighbours except in terms of its dimensions and proportions. Since the glazing is fixed, there are no glazing bars, and a central rib, louvred from top to bottom, provides ventilation. The lower right, entrance panel is opaque and fitted with a pressed metal bulkhead door with a porthole and the number '26' prominently painted on it. On the roof there is a terrace with perforated metal balustrading and an early display of satellite communications antennae.

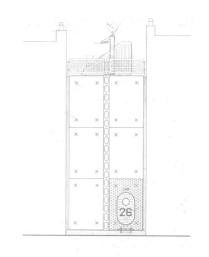

House 26 shares some of the uncompromising abstraction of traditional terraced housing form that was characteristic of the housing erected at Milton Keynes in 1975, but it goes much further in its use of non-domestic, industrial building components in a totally convincing way. In its extraordinary simplicity and perfection of proportion it models an unborn vernacular: a way of building with advanced construction materials and methods in the context, and according to the rules of ancient towns and cities. A domestic counterpart in fact to the commercial achievement of Willis Faber Dumas, the work of Foster Associates that Kaplicky always has admired most.

Four months after House 26 came Unit K, otherwise known as Project 003. In a way this, too, is a 'contextual' design, intended to take its place in the obsolete, but apparently immovable, 19th-century urban context of Britain, but no longer in the accommodating vein of its immediate predecessor. Unit K returns to the uncompromising engineering style of Cabin 380, but this time it is placed above the roof of one of the terraced houses outlined in Project 002. The structure is a metal cylinder, 5m in diameter, set vertically upon an undercarriage that transfers its weight to the party walls of the house. Otherwise, the 'parasitic' capsule dwelling enjoys only the same flexible connections to its host as Cabin 380.

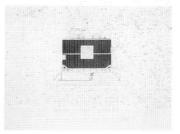

Other personal projects were drawn before the 'small professional design unit' of Future Systems was born in 1979. From 1970 Kaplicky had kept numbered notebooks, filled with sketches, observations, cuttings, photographs and images from all sources that stimulated his creative interest. Nearly 30 of these existed by the begin-

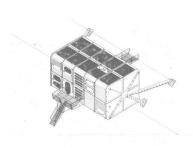

ning of 1992. In the early years their relationship with the personal projects was close and obvious; later it became more indirect.

Project 004 is for an apartment megastructure capable of stacking and removing small pod dwelling units by means of a built-in overhead crane. Project 005 marks an improved version of Cabin 380 utilising solar electricity generation to increase its autarkic potential but, more importantly, marking another leap in presentation technique into the full cutaway axonometric style favoured by the motor industry and other industrial product manufacturers. Project 006 marks a further development of the small industrialised dwelling unit. So does Project 007, a structure influenced by a visit to Michael Hopkins' new Hampstead house, that is intended to incorporate changes in level by fastening itself to the foot of steep natural slopes or corresponding declivities in buildings or civil engineering structures. Project 008, the last of this series, marks the most elaborate development of Cabin 380. It takes the form of a space frame-supported helicopter platform with a small solar-powered dwelling mounted on it, the whole resting upon a six-legged, adjustable undercarriage.

It is tempting to see in these projects a progressive exposure of the subconscious anxieties of the exiled Kaplicky as he endeavoured to come to terms with his adoptive land. His meticulously drawn, solitary metal and plastic dwelling units tucked into interstices in the built environment or located on unspecified lake shores, cliffs, hills and mountains, were in effect the beginnings of a new separate creative identity, which was soon to take him beyond reach of the anonymous architectural employment that had sustained him for his first 10 years in Britain.

PART 3 'MORE EFFICIENT, EXCITING AND RESPONSIVE THAN CONVENTIONAL COUNTERPARTS'

Towards the end of 1975 Kaplicky stopped doing drawings for Brighton Marina at home and moved into Louis de Soissons' office in Tolmers Square as a member of the design team. He did not exactly enjoy the work but can recall to this day his surprise at the immense number of drawings generated by the ambitious £140m project, all of them continually needing updating as the design of the floating platforms, ramps, caissons, piles, breakwaters and central spines navigated the uncertain political climate and the great inflation of the 1970s.

The marina was a vast but ill-timed project; to this day it remains unfinished in the form in which it was originally proposed, more than 20 years after work on it commenced. At the time Kaplicky joined, the design office was served by a staff of more than 20 and Eva Jiricna, who had been working on the marina since 1969, was effectively job architect, although she was denied the commensurate rank or salary. The scale of the project, virtually unique in the 1970s, attracted many talented architects. John Randle, later to carry out such brilliant work with Ron Herron on the Imagination building in London; Peter Cook of Archigram, and Christine Hawley were among those briefly involved.

One of the 1976 influx into the Louis de Soissons office was an architect named David Nixon, who, by chance, was given an adjoining drawing board to Kaplicky's. Born in Bradford, England, Nixon was a graduate of the school of architecture at the Polytechnic of Central London. Although 10 years younger than Kaplicky, he had also led an adventurous life, with a failed marriage already behind him and an enthusiasm for America that was soon to shape his whole career. He shared Kaplicky's enthusiasm for material culture and the machine aesthetic and greeted the sight of Kaplicky's lone projects with an

immediate proposal that they should enter competitions as a team. In the early 1970s he had worked for the Martin Francis' engineering consultancy on the design of advanced building structures, and subsequently at Foster Associates where he had overlapped with Kaplicky, although they had barely been acquainted. This time round their shared predilection for engineering design, aviation and the USA space programme – plus their propinquity at Louis de Soissons – gave them a common bond.

No sooner had they struck up a friendship than they went to work on an entry for an English Industrial Estates' competition for a low-cost, standard industrial building, and to their delight were included among the joint first prize-winners. Kaplicky's old friend, the engineer Tony Hunt, worked on this project without a fee – his assistance proved vital. The Kaplicky/Nixon scheme went through several variations. One version was severely criticised by a quantity surveyor on cost grounds. Undeterred, the pair started again from scratch and completed a new version over one weekend. This final design is a simple metal-clad box structure of welded steel beams and stanchions. Its sole, but important, original feature is the location of all office accommodation in lean-to aisles on either side of the main rectangular building box. These sloping aisles, day-lit by means of projecting polycarbonate bubble domes, are all that is necessary to give the flat-roofed shed an unconventional appearance. Besides which, as Kaplicky recalls today, it is 'so pragmatic and inexpensive that even the most conservative of judges would have had to see that it had merit. I think it was costed at about £10 a square foot then, which was incredibly cheap for an industrial building'.

The English Industrial Estates success was followed by an entry in the 1978 Liverpool Focus on the Centre contest, where Nixon and Kaplicky proposed the erection of a Saturn rocket to be donated by the National Aeronautics and Space Administration (NASA). Perhaps surprisingly, this *jeu d'esprit* also attained an equal first prize. But it was in the following year that the pair attained their biggest win, with another equal first place in the Australian government's Melbourne Landmark competition, a contest in which they beat off no less than 650 competitors worldwide.

Given such a run of encouraging results – although tantalisingly not one actual construction had yet resulted

from them – it would have been surprising if the pair had not aroused critical interest. For the first time, architectural magazines began to take an interest in their work and their competition victories were widely published. The first ever reference to Kaplicky's name in a British journal was in *Building Design* in October 1976 when Peter Cook, then an Architectural Association (AA) tutor and director of the avant-garde Covent Garden cultural centre Art-Net, praised the English Industrial Estates project. Then, in 1977 and 1978, Cook asked Kaplicky to mount exhibitions of his work at Art-Net. In the programme notes for the first of these exhibits Cook wrote of Kaplicky's designs: 'Less and less do they depend on the sustenance of "day-glo" colours and cute styling. More and more do they attain a recognisable style of their own: a way with the corner of a panel, a way with the precise line of the corrugation, and beautiful, beautiful bolts.'

It was at the time of the Art-Net exhibition that Kaplicky and Nixon seriously considered the formation of a partnership. The name 'Future Systems' had already been used in connection with their work, but it was yet to be made official. One of the problems was Nixon's ambition to live in the USA and become involved with the American space programme. Surely, they reasoned in their more pedestrian moments, a partnership with one member living and working in London, and the other resident in Los Angeles could never work? The less so since neither had private means and both were compelled to work to support themselves? In fact it could, or at least did. Despite Nixon's desire not to remain in London, the unique practice of Future Systems was founded in 1979. Taking their faith in advanced technology literally, Kaplicky and Nixon resolved to maintain their practice over great distances 'by airline, telephone and courier if necessary'. It was to become necessary sooner than either of them thought.

In March 1980, Nixon left England and his second marriage and took a job in Los Angeles working for an architect named Albert C Martin. After a few months at the drawing board he found a better job teaching at the Southern California Institute of Architecture – SCI-ARC, as it was called. This newly opened and adventurous school of architecture, headed by Ray Kappe, offered him exactly the opportunity and encouragement he needed. By 1983 he and his SCI-ARC students and his London partner had

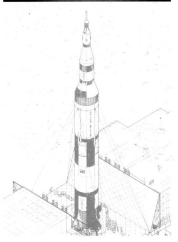

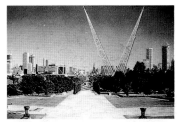

In 1985 Kaplicky and Nixon applied to the Graham Foundation in Chicago for a grant to explore the ultimate possibilities of high-rise construction. Impressed by their outline, the foundation awarded them the largest bursary that it was within its power to bestow. The result was Project 112, the Coexistence tower.

been awarded a research grant to help develop proposals for the interior of NASA's orbiting space station, then scheduled for deployment in 1991. In an astonishingly short time, and albeit in a tenuous manner, Future Systems was in the space business.

In all, three Future Systems extra-terrestrial projects were carried out 'by airline, telephone and courier' before Kaplicky ceased to be involved in the NASA-related work. During that time the practice at last began to achieve the subcultural recognition that is the necessary prelude to real fame. At a series of exhibitions in Los Angeles, at the Centre Pompidou, at the Royal Institute of British Architects (RIBA), at the Deutsches Architekturmuseum in Frankfurt, and again at the Centre Pompidou, Future Systems' NASA-related projects began to create a distinct identity for their creators, one that brought a second phase of interest on the part of magazine editors and architectural critics. Major articles by Nixon and Kaplicky on their aerospace work were published in the *Architectural Review* in 1983 and 1984 and, as late as 1987, the Archigram alumnus Ron Herron, who by then was sharing an AA teaching unit with Kaplicky, wrote: 'I envy them their position as "the only British architects working for NASA"'.

Seen together with Kaplicky's own monocoque and semi-monocoque, aircraft-like building designs, the projects Kaplicky and Nixon developed jointly for space applications represent a unique departure in late 20th century architectural design. The solar flare- and meteorite-proof Preliminary Lunar Base, the octagonal Orbital Space Beam System for assembling deep space structures and the Space Station Wardroom Table (to which sheets of paper would adhere by velcro) were in their way a removal of all the difficulties of acceptance that had hindered the progress of their terrestrial work. In space there could be no aesthetic objection, no conservationist retreat. As Herron observed in his introduction to the 1987 exhibition catalogue: 'Design within the "unreal" real environment of space...is not being surrounded by second- or third-rate buildings.'

Unfortunately, as it turned out, it meant no speedy production of hardware either. Even before the 1986 *Challenger* disaster, the NASA space programme was slowing down. Soon, with its funding cut and innumerable problems with the Shuttle itself to be overcome, the dead-

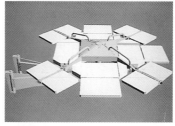

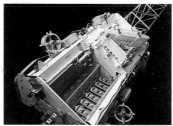

line for the spacelab project was shifted further and further back towards the end of the century. Elaborate plans for enlisting the help of small businesses and university departments in the next phase of the space programme soon withered and died. By 1987 the aerospace dimension in Future Systems' work, though dominant in their publicity, was moribund.

Nixon's role in the evolution of the practice, however, was not confined to the space programme. A native English-speaker, blessed with a direct and forceful style of writing, Nixon also succeeded in setting down in words all the theoretical underpinnings for the Future Systems *oeuvre* that Kaplicky himself had learned to confine to short titles and dramatically effective pictorial juxtapositions.

The contrast between their two approaches can be made clear by two examples. One of Kaplicky's most frequently illustrated designs, the Peanut House of 1984, consists of a tiny living capsule at the end of an articulated hydraulic arm, which enables it to rotate, rise and fall and generally adopt different configurations at the owner's whim. This project, apart from a detailed cutaway of the capsule itself, looking like the cabin of a helicopter or a light plane, remains virtually undescribed.

There are just four reference images that establish the Peanut House's capabilities perfectly. The first shows maintenance engineers at work on the underside of a bridge using the commercial mobile version of the same hydraulic device. The second is a double image showing the house in two positions at the edge of a lake: in one it has risen to enjoy the view; in the other it has dipped down as though sipping water from the lake – in fact it is permitting its owner to step into the water for a swim. The final image is of a survival tent on the snowy slopes of a mountain. Between them these images say all that is necessary about the dramatic, personal freedom bestowed by the Peanut House – a freedom inconceivable within he conventional constraints governing the use of the word 'architecture' and the word 'house'.

The Peanut House exploits the capability of movement in a way that is denied to all conventional architecture without exception: the views from its cockpit will be as different as the viewpoints of a thousand photographers; without wheels it can move from place to place; without wings it can be a single-storey building or a 10-storey

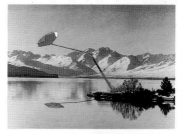

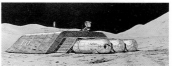

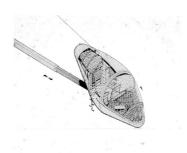

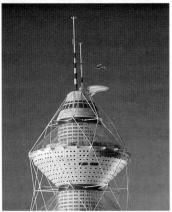

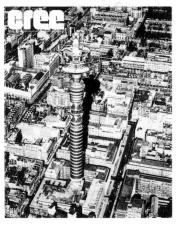

building. And Kaplicky conveys this freedom almost without words. Instead he uses exquisitely chosen photomontages to contrast the limitless but real technological capabilities that exist in our world, with its paralysed and stunted notion of what is architecture.

Kaplicky the *émigré*, the refugee from a totalitarian political system, must have perfected this wordless means of communication many years before. A very early example is the Volkswagen Beetle on the roof of the DRU building in Aybrook Street; another the 1976 cover for *Cree* magazine that showed the newly-completed London Post Office tower topped with the Queen's crown. Such facility with images is not easily come by. In his case it is the creative fruit of the years of alienation forced upon him by immigration, by total immersion in a language and a culture other than his own. Kaplicky endorsed everything that Nixon wrote, but he did not write it down; he drew, modelled and caricatured it instead. Nixon the Americanophile, the corporate negotiator, the competition entrant, the proposal writer, was the man who put the words to the music of Future Systems.

Consider another project of their collaboration that is as different from the Peanut House as it is possible to imagine. In 1985 Nixon and Kaplicky applied to the Graham Foundation in Chicago for a grant to explore the ultimate possibilities of high-rise construction. Impressed by their outline proposal, the foundation awarded them the largest bursary that it was within its power to bestow and the result was Project 112, the Coexistence tower. This structure, developed with the enthusiastic assistance of Ove Arup & Partners, structural engineers, takes the form of a 150-storey skyscraper combining 672 apartments in 76,000m^2 of residential accommodation with 285,000m^2 of offices, the whole disposed in seven superimposed, accommodation elements encircling a structural and service core.

Two photomontages show this immense megastructure, one in the City of London, the other on Manhattan Island. Seen by most critics as an act of deliberate defiance at a time when high-rise public housing was still being dynamited to the ground, this project – a huge model of which dominated the Future Systems exhibition at the AA in 1987 – was nevertheless a deliberate attempt to rehabilitate the concept of high-density, high-rise living. Indifferent to the antagonisms this project awoke, Kaplicky's image-based derivations show a

cutaway spiral sea shell and an arcadian scene intended to invoke the reality of the sheltered parks located on the seven primary levels of the tower. In his eyes the project itself is thus its own best justification.

Nixon, on the other hand, a major design contributor but solely responsible for the text accompanying the design, came out fighting: 'Of all mankind's achievements in the field of architecture in the 20th century,' he wrote, 'the skyscraper is the most dramatic, exciting and profound. As we approach a new millennium, the skyscraper, like the aeroplane, will be celebrating its centenary as a monument to human endeavour...However, as we near the new century, the function of cities as commercial nuclei is beginning to be challenged by the impact of the information and communications revolution. The historical role of the city centre as the focal point for the business community is being questioned...The role of the skyscraper as the accepted flagship of urban commerce will need to be re-evaluated.

'The skyscraper must find new urban applications and one long-neglected application is that of high-density residential use. The United Nations predicts that by the year 2000, half the world's population will be living in cities and there will be between 18 and 20 megacities around the world. The pressure for efficient land use and occupancy optimisation will inevitably grow and new ways will have to be found in city centres. The skyscraper offers the best solution, but only if radical new design concepts are explored.'

Thus in a few hundred words Nixon not only bypassed any questions about the structural feasibility of such a 600m tower, but linked the Coexistence project, not to declining commerce or arguments about context and style, but to world demographic projections, the advent of the millennium, soaring urban populations and the absolute necessity for structures of an appropriate scale to accommodate them.

Although in appearance and graphic style all the projects of their years of collaboration indisputably flowed from the creative stream of Kaplicky's earlier designs, Nixon undoubtedly possessed a unique facility in explaining the significance of their work in relation to the long-term, real world issues that dominated their thinking. On occasion these explanations could be highly specialised, as are those discussed in his article 'Living in Space', published in the *Architectural Review* in July 1984. But a

year previously, in another article published in the *Architectural Review,* entitled 'Skin: monocoque and semi-monocoque structures' – which formed the basis for the manifesto *Constructing the Future* – Nixon set out to explain the rationale behind all the designs that he and Kaplicky were creating.

Unlike his partner, Nixon did not attempt this task with images alone. Instead he set forth a verbal argument that is so cogent an expression of the beliefs of both partners, and so clear an explanation of their aims at the time of the foundation of their practice, that *Constructing the Future* still deserves to be treated as Future Systems' most important theoretical statement. It is certainly the most lucid exposition of the difference between Kaplicky and Nixon's conception of architecture as a continuously evolving process of technology transfer; and the opposing academic view of architecture as an art rooted for ever in historical principles.

As such, the text deserves to be quoted at length: 'In the fields of medicine, electronics, aerospace and surface transportation, technological progress has been widespread and continuous. In the building industry, technological development has been intermittent and isolated. In the 66 years of achievement from the Wright biplane to the Lunar Module, the building industry has achieved comparatively little in the way of technological progress. If progress is measured by technology, the building industry is still heavily dependent on basic materials such as steel and reinforced concrete that were discovered in the 19th century, or very much older ones like stone, brick and timber. If progress is measured by scale, the industry has evolved from buildings with 10 floors in Chicago a century ago to buildings with just over 100 floors in the same city in the 1970s. The mile-high skyscraper conceived by Frank Lloyd Wright a year before the Soviet Union launched *Sputnik I,* is yet to be built whereas the descendants of *Sputnik* have visited other planets and are now on their way to the stars beyond...

'Future Systems was set up as an ideas laboratory to demonstrate how this inertia can be overcome through revitalising building technology. Over the years, a series of concepts has been developed on paper which how technology derived from advanced industries like aviation engineering, space technology, marine engineering and land transportation can be used in the building industry. This is generally known as "spin-off" or "transfer" tech-

nology...Future Systems believes that borrowing technology developed from structures designed to travel across land (automotive), or through water (marine), air (aviation) or vacuum (space) can help to give energy to the spirit of architecture by introducing a new generation of buildings which are efficient, versatile and exciting. This approach to the shaping of the future of architecture is based upon the celebration of technology, not the concealment of it.'

Nixon went on to outline the advantages of the techniques of monocoque and semi-monocoque construction used in the aviation and automobile industries and already adopted by Kaplicky. He cited facts and figures to prove their strength, durability, efficiency and cheapness, and went on to to speculate about the ways in which this level of technology might 'filter down' to the level of building construction. Nixon wrote with particular enthusiasm about the potential of the aerospace industry, but he concluded prophetically: 'All this technology is capable of yielding an architecture of sleek surfaces and slender forms – an architecture of efficiency, elegance and excitement. The technology is out there, waiting. The effect of introducing this technology into the built environment will be positive and profound. But the decision whether to use it or not is up to architects and engineers. Ultimately the limits to design will be set, not by the limitless capabilities of technology involved, but by the limits of their creative imaginations.'

This final note of doubt about the limited 'vision' of which the construction professions are capable, expressed Nixon's own position perfectly. When the first two partners of Future Systems parted company in 1987 after an association of 10 years, it was ultimately because a schism had opened up between them of far greater significance than the distance between London and Los Angeles. Kaplicky was still prepared to pursue the the idea of a terrestrial architecture of technology transfer: the idea of developing buildings out of whatever is being discovered and manufactured in the world provided only that it could contribute to a closing of the crucial gap between advancing technology and static or retreating architecture.

Nixon was different: although he had enunciated this position with great clarity, he was already in pursuit of something else. As his former partner puts it today: 'As time passed I think he became progressively less interested in architecture on this planet.'

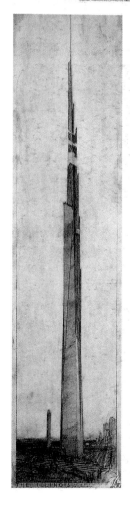

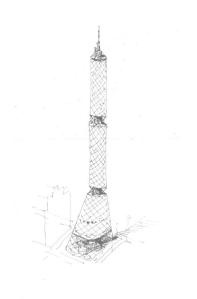

By 1987, the aspirations that had engaged Kaplicky and Nixon at their neighbouring drawing boards at Louis de Soissons were no more than a memory. Ten years before, in the autumn of 1977, a final financial crisis had led to a massive reorganisation of the Brighton Marina management and many of the architectural staff had left, Kaplicky and Nixon included. Nixon had seized the opportunity of a trip to the USA and spent the next year working for Skidmore Owings and Merrill in Chicago, before returning to work in a succession of well-known London offices: Terry Farrell & Partners, Nicholas Grimshaw & Partners, and then finally, just before his permanent departure to the USA, Richard Rogers and Partners. Kaplicky did not follow him. After some heart-searching, he resolved to return to Foster's. After one or two abortive approaches, he gained a second job interview and was offered a position at Foster Associates for what was to be his last and longest period of salaried employment.

On this occasion he started off on a different footing with his employer. At the show-and-tell interview where his portfolio was displayed, Norman Foster was forcibly impressed by Kaplicky's formidable draughtsmanship and

bid to design the St Louis Humana building (whose final form owed a great deal to Kaplicky's ideas); the interior design of the large new offices in Great Portland Street to which the firm moved in 1981 and, most importantly, the proposed BBC Radio building at Langham Place. This last project, which ran to 108 different concept models in its early stages, included for a time two revolutionary egg-shaped semi-monocoque design proposals by Kaplicky that were later discarded for contextual reasons. They were to surface again in Kaplicky's work later on.

When not playing his part with one Foster design team or other, Kaplicky spent time in the 'think tank' section of the office, along with an associate of the American inventor and engineer Richard Buckminster Fuller, named James Meller. There he prepared impeccable design drawings of all the Foster projects since 1969 for a book on the evolution of the practice. Although it was destined never to be published in the form conceived in the 1970s, this book project occupied part of Kaplicky's time for most of the six years he spent at Foster Associates.

Outside the office, the leitmotif of his life between 1978 and 1983 was the work of Future Systems. Working

PART 4 'EVERYBODY IN ARCHITECTURE HAS A HARD TIME'

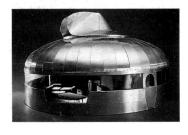

from then on always valued it highly. In the six years that followed it joined the unique freehand sketches of Birkin Haward in defining part of the unmistakable Foster approach to a long string of projects. Even after Kaplicky had left, his precise but economical drawing style lived on, resuscitated and replicated by others, in the three volumes of the definitive *Foster Associates: buildings and projects*, published in 1989 and 1990.

But, in 1978, the state of affairs which greeted Kaplicky at Foster Associates bore no resemblance to the state of affairs he had encountered at Richard Rogers and Partners on the eve of the Pompidou breakthrough seven years before. This time Kaplicky played a crucial role in the hurly-burly of an office working on feasibility studies for out-of-town leisure and shopping centres; housing at Milton Keynes; offices for IBM; an ultimately unsuccessful proposal for the new Lloyd's building; the opening moves in the saga of the Hongkong and Shanghai Bank; the narrow defeat at the hands of Michael Graves in the

closely with Nixon prior to his departure, and later via long-distance communication with Los Angeles, the pair produced a number of competition designs, but this time without the success that had come to their informal partnership. Kaplicky in particular was bitterly disappointed when Project 113, a segmental, partially subterranean exhibition building they had designed for the Kew Gardens competition of 1982 was unplaced. This project not only possessed the same compelling, functional logic as the earlier English Industrial Estates design, but marked an important new departure in Kaplicky's work, its form and structure being closely and elegantly derived from the natural model of an unfolding flower.

In November 1983, Kaplicky's six-year employment at Foster Associates came to a sudden end. For reasons that have never been fully explained, but were no doubt connected with the reorganisation of the practice brought about by the financial and manpower demands of the Hongkong and Shanghai Bank and the BBC Radio build-

ing, Foster Associates sacked 11 staff, including several established figures, among them Kenneth Armstrong, James Meller and Kaplicky. This unexpected turn of events meant Kaplicky was thrown on his own resources for the third time since he had arrived in England.

This time, however, he was better able to adapt to his changed situation. One year earlier Alvin Boyarsky, chairman of the AA school of architecture, had invited Kaplicky and Ron Herron of the Archigram group to form a High-Tech unit at the school, as part of his continuing effort to integrate the large but inadequately funded AA school with all the more advanced and important architectural offices in London. Kaplicky and Herron worked harmoniously together on a part-time basis and continued to run Unit 8 in the Diploma School at the AA until 1989, each spending one-and-a-half days a week supervising student projects.

Also in 1983, a private commission had arrived, in a form strikingly similar to the sort of small jobs Kaplicky had undertaken before he left Prague. Deyan Sudjic, the well-known design writer and editor of *Blueprint* magazine, asked Future Systems to remodel his apartment in north London. This project was never carried out in its entirety, but it called for a system of raised floors and fabric suspended ceilings that transformed the conventional rooms of a converted 19th-century London house into a series of neutral volumes linked by shipboard-bulkhead doorways and a new wall opening with ramps on either side. With concealed services and an island 'culinary workstation' instead of a cellular kitchen, the entire installation of Project 118 takes place inside the structure of its 'host' dwelling without damaging it. The elongated lozenge shape of the wall opening is an expression of one of Kaplicky's favourite shapes. It is an outline that appears in three dimensions in Project 124, the Peanut House.

Soon after, Project 133 – a much larger interior job – hove on the horizon. Jointly with Eva Jiricna – who by now had successfully diversified into shop design with a number of much admired outlets for the fashion entrepreneur Joseph Ettedgui – Future Systems made a pitch for the the £1m refurbishment of a floor of Harrods. This project was destined to become Harrods' Way-In – an up-market, younger customer department designed to carry the venerable store into the high-tech retail environment of the 1980s. Style played an important part in gaining

this commission and Kaplicky remembers the deliberations that led to his attending client presentations in an open-neck shirt and without a jacket. 'I didn't wear a jacket deliberately,' he says, 'in order to be taken for an artist by the management.'

Whatever Harrods thought of this sartorial presentation, Future Systems did get the job and Kaplicky carried out much of the design work, most visibly contributing the unique Way-In graphics that are used in the famous Knightsbridge store to this day. He also designed the modular, multi-purpose, mobile display trolleys that are used there.

In 1985, while still working on Project 133, Kaplicky asked for the brief for the Trafalgar Square Grand Buildings competition, which he and Nixon studied. This architectural contest, which attracted nearly 200 entries, was eventually won by a firm proposing to construct 13,935m² of state-of-the-art office floorspace inside a replica of the Victorian building already on the site on the South side of the square. This outcome, bitterly criticised in the architectural press at the time, marked one of the high points of conservationist influence during the 1980s. It followed upon the rejection of the Palumbo scheme to build a posthumous Mies van der Rohe tower near the Mansion House, and the rejection of Richard Rogers' design for the proposed National Gallery extension on the other side of Trafalgar Square.

Although Future Systems had considered entering this competition, neither Kaplicky nor Nixon liked the brief and, after some preliminary work had been done, they did not submit. But the exercise was not entirely wasted: the site was destined to surface later as the location of one of Kaplicky's most controversial designs, Project 135 or the Blob.

The Blob is Future Systems' answer to the outburst of new office construction in and around the City of London that had come with the deregulation of the financial services industry. Unlike the 'stealth bomber' offices going up at Broadgate, Saint Martin's le Grand and Fleet Street, with their extensive information technology infrastructure hidden behind retained or fake historical facades, the Blob represents unalloyed advanced technology architecture. Where more conventional architects were content to increase floor-to-floor heights in order to make room for under-floor cabling and overhead air conditioning,

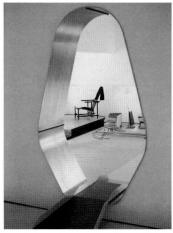

Kaplicky saw that the structural capacity to relocate office floors within the building shell was the only long-term answer to the uncertainty that existed at the time about the ultimate space demands of cabling and cooling. In the same way he saw that the maximum internal volume for the minimum surface area; the highest energy efficiency, and the highest net-to-gross ratio between usable floor space and actual floor area could only be gained by abandoning trabeated building forms altogether in favour of a three-dimensional space-frame structure enclosed by a curvilinear skin.

With the assistance of Frank Newby, the structural engineer, Kaplicky developed the design of the Blob to an advanced stage. Although it was not entered for the Grand Building competition, it followed the same brief, achieving a net-to-gross ratio of usable space more than 20 per cent higher than the winning design. Photomontaged into position in Trafalgar Square, it demonstrates (as Ralph Erskine's Hammersmith Ark has since confirmed), how powerful and liberating even the mildest abandonment of rectangular geometry can be in architecture.

After Harrods' Way-In, other minor jobs followed. A less dramatic apartment refurbishment in 1986 was followed by the design of the Sir Owen Williams memorial exhibition in London at the AA. Then came another tantalisingly close competition result. The magazine *Japan Architect* called for designs for a new bridge across the RIver Seine in Paris and Future Systems, along with 650 other architects, entered a project. The venerable Japanese Modernist Kenzo Tange was one of the assessors and the Future Systems structure received second prize. Once again victory had eluded them by the tiniest of margins.

In the following years the AA was scheduled as the venue for the largest-yet Future Systems exhibition and much time was spent in preparing for it. This was the crucial period of separation between Kaplicky and Nixon, although this did not become apparent until later. More significant at that time was the developing relationship between Kaplicky and the English architect Amanda Levete that was to lead to partnership and marriage.

Levete is a charming and energetic person who made her way into the world of architecture through what she calls a 'vacuum of encouragement' for women: something that may now have changed but, in her day, extended from careers advice at school right through the long years of training. Born in Wales in 1955, the daughter of a banker

and a ballet dancer who later received the MBE for her pioneering work with disabled children, Levete grew up in London and rapidly tired of conventional education. She left St Paul's school in London at the age of 16 and, after an inconclusive year at art school in Hammersmith, decided that architecture seemed a more defined course of study and enrolled at the AA. 'I knew then that I work best when I have something to rebel against,' she remembers. 'Art school was too undisciplined and unstructured.' But half-way through her five-year course at the AA she had second thoughts about that, too, and went to the USA, undecided whether to continue or not. Whilst in the USA she did odd jobs: she worked as a waitress in a hamburger joint in New York, where the chef turned out to be Julian Schnabel, and delivered a car from New York to Los Angeles. 'I wanted a Mustang but when I picked it up it turned out to be a British car! I couldn't believe my rotten luck. And they didn't even give me a tip when I arrived!'

Rather like Kaplicky himself some years earlier, she gave up on America and returned to Europe. Back in London she went to work for avant-garde architect William Alsop and enjoyed it so much that she decided to finish her course at the AA, where she graduated in 1982. 'I applied immediately to work for Richard Rogers, but he had no vacancies. From then on I rang up practically every week.' Whilst waiting for Rogers to weaken she worked at YRM Architects, quickly discovering a unique talent for the business side of architecture in addition to her considerable design abilities. Finally, in 1984, she was offered a place by Rogers and, by the age of 30, was running the £30m conversion of Billingsgate fish market into an electronic superbank for the Richard Rogers Partnership.

She has decided views about the role of women in architecture, dating from that period. 'I thought hard about it,' she says, 'and I decided that the idea of "women in architecture" as an issue in itself is no more than a myth. Feminism is a very important movement but it cannot address architecture if it cannot be specific. Women won't go around demanding laws to say that hard-hats and site boots should be smaller, or that nobody should call you "darling", or that reps in the office shouldn't make remarks. You can't legislate against people making remarks. Architecture is a hard, personal, disappointing, competitive profession. Everybody in architecture has a hard time.' Chairing the weekly site meet-

ings at Billingsgate – the only woman among 15 or 20 builders, engineers and subcontractors – she recollects that nobody behaved any differently because she was a woman. 'I certainly didn't. I think they were all more frightened of me than they would have been if I had been a man.'

Amanda and Jan had met for the first time in 1983 and had encountered one another on various occasions thereafter. Then in the spring of 1987 they found themselves in Prague together on holiday. That was when the episode of the birthday tree occurred. On their return to London they became lovers. That summer Amanda moved into Jan's flat in Bayswater and they commenced to live and work together. 'I went into it with my eyes open,' she says. 'I knew from the beginning that his life had to change and I was going to change it. We had to have an office; he had to give up teaching, and we had to start meeting people.'

The first Future Systems scheme Levete worked on was Project 153, the competition for the Paris Bridge. In the following year she and Kaplicky worked on Glass and Grass, their entry for a 'home of the future' competition organised by The Building Centre, for which they received an honourable mention. Also in 1988 they worked on Project 161, an invited competition to design Berlin offices for the Heliowatt Corporation called the Wrap, whose curvilinear form echoes in three dimensions the rounded corners of 1920s' Berlin department stores and cinemas. On a different scale they worked together on Project 165, a tiny 6m-long 'country house capsule' called the Drop that was commissioned by Artec '89 for the Nagoya Biennale and survives in the form of a beautifully constructed model.

Scaling up again, they worked on Project 158, a much larger conception called the Spire. This structure, an immensely tall, inclined observation tower for Hyde Park, was sponsored by British Telecom and exhibited in London at the Institute of Contemporary Art's *Metropolis* exhibition. It is the first project in which Levete feels that her direct design influence was felt in a manner distinct from Kaplicky's own. She insisted that the base of the 480m tower be landscaped into the site near the Serpentine, and not simply treated as a vast piece of technology emerging from the grass.

In those early years it became clear that while their partnership suited them both and enriched their lives, there was a strong element of contrast in it that later dis-

appeared. In the beginning, if Kaplicky's almost reclusive life of teaching and drawing was the thesis, Levete's day-to-day experience as a job architect at Richard Rogers and Partners – a life filled with the heady excitement of construction in a city booming with Big Bang projects – was the antithesis. The centre of her motivation for architecture came not from drawing, but from direct experience of the building process. She positively relishes the intense co-operation and teamwork that goes into putting up buildings and remembers that period fondly: 'I got an incredible buzz out of the number of people involved, the teamwork, the energy and interaction that went into turning paper drawings into the real thing. Once you have been a part of that process you can never settle for anything less. For that reason I was prepared to take decisive action, to take risks.'

Kaplicky could hardly have been unaffected by Levete's enthusiasm and conviction that everything was possible. For her part, Levete saw that to transform the limited design excitement of a Future Systems project into something that could claim its place in the world of built realities with which she was familiar, called for an enormous and sustained effort. To make this effort they would have to transform their lives, and in the spring of 1989 they did.

With bewildering suddenness three all-but irrevocable changes in their lifestyle took place: Levete left Richard Rogers' office and formally became a partner in Future Systems; Kaplicky gave up teaching at the AA and they opened an office to begin the practice of architecture full time. Once again the moving force behind this last change was Levete. She saw that the practice could never break out of its cycle of competition near-misses and exotic but nebulous consultancies so long as it lacked an office address and the obvious capability to undertake real jobs. The next step was to take over a short lease on a small suite of offices in Store Street formerly used by the structural engineer Tony Hunt. Once in Store Street, Future Systems became an architectural practice in every sense of the word. From now on there was to be no looking back. As yet with no staff, they even forebore to go out to lunch together in case an important client called and found the office empty.

Though neither of them knew it, the existence of the office was soon to become most opportune. At first they concentrated on developing existing projects like Project

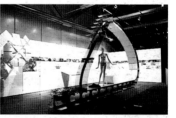

Centre de Création Industrielle
Centre Georges Pompidou

In August it emerged that Future Systems had not only made the second stage of the competition, but was to be included in the shortlist of four, with Dominique Perrault, Chaix et Morrell, and James Stirling, Michael Wilford & Associates. With this, a period of almost unbearable tension began.

139, a 1985 idea for a large-span, air-deliverable shelter structure for disaster areas that had been inspired by conversations with the charity Save The Children Fund during the Ethiopian famine. With its low weight, low cost and capacity to shelter up to 200 people, this project seemed a likely candidate for an RIBA research grant, but the application was unsuccessful.

Then, like a bolt from the blue, in the summer of 1989 they found themselves included among only 20 entrants out of 230 asked to go forward to the second stage of the international competition to design the new £500m Bibliothèque Nationale de France in Paris. This was a project of such grandeur that even to reach the second stage stimulated a surge of professional interest in their work. Tom Barker, a services engineer at Ove Arup & Partners, whose acquaintance Levete had made whilst working on the Billingsgate conversion for Rogers, brought the considerable resources of one of the most famous engineering consultancies in the world to the concerted team effort that ensued to develop the Future Systems vision of a twin-peaked, aerodynamic library enclosure, divided by a vast, glazed, central valley penetrated by a pedestrian bridge, into the superbly worked-out competition entry that was finally submitted.

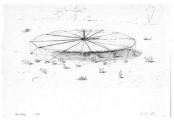

At the beginning of August 1989, it emerged that Future Systems had not only made the second stage of the competition, but was to be included in the shortlist of four, with Dominique Perrault, Chaix et Morrell, and James Stirling, Michael Wilford & Associates. With this, a period of almost unbearable tension began, but there was worse to come. Just when it seemed that the suspense had become intolerable a final unprogrammed shortlist of two projects was announced – Future Systems and Dominique Perrault. These two totally different schemes were put before François Mitterand. For 10 days the final decision lay with the president of France, for the Bibliothèque was to be the last *grand projet* to be approved during Mitterand's term of office. If he had decided in favour of Future Systems – 'a door opening upon the future', as the judges' report described it – the repercussions of his decision of 17 August 1989 might have been as great as those of that another presidential decision taken on 15 July 1971, when Georges Pompidou confirmed that Piano and Rogers had won the Plateau Beaubourg competion with a design that was later to become famous as the Centre Pompidou. But it was not to be. Disappointingly, he chose Perrault.

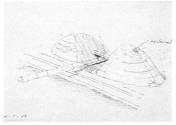

Victory in Paris for Future Systems would have been sweet. It would have broken a tantalising run of competition near-successes that had started with that other joint first, the 1979 Melbourne Landmark competion. After coming so close, so often, it is cruel to be reminded – as was an incredulous Queen Victoria after the British yacht was beaten in the first Americas' Cup race – that in architectural competitions, too, 'There is no second, Ma'am'.

The Future Systems library project is like no other entry. While devoting scrupulous attention to the needs of a vast metropolitan library in the cusp of transition between the book and electronic information storage and retrieval, it makes no compromise with historical urban architectural styles, or indeed the rest of the monumentally modern *grands projets* commissioned in Paris in recent years. It is far more synergetically advanced than any of these. Instead it concentrates on enclosing the brilliantly conceived morphological function of a stronghold of the printed word, whose task is to provide democratic nurture for electronic information technology, which is its infant offspring. If this metaphysical brief produced nothing to resemble other Paris public buildings, it certainly produced nothing that can be compared with the British 'National Library' on the Euston Road.

Standing on a spectacular riverside site, as far down the River Seine from Notre Dame as the Eiffel Tower is upstream from it, the Future Systems design for the Bibliothèque Nationale de France looks like nothing so much as a vast wind-sculpted rock formation in the Arizona desert split by a scooped, north–south valley of glistening quartz. The future centrepiece of a large-scale regeneration of the Tolbiac district, the new library will dominate an entire city block between the de Bercy and Tolbiac bridges over the Seine. The Future Systems design intensifies this dominance by centring the library itself in a rectangular park formed largely from the spoil excavated to make way for its substructure. The building itself resembles an immense, metallic, built-up topographical saddle. With the engineering assistance of Ove Arup & Partners this shape was structured from two six-storey service cores, which support library space and carry a double-curved, steel space-frame collar to support the breathtaking sweep of catenary tension

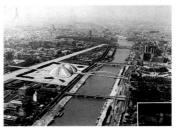

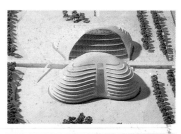

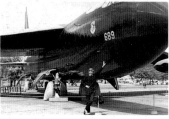

cable-supported glazing that illuminates the central reading room below.

The saddle envelope configuration has impressive functional advantages. It requires minimal surface area for maximum enclosed mass. In order not to disrupt this aerodynamic cleanness, notwithstanding the high information content of the building, the designers even eschew the iconography of prominent antennae clip-ons, by using the two peaks of the saddle as large composite 'nose cones' to contain line-of-sight microwave and satellite equipment. The final result is a gross floor area of 177,000m² on five basement and six above-ground floors. The outer skin to floor ratio is an incredible 0.39:1, which can be compared to 0.7:1 or more for conventional rectangular structures.

The metal outer cladding of the envelope itself is intended to be a smooth compound-curved assembly of large, ceramic-coated aluminium panels that would be cleaned by robot crawlers of the kind used to anti-foul supertanker hulls. Punching through this envelope in broad thin strips are rows of horizontal, sealed windows. These windows are shaded by horizontal external fins with motorised louvres powered by solar cells in the reading rooms.

Such efficiency of enclosure, like the aerodynamic efficiency of a low Cd number in car design, not only translates immediately into low heat loss and low energy consumption, but also into smaller structural mass per square metre of floorspace. This in turn permits either cost economies or more resources for other elements of the project. Direct cost comparisons with the other three final schemes are not available but it is believed that this efficient envelope design, coupled with the relatively minimal groundworks required for the Future Systems design, made Davis Langdon & Everest's £392m cost-estimate one of the lowest under consideration.

After the bitter disappointment of the Paris result, there was only the consolation of the fee paid to the three runners-up and a brief visit to Paris for the opening of the exhibition of the 20 shortlisted designs. But back in Store Street, Future Systems' office, laid out like a mouse trap, appeared to be catching 'real' clients, albeit it on a small scale. A private family trust, formed to manage some London properties, asked Future Systems to reconstruct a run-down 18th-century house converted into offices at

No 23 Gosfield Street, W1. It was a far cry from the Paris library, but it was here that Levete's determination about the direction the practice should take really made itself felt.

From the very beginning it was clear from conversations with Westminster City Council that there could be no question of changing the external appearance of No 23 Gosfield Street. At this dispiriting news Kaplicky was prepared to relinquish the job immediately, on the grounds that nothing meriting the reputation of Future Systems could be done within such crippling restrictions. But Levete stood firm and, after long discussions, it was decided to build a 'stealth bomber' instead.

Thus Project 167 became the first exercise in architectural contextualism that Future Systems had ever undertaken. The design maintains the street facade intact but everything behind the facade is gutted and new, steel floor decks are set back behind the window line so as not to break up the original glazing pattern. Behind the preserved elevation, Kaplicky and Levete have created a large, open-interior space with separate but interconnected floating floorplates beneath a vast, undulating glass roof. The effect of this transformation is particularly striking in model form. From the front there is no hint of what lies behind, yet the front itself is wafer-thin. Behind it is a completely integrated spatial experience belonging to a different world.

The Gosfield Street project was granted planning permission in 1989. It was the first Future Systems project for a whole building to move so far into the realm of real construction in 11 years. But once again fate was destined to intervene to prevent the job from going through. Following the stock-market crashes of 1987 and 1989, the overheated 1980s' commercial property market in London had begun to collapse. With every hurdle passed but one, Gosfield Street became another statistic in the lengthening list of projects put on hold until demand for office floorspace should revive.

In the spring of 1990 there emerged another competition of the grandeur of the Paris library: the Greek Ministry of Culture-sponsored contest to find a design for a new Museum of the Acropolis at the foot of the great symbol of European culture in Athens. The building was intended to resolve the essential problem of the Acropolis site in the late 20th century: to protect it from erosion,

damage and pollution, and also to celebrate its status as one of the world's most important tourist attractions.

The Future Systems entry, Project 172, was again supported by services engineers from Ove Arup & Partners, but this time the structural engineering input came from YRM Anthony Hunt Associates. The result of this collaboration is a unique structure called 'a museum without walls'. This combines an advanced asymmetrical dome structure, clad in glass and aluminium by Tony Hunt, with one of the first of the advanced low-energy cooling systems that the Arup services engineers had begun to develop to counteract the cost and pollution of conventional air conditioning. The object of the museum is to interpret the Acropolis site, particularly the Parthenon itself, by enclosing a full-size plan and actual sculptural exhibits within eyeshot of the original.

Like the Spire and Gosfield Street, the Acropolis project shows Levete's design influence acting in a complementary way to Kaplicky's own. The topographical site-specificity of the design, as well as its extensive and dramatic use of transparent glass cladding – not normally preferred by Kaplicky because the limitations of contemporary technology means it cannot be combined with semi-monocoque construction – clearly shows the results of their collaboration. Until Athens, few Future Systems projects had sought to complement the landscape; rather they had achieved their powerful impact by stark contrast, as with the Peanut House or the Blob.

The Acropolis museum takes an entirely different approach not only by refusing to ape the architecture of the Acropolis itself, but also by ignoring the distracting demands of the buildings around the plateau on the three permissible museum sites. Instead, the design combines a large, advanced technology enclosure of minimal visual impact with an extraordinary transparency to permit a startlingly clear view of the Acropolis through its own domical glass envelope. 'The building was designed to be as "innocent" as possible,' Kaplicky recalls. 'Any "strong" building would have smothered the exhibits and detracted from the primary importance of the Acropolis itself.'

Future Systems went on to provide the crucial physical link between the new museum and the Acropolis by means of a direct and spectacularly attenuated bridge structure of minimal mass and minimal visual obstruc-

tion. The bridge, in turn, obviates much vehicular traffic and enables Future Systems to propose the closure of an existing road and bus park to improve the immediate surroundings still more.

The failure of Future Systems' competition entry not only to win, but even to achieve even an honourable mention was, if anything, an even more bitter disappointment than the failure of the Paris library to win a commission as grand as Pompidou. In part this was because there was a general feeling amongst all those involved, including the engineers Hunt and Barker, that the scheme was a superb solution to the problems confronting the Acropolis as it enters its third millennium. That these sentiments were not shared by the protagonists alone is proved by the wide publicity given to the entry after the results were made known. Unplaced as it was, the Future Systems proposal for the New Acropolis Museum was published in *Building Design*, the *Architects' Journal, L'Arca* and *Progressive Architecture* and gave rise to a spirited correspondence. But in the end the unpalatable fact had to be faced that the termination of the 1980s – a period of enormous construction activity in Britain – had been reached without a single physical contribution from Future Systems. Correspondence, controversy, criticism, praise and publicity were one thing: building real buildings was something else. Something in fact that was tantalisingly closer than either partner could have imagined.

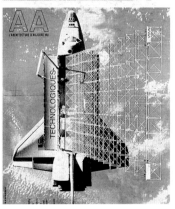

On 5 March 1991, the largest-ever exhibition of the work of Future Systems opened at the RIBA in London. The opening party, an event held in an atmosphere of increasing professional anxiety in an economic recession that already had the construction industry firmly in its grip, was an extraordinary occasion. It was attended by a vast number of people, so many that the sponsors, Beck's Bier, twice ran out of their product and had to send for emergency supplies.

A galaxy of architectural stars attended the party and there were journalists present in force. The BBC2 arts programme, *The Late Show,* made a short film about the occasion. For a firm of architects that had, at that time, not built a single building, this *vernissage* was a magical event. There was an atmosphere not of hype, but of history. So much so that the scene prompted a reviewer to declare in the *Architects' Journal* that the Future Systems projects on show were as revolutionary as Mies van der Rohe's famous glass skyscrapers had been in 1919. 'It may be absurd to judge a play by the behaviour of the audience on the first night,' he went on, 'but that is what critics do. At the Future Systems' opening last week

built, their international reputation is underscored by distinguished peers including Richard Rogers. The high-flying schemes of Future Systems may yet be grounded in reality.' So, too, thought John Winter in *Blueprint* magazine and Sutherland Lyall in *Design Week.*

As events were to show, these notices were but the prelude to a strange phenomenon by which images of the work of Future Systems began to be reproduced from magazine to magazine and proliferate in the media until a minor flood of publicity began that propelled the outlines of their key projects into the global mainstream of images that constitutes today's design consciousness. Like a robot photocopier, the world's design press has been circulating and recirculating images drawn from the 1991 Future Systems exhibition ever since; and from the design press these images have filtered out into newspapers, fashion magazines, avant garde style publications and tabloids. Since 1985 popular articles on the work of Future Systems have been published in Britain, the USA, Japan, Germany, France, Italy, Spain, Denmark, Czechoslovakia, Australia, Colombia and Cyprus. An analysis of this media coverage shows a total of 85 illus-

PART 5 'IN A RECESSION THE COMPETITION IS MORE EQUAL'

it was as if the whole architectural community had spontaneously decided that the monstrous bureaucracy that compels it to filter the future through Georgian fanlights and Victorian bluster, has simply got to give way. Sooner or later a real life Future Systems epic – like the 1989 Paris library or the 1990 Acropolis museum – will have to be built.'

Other reviewers were scarcely less enthusiastic. Writing in the *Independent,* Jonathan Glancey exclaimed: 'If you find these designs uninteresting, it is likely you prefer fake German lager to the real thing, a Nissan Cedric to a BMW 535, or a Post-Modern shopping mall to a traditional shopping arcade.' In the *Daily Telegraph* Kenneth Powell enthused: 'Future Systems' work offers a solution to the increasing squalor of urban life – an alternative to historicist escapism. It also has a sculptural elegance that marks Kaplicky and Levete as artist-architects of distinction.' In the same vein Nonie Niesewand pointed out in *Vogue* that, 'although their ideas may be so advanced that they are dubbed the best architects *never*

trated mentions in books, newspapers and periodicals, with a peak of 28 major magazine features in five languages in 1991.

Although during 1991 Future Systems had embarked on four 'real' projects for construction – only one of which was destined to be halted for financial reasons in the following year – the image from the exhibition most frequently taken up by the media was a theoretical design conceived almost, but not quite, in the abstract. This project, numbered 166 in the chronology that runs unbroken from Kaplicky's earliest designs, was designed in association with Ove Arup & Partners shortly after their collaborative failure in the 1990 Acropolis competition. Images of a detailed model of it, either photomontaged into an urban context or sculpturally bare, have been appearing in magazines ever since.

Unique though it is, Project 166 did not spring fully clothed from the aftermath of the Acropolis competition. There are threads in its lifeline that extend back, not only to the Blob of 1985, but to two of the 108 concept models

of the BBC Langham Place Radio headquarters developed by Foster Associates in 1982. These two, easily recognised by their aerodynamic shape, were initiated by Kaplicky while he was employed at Foster's. They were only briefly developed there before being discarded as too radical for the client and the sensitivity of the site.

The unique thing about these predecessors is that they were all conceived for actual urban sites. Indeed the Blob was not only designed for a real-life location in Trafalgar Square, but was also structurally and internally worked up to design drawing stage in consultation with structural engineer Frank Newby. In a sense the Blob was the instrument of Future Systems' crucial confrontation with contextualism. When it appeared in model form at the 1987 AA exhibition, the brutal juxtaposition of its aerodynamic curves with the mansards, cornices and general 19th-century bric-à-brac of the south-side of Trafalgar Square, roused a strong hostile reaction amongst those who favoured the then popular 'invisible mending' approach to the urban grain of the old city.

To this day, Kaplicky has never been able to come to terms with this level of opposition. With some justice he points to the thoroughly uncontextual appearance of many now-prized 19th-century structures, like the great London railway stations, listed gasometers, water towers and even the Albert Hall, but no reconciliation with the uncompromising appearance of the Blob appeared possible in 1987. Instead its line of development has to be projected forward another five years before a near-perfect relationship between an aerodynamic envelope and a traditional city quarter joined the Future Systems oeuvre. The conclusive project is the entry for the 1992 limited competition to design a new building for the Department of the Environment of the city of Hamburg, the Hamburg Umweltbehörde.

In this proposal Future Systems sought to harmonise an advanced technology envelope with the grain of the city by employing an efficient low-Cd aerodynamic shaped building in a carefully landscaped park setting. Instead of following the zero lot-line profile of the Blob, the Hamburg building grows out of a carefully landscaped urban setting. Of unique but functional appearance, it is clad in glass and shaped in such a way that its surface area is minimal for the volume of serviced floorspace it encloses. Its shape, its energy systems and its transparency all

combine to cut its operating energy consumption and its polluting emissions to a very low level. At the same time it creates a pleasant and invigorating working environment through its use of natural ventilation, natural lighting and unobstructed views.

The Hamburg project would have been an important visual addition to the city. The design exploits the prominent site by integrating into the building a major artwork for the first time in the history of Future Systems. This takes the form of a vast, vertically divided composition of coloured glass, designed by Brian Clarke, which would make the building as distinctive at night as its unique aerodynamic outline would make it during the day. Thus, in form and appearance it would ensure immediate identification as a landmark associated with its important administrative role.

Unlike the Blob, the Hamburg competition project takes space to integrate itself into the street pattern surrounding the site. Its site was to have been cleared and landscaped, with the other buildings on it relocated to nearby derelict land. This land, too, was to have been landscaped to create a new, linear pedestrian approach to the building, through two public parks, so that the building would have become the dramatic terminus of a 'green finger' extending from the banks of the River Elbe.

Despite the beauty and genuine contextual ingenuity of this project, like its Athens predecessor it failed to be premiated in the competition results. Nevertheless, it remains an impressive example of a kind of contextualism that most conventional architects and planning authorities consider impossible.

Project 166 represents an important intermediate stage between the Blob and the Hamburg Umweltbehörde, but one that has enjoyed considerably more success in terms of publicity. It was originally conceived as an 'alternative' project for Mappin & Webb corner. This is a prominent site in the City of London, which was made notorious by the 1984 rejection of a redevelopment proposal featuring a new public square, and a steel and glass office tower designed by Mies van der Rohe. Kaplicky began work on a variant of the Blob raised up on tripod legs in order to exploit the Corbusian technique of recreating public space beneath the building itself. This time, however, the resemblance to the Blob is purely formal. The real aim of the scheme, which was

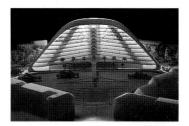

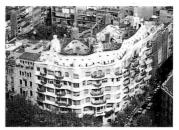

Tom Barker suggested a theoretical study for what he called a 'green building'. Not a primitive earth structure with a thatched roof in the manner generally called to mind by that term, but a serious attempt to apply advanced technology architectural thought to energy consumption and atmospheric pollution.

soon resited away from the contentious Mappin & Webb corner to a similar triangular site nearby, is far more ambitious.

This time the triggering event was a lunch with Arup services engineer, Tom Barker, to thank him for the work done on the Acropolis project. By then the expiry of their short lease had led Future Systems to move from Store Street to new offices of their own in Whitfield Street on the other side of Tottenham Court Road, taking with them Royal College of Art student Mark Newton who had worked with them on the Athens museum project. At the 'thank you' lunch, Barker, keen to prolong the partnership that had already produced such remarkable, though so far unsuccessful results, suggested a theoretical study for what he called a 'green building'. Not a primitive earth structure with a thatched roof in the manner generally called to mind by that term, but a serious attempt to apply advanced technology architectural thought to the twin problems of massive energy consumption and atmospheric pollution associated with the 'gas-guzzling', large floor plate, air-conditioned office buildings that had recently emerged in the City and elsewhere in response to the demands of the burgeoning financial services industry.

By the end of lunch both parties had agreed that the Arup service engineers would come up with a theoretical model for a day-lit, passively heated and cooled office building, while Future Systems would produce an architectural design to accommodate it. The result of this unique collaboration is Project 166, a complex, asymmetrical egg-shaped Green Building. It was unveiled in model form, together with drawings and photomontages showing it on a triangular site in the City, in the 1991 Future Systems exhibition at the RIBA.

Like many attempts to avoid the extremely high cost of air conditioning, the Green Building employs a natural energy system known as 'stack effect', whereby ambient temperature air enters a building at the bottom and rises as it warms to exit at the top, thereby creating an entraining current, which can be used for ventilation. Nowadays the main drawback to this system is the polluted condition of ground-level air in urban environments but, because the envelope of the Green Building is carried on a massive, tripod support structure, it is able to bypass this difficulty by taking in air 17m above ground level,

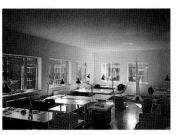

where particulate and gaseous pollution is much reduced. The building takes an asymmetrical egg form as a result of wind-tunnel tests carried out using models that included representations of the surrounding buildings. This shape optimised heat gain, through a sealed glass outer envelope, and achieved ventilating effects by means of an inner glass envelope with openable 'windows'. In winter a heat recovery system at the top of the envelope, where the convected air is hottest, would be used to pre-heat colder entry-level air; in summer, a cooling effect will be achieved by stack-induced air movement and, in extreme conditions, by tepid water loops run from heat pumps.

Quite apart from the daring nature of its ambient energy systems, the shape, appearance and name of the Green Building captured the imagination of generation fed for a decade on standard 'New Age' office buildings. In June 1992 it was featured on the cover of the authoritative American monthly *Architectural Record*, only weeks after Kaplicky and Levete had delivered a public lecture at Harvard to a disinterested audience of fewer than 20 students and staff.

With a perversity characteristic of the course of Kaplicky's fortunes over a number of years, the onset of the construction recession in Britain, a period marked by a severe reduction in work for almost all firms of architects, also signalled the beginning of real construction activity for the small office in Whitfield Street. At that time, when prominent architects openly talked of the 'casualisation' of the profession by recession, with 60 per cent of all business failures construction-related, it seemed miraculous that Future Systems could stay in business at all. But somehow they did. Part of the reason was a long shot that finally came good.

In 1989 Future Systems had been invited, along with many architects from around the world, to submit a portfolio of work for the selection of a shortlist of five practices who would be asked to design a 'caravan of the future' for construction and exhibition at the Museum of Contemporary Art in Sydney, Australia. This project was the brain child of Craig Bremner, the curator of the museum, who had conceived the idea of transforming elements of contemporary Australian life into cultural icons by redesigning them. In his view it should be possible to take a conventionally manufactured object, part of the

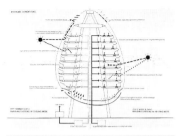

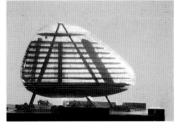

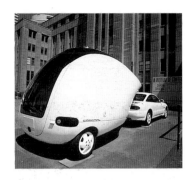

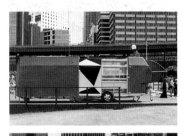

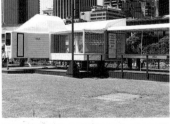

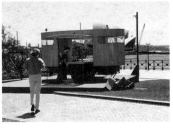

unremarkable machine environment of suburbia, and invest it with new meaning by inviting an international group of designers to redefine its form and function. His Caravan project sought to do just this by combining the skills of art and industry under the administrative umbrella of the museum.

Some time after their portfolio submission, Future Systems were advised that they had been selected along with two Australian, one Japanese and one American architectural practices to proceed with their design. This they did, sending off their project in due time. After another long silence, which lasted nearly one year, Future Systems were finally asked to contact Coromal Caravans of Perth, Western Australia, the firm that had been instructed to build their design.

The Future Systems Caravan project is a pure monocoque construction, a streamlined pod formed in composite foam mouldings with a large liftback hatch at the rear. Designed to cantilever forward over the tow-car, a 1990 Toyota Celica, whose profile was carefully studied, the hump-backed design reduces the overall length of a typical car/caravan combination and considerably improves its turning circle and manoeuvrability. Although the project hovered on the brink of abandonment when the compound sandwich structure of the caravan proved to be beyond the capacity of Coromal, the project was eventually subcontracted out to a glass fibre boat-building company in Perth. Throughout this process its design was detailed and monitored by mail, fax and telephone halfway round the world.

The Future Systems Caravan was finally completed early in 1992, trucked to Sydney and exhibited at the museum as part of Bremner's 'dialogue between industry, design and a museum'. Quite apart from its 'cultural' significance, the Future Systems caravan emerged as by far the lightest – at 400kg – and the most energy efficient of the selected designs, and was also judged to be the cheapest to put into production.

A second Future Systems project reached completion in 1992 – by which time not only were the majority of UK architects without employment, but major property and construction companies were falling into bankruptcy with increasing frequency. Project 184 is a demountable hospitality tent designed for the London Museum of the Moving Image. The project had its origins at a London Film

Festival party held in a rented marquee under Waterloo Bridge, where guests Kaplicky and Levete, learning the cost of leasing such marquees, voiced their opinion that they could design something considerably better for very much less money. Sure enough, early in 1991, they received an invitation from the Museum of the Moving Image to explore such a project. Future Systems immediately contacted Peter Rice, the structural engineer (now deceased), and he in turn expressed great enthusiasm about the challenge of a small demountable building.

In their first approaches to the MOMI Tent design, Future Systems concentrated on devising a concertina envelope that could arrive on site as a single assembly. But, as so much time and money would have been consumed developing the articulated jointing system, it was judged impractical to proceed in this way. Instead, repeated consultations with Rice enabled them to conceive a two-piece enclosure consisting of a 30m-long raised floor deck, above which looped extraordinarily thin structural members supporting a taut, white envelope made of Tenara, a 60 per cent light-transmitting, German synthetic fabric never before used in Britain. The floor deck concealed the heating and cooling fans and other servicing systems. Because of its untried nature, the startlingly white Tenara fabric had to be extensively firetested in order to satisfy the local authority building department. Lambeth borough council presented no obstacles and even permitted the use of self-illuminating radioactive exit signs to avoid the need for high-level wiring where it would be visible against the diaphanous enclosing membrane.

The MOMI Tent was test-erected in March 1992 and put into use for the first time early in May. Glowing at night under the sweep of Waterloo Bridge, it attracted much interest and received a universally good press, largely perhaps as a result of its refreshing difference from the diet of large commercial buildings upon which the critics had been feeding for the preceding few years. Writing in the *Guardian*, Deyan Sudjic described it as 'an ethereal visitation from another universe, braced by a structure as delicate and fine as a web of fishbones.' In the *Sunday Telegraph*, Kenneth Powell saw a practical future for it, not only as a successor to the conventional marquee 'used for wedding receptions and village fêtes', but as a prototype emergency shelter for the homeless. The

Architects' Journal subsequently published drawings of some of its unique structural details.

The last of the trio of 1992 completions is also the most orthodox piece of construction of the three. Caravans, whether of advanced or reactionary design, are mobile structures, while tents, however large and beautiful, are invariably taken down in the end. But Project 183, a small house in Berkhamsted, Hertfordshire, is quite different. Designed for Andy Sedgwick, an electrical engineer at Ove Arup & Partners who had worked on the two major Arup/Future Systems competition entries, the project called for a very cheap single-family house of advanced design. Initiated in December 1990, the project trod water until Sedgwick and his partner Jenny Thorburn were able to purchase a suburban site in April 1991. Then the house was rapidly designed and planning permission obtained without difficulty in October 1991, despite its unconventional appearance.

The siting and design of the Berkhamsted house owes a great deal to a much earlier Kaplicky design, the unexecuted Île de Cavallo house project of 1972, which employs the same economical crosswall construction, given distinction by deep, lightweight steel trusses and completely glazed end walls. Smaller than its predecessor, the Berkhamsted house is of a more aerodynamic shape, with its inclined glass end walls, more compact plan and structural roof decking permitting 100m² of covered area with only two compound steel trusses. Each truss is cable-stiffened with pin-ended portal frames prestressed into position. In siting the house, advantage has been taken of the south-sloping site coupled with trees and dense hedges to cut-and-fill the split-level house into the slope. This gives it a very low profile, which is barely visible from the access road.

Most of the house is open-plan with an island food preparation module set at one end of a large south-facing living room whose sliding doors lead to a terrace with a garden beyond. The cellular bedrooms and bathrooms at the rear of the house have views to the north with high-level partition glazing giving borrowed light from the larger space to the south. A separate front door gives access to the house through the east crosswall. Work started on site in Berkhamsted in March 1992 and the house was completed in September 1992.

That Future Systems should have achieved production success with three projects at the end of a list of nearly 190 is at once remarkable and a commentary on the caution and uncertainty of the environment in which all architects work. At least four other recent competition projects – the Paris library, the New Acropolis Museum, the Frankfurt Kindergarten and the Hamburg Umweltbehörde building – represent such a level of technical and aesthetic distinction that they deserve to have been competition winners. Only one even came close. In the repeated publicity given to the unsuccessful projects as well as the nearly successful one, there is surely something very close to the homage paid by vice to virtue – which was La Rochefoucauld's definition of hypocrisy.

If these projects are so impressive that their image commands the attention of a world that remains fearful to commission them in actuality, what does this say about their status in the creative realm? Surely no more and no less than that they are being 'stored up' for execution at some future time – a time when the triumph of ignorance, prejudice and vested interests that have led to our present state of abject fear of all forms of architecture except those that slavishly imitate the past, gives place to clearer thought and a more honest acceptance of the irreducible importance of advanced technology in the structure of modern life.

That such a revolutionary turn of events might not permanently belong to the realm of the impossible was indicated by the commencement of a fifth project in 1992. This time the scheme was a collaborative endeavour with the Richard Rogers Partnership, with Future Systems commissioned to design a technology park in Brno, Czechoslovakia, home of Mies van der Rohe's legendary Tugendhat House and some of the most advanced structures of the pre-war Czech Functionalist era.

In its sheer unexpectedness, the arrival of this project must have confirmed Kaplicky and Levete in their belief that – with the exception of the disappointment of the Hamburg Umweltbehörde competition – 1992 was indeed the year of miracles. As Kaplicky flew to Prague that summer to inspect the site – neither as a failed emigrant nor as an alien cut off from his homeland by repressive politics, but with Levete as architects called upon to exercise their unique skills – it must have crossed both their minds that the tree in the garden at Orechovka had not survived in vain.

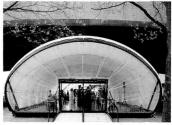

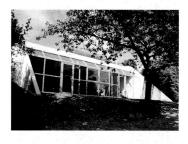

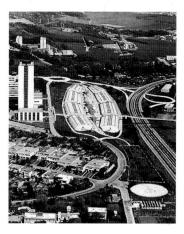

'MIES VAN DER ROHE'S GLASS SKYSCRAPER OF 1919 AND FUTURE SYSTEMS' "GREEN BUILDING" OF 1981: TWO PHOTOMONTAGES, TWO HISTORIC MOMENTS IN THE MAKING OF THE FUTURE'.

THE ACHITECTS' JOURNAL, 20 MARCH 1991

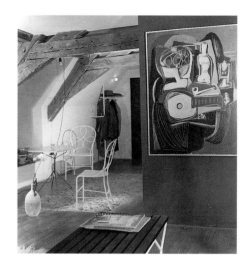

JAN KAPLICKY'S FIRST EXE-CUTED PROJECT. THIS SELF-BUILD CONVERSION OF THE DISUSED ROOF SPACE OF A LISTED 16TH-CENTURY BUILDING IN THE CENTRE OF PRAGUE INTO A SINGLE-PERSON APARTMENT, WAS DESIGNED AND BUILT WHILE KAPLICKY WAS STILL A STUDENT AT THE SCHOOL OF APPLIED ARTS AND ARCHITECTURE. A MEASURE OF THE ISOLATION OF PRAGUE AT THAT TIME IS THAT THE ITALIAN CANVAS-SLING CHAIRS SHOWN IN THE PHOTOGRAPHS WERE UNOBTAINABLE AND HAD TO BE MADE UP AS COPIES.

ATTIC FLAT

0 1 2 3

TRANSFORMATION

1958

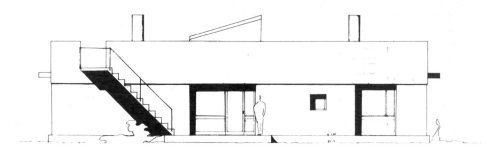

PROJECT 02

CONCRETE
HOUSE 1960

INTENDED AS A WEEKEND RETREAT, KAPLICKY'S SECOND STUDENT PROJECT IS BASED ON THE USE OF COMPONENTS FROM A STANDARD CZECHOSLOVAK CONCRETE-PANEL BUILDING SYSTEM INTENDED FOR HIGH-RISE APARTMENTS. KAPLICKY ADAPTED THE SYSTEM FOR SINGLE-STOREY USE BUT THE PROJECT NEVER PROGRESSED BEYOND THE DRAWING STAGE. THE DESIGN SHOWS THE STRONG INFLUENCE OF THE PRE-WAR CZECH MODERN TRADITION UPON KAPLICKY'S THINKING, AS WELL AS AN AWARENESS OF THE LATER WORK OF LE CORBUSIER AND THE NEW BRUTALISTS.

KAPLICKY'S FIRST COMPETITION WIN, THIS RECTANGULAR, INCISED CONCRETE TABLET WAS DESIGNED TO COMMEMORATE THE VICTIMS OF A PEASANT UPRISING IN BOHEMIA IN 1644. IT STILL SURVIVES.

UPRISING
MONUMENT
1965
PROJECT 07

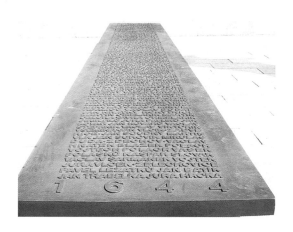

JK EXHIBITION

1964

PROJECT
05

AFTER HIS FATHER'S DEATH IN 1962, KAPLICKY WAS COMMISSIONED TO DESIGN A LARGE RETROSPECTIVE EXHIBITION OF HIS FATHER'S WORK THAT WAS HELD IN PRAGUE IN 1964. FOLLOWING THE MODEST BEGINNINGS OF THE JIRI JOHN EXHIBITION, HE DEVELOPED THE SAME THEME WITH AN EVEN GREATER USE OF FREESTANDING ELEMENTS AND DISPLAY TABLES, TO CONVERT THE EXHIBITION SPACE ITSELF INTO AN ABSTRACT COMPOSITION IN THREE DIMENSIONS.

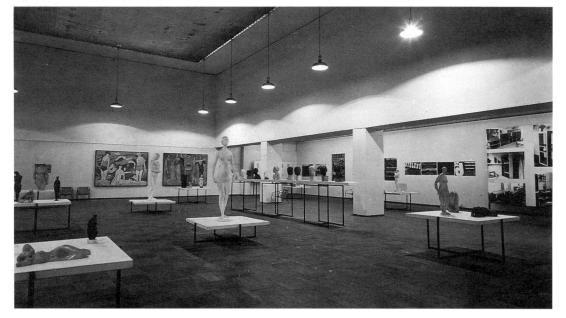

THE MOST IMPORTANT COMMISSION THE YOUNG KAPLICKY WAS TO UNDERTAKE BEFORE LEAVING CZECHOSLOVAKIA, THIS PROJECT INVOLVED THE MODERNISATION OF A HOUSE AND GARDEN IN ORECHOVKA BELONGING TO THE PARTIALLY DISABLED FILM-SCRIPTWRITER JAROSLAV DIETL, WHO HAD TRAVELLED WIDELY IN THE WEST. ONE OF DIETL'S REQUIREMENTS WAS THAT THE NEW MINI GOLF COURSE IN HIS GARDEN SHOULD BE ACCESSIBLE FROM THE FIRST-FLOOR, LIVING ROOM BALCONY OF HIS HOUSE. KAPLICKY SATISFIED THIS DEMAND WITH A SLENDER 10M WHITE-PAINTED, WELDED-STEEL RAMP, PIN-JOINTED FROM THE GARDEN TERRACE UP TO A SINGLE VERTICAL SUPPORT WITH A 2.4M CANTILEVER TERMINATING MILLIMETRES SHORT OF THE EDGE OF THE LIVING ROOM BALCONY.

1965

PROJECT 08

JD
HOUSE
AND
GARDEN

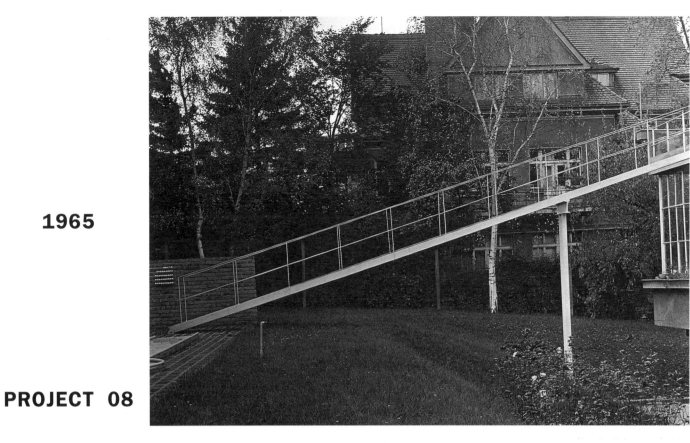

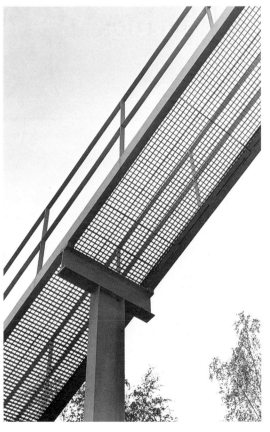

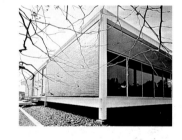

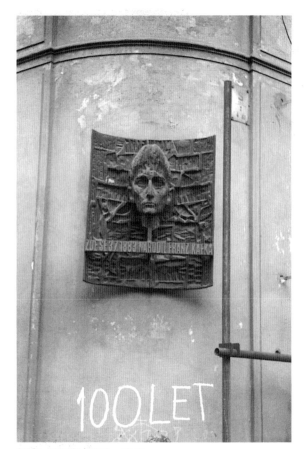

PROJECT 09

KAFKA MEMORIAL 1966

ANOTHER SMALL COMMISSION WAS THE DESIGN OF A PLAQUE TO HOUSE A SCULPTED HEAD OF FRANZ KAFKA ON THE SITE OF HIS BIRTHPLACE. THE PLAQUE, WHICH SURVIVES, COMPLEMENTS INGENIOUSLY THE CONVEX-CURVED CORNER OF THE BUILDING ON THE SITE WITH A REVERSED CONCAVE METAL BACKGROUND TO THE WRITER'S HEAD AND INSCRIPTION.

PROJECT 15

PF HOUSE 1967

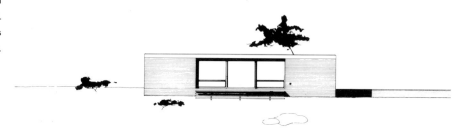

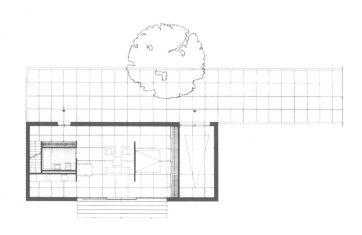

THIS STRONGLY MIESIAN PROJECT MARKS THE BEGINNING OF A LONG LINE OF SMALL ADVANCED-TECHNOLOGY DWELLINGS IN REMOTE, ALMOST ABSTRACT NATURAL SITES. POISED AT THE EDGE OF A CLIFF, THE WELDED STEEL FRAME STRUCTURE OF THE TINY HOUSE IS BOLDLY CANTILEVERED AND DIAGONALLY STEEL-BRACED. CLADDING IS IN PLATE GLASS IN THE MANNER OF MIES VAN DER ROHE'S FARNSWORTH HOUSE.

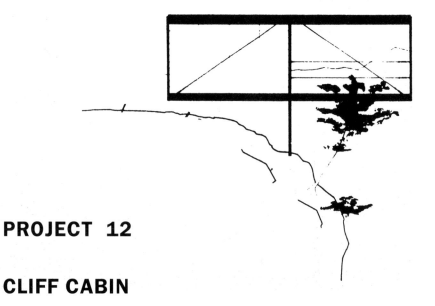

PROJECT 12

CLIFF CABIN 1967

A PROJECT FOR A MODERN SUBURBAN HOUSE IN PRAGUE THAT IS CHIEFLY NOTABLE FOR ITS SEVERELY MIESIAN PLAN. INTENDED TO BE BUILT IN BRICK, THE DESIGN CONSISTS OF A SINGLE LIVING SPACE WITH A SCREEN AND AN ENCLOSED BATHROOM CORE. THERE IS AN ATTACHED GARAGE THAT COMPLETES THE SYMMETRICAL ELEVATIONAL COMPOSITION.

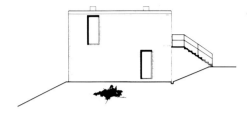

SELF-BUILD MODERN

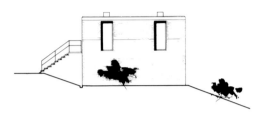

1967

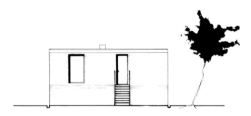

PROJECT 10

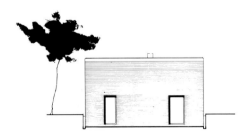

DESPITE ITS EARLY PROJECT NUMBER THIS HOUSE WAS NOT COMPLETED UNTIL AFTER KAPLICKY HAD LEFT PRAGUE. CONSTRUCTED OF PARTIALLY RENDERED BRICK WITH A STEEL-FRAMED FLAT ROOF FINISHED IN ZINC, THIS TWO-STOREY FAMILY HOUSE AND STUDIO ON A SLOPING SITE WAS SELF-BUILT BY THE CLIENT OVER A NUMBER OF YEARS. THE PLAN REVEALS STRONG MIESIAN ELEMENTS WITHIN INDIVIDUAL SECTIONS BUT THE WHOLE IS MORE PRAGMATICALLY PLANNED THAN ANY EARLIER DESIGN. THE ORIGINAL OWNER-BUILDER WAS STILL IN OCCUPATION AT THE TIME OF WRITING.

FD
HOUSE
AND
STUDIO

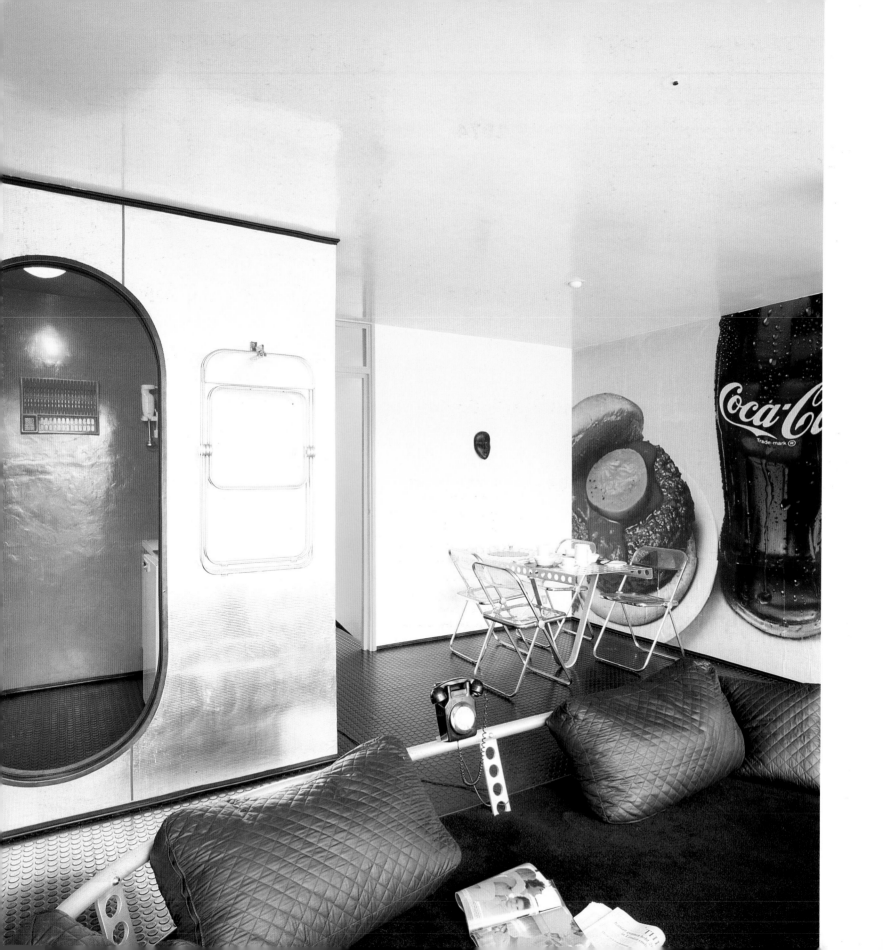

1974

61 ARCHERY STEPS

PROJECT 017

CONVERSION

PLANNED AS A LOW-COST INTE-RIOR CONVERSION OF A SMALL APARTMENT IN A NEW COMPLEX NEAR HYDE PARK IN LONDON, THIS DESIGN CENTRES ON A TUBULAR ALUMINIUM-FRAMED RELAXATION PIT IN THE ORIGINAL LIVING AREA ADJOINING A BALCONY. TO ONE SIDE IS A DINING AREA WITH A CANTILEVERED, PERFORATED-ALUMINIUM TABLE AND RECESSED BEYOND IS A KITCHEN ENTERED THROUGH A BULKHEAD-STYLE DOOR OPENING. WITHIN THE APARTMENT, WALL FINISHES ARE SILVER IN COLOUR AND THE FLOOR IS FINISHED IN BLACK RUBBER. ANCILLARY ROOMS ARE DESIGNATED BY LETTERS AND NUMBERS, AS ON ARCHITECTURAL DRAWINGS. DECORATION TAKES THE FORM OF A HUGE COMMER-CIAL POSTER OF THE KIND THAT MOST IMPRESSED KAPLICKY WHEN HE FIRST ARRIVED IN THE WEST FROM CZECHOSLOVAKIA.

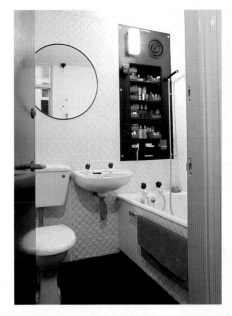

PROJECT 009

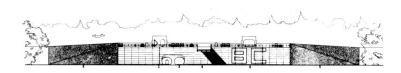

7. BURRELL COLLECTION.SOUTH ELEVATION.SCALE 1:800. 1 PUBLIC LIFT. 2 SERVICE LIFT. 3 PLASTIC ENTRANCE TUBE. 4 RAMP. 5 ARTIFICIAL BANK.

7. BURRELL COLLECTION.WEST ELEVATION.SCALE 1:800. 6 EMERGERGENCY EXIT. 7 PUBLIC LIFT.

AN UNSUCCESSFUL JOINT COMPE-
TITION ENTRY WITH EVA JIRICNA,
THIS PROJECT INCORPORATES
MANY ELEMENTS DESTINED TO
EMERGE IN MUCH LATER FUTURE
SYSTEMS DESIGNS. TOP-LIT, THE
GALLERY IS CONCEIVED AS A
PARTIALLY BURIED STRUCTURE
BARELY DISTURBING THE
PROFILE OF THE LANDSCAPE. A
LONG, THIN RAMP PROVIDES
VEHICLE ACCESS TO THE ROOF-
LEVEL CAR PARK. THE GLASS
CLADDING OF THE ONE EXPOSED
WALL IS RELIEVED BY THE
ENORMOUS LETTERS 'BC', STAND-
ING FOR BURRELL COLLECTION.
PEDESTRIAN ACCESS TO THE
GALLERY ITSELF IS THROUGH
A TRANSPARENT, AIR-
LOCKED INFLATABLE TUBE.

BURRELL COLLECTION GALLERY

1971

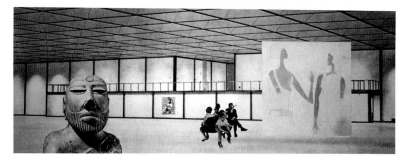

PROJECT 020
ILE DE
CAVALLO

THIS SMALL SUMMER-HOUSE
PROJECT FEATURES SIMPLE
CROSSWALL CONSTRUCTION
BETWEEN THICK STONE WALLS.
THE PROJECT WAS DISCONTINUED
AFTER DESIGN DRAWINGS WERE
COMPLETED. INTERESTINGLY,
APART FROM THE ABSENCE OF
EARTH BERMS TO THE SIDE
WALLS, THE ARRANGEMENT OF
INSET, GLAZED END WALLS
AND LIGHTWEIGHT, STEEL
ROOF TRUSSES PREFIGURES
THE DESIGN OF THE SEDG-
WICK HOUSE (PROJECT 183)
BUILT 20 YEARS LATER.

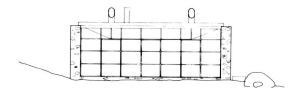

1972

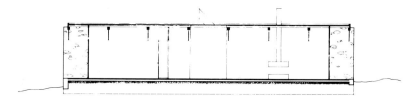

THIS PROJECT MARKS A MAJOR SHIFT IN KAPLICKY'S DESIGN THINKING. SIMILAR IN CONCEPTION TO PROJECT 12, THE CLIFF CABIN OF 10 YEARS BEFORE, CABIN 380 SHOWS KAPLICKY JETTISONING FOR THE FIRST TIME THE CONCEPT OF MIESIAN COLD-ROLLED STEEL SECTIONS IN FAVOUR OF A LIGHT-WEIGHT, AIRCRAFT-STYLE, ALUMINIUM ALLOY BUILDING ENVELOPE.

PROJECT 001

CABIN 380

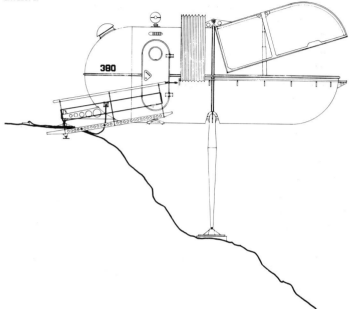

ONLY 5M IN LENGTH, THE PROPOSED SINGLE-PERSON RURAL RETREAT FEATURES AN OPENABLE COCKPIT COVER WITH EXTERNAL MOTORISED BLINDS INSTEAD OF INTERNAL CURTAINS. APART FROM ITS GROUND SUPPORT SYSTEM AND ACCESS BRIDGE ITS ONLY CONTACT WITH EARTH IS THROUGH ITS FLEXIBLE SERVICE CONNECTIONS.

1975

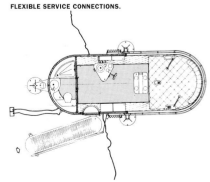

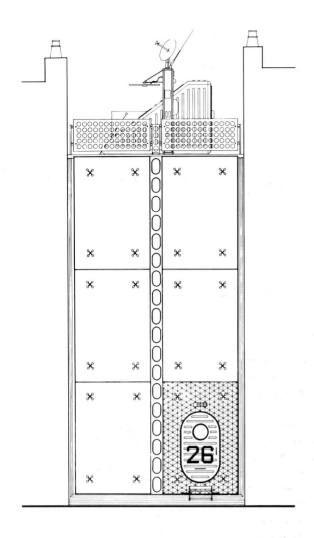

THIS PROJECT IS A VERY EARLY EXAMPLE OF KAPLICKY'S CAPACITY TO ENTER THE CONTEXTUALIST ARENA WITHOUT SURRENDERING CREATIVE INITIATIVE OR COMPROMISING WITH MATERIALS. INSERTED INTO A STANDARD 5M GAP IN A 19TH-CENTURY LONDON STREET OF TERRACED HOUSES, ARE SIX, SILICON-JOINTED GLASS PANELS, ONE OF WHICH IS OPAQUE AND PERFORATED FOR A FRONT DOOR. THE JOINTS BETWEEN THIS GLASS-CLAD ELEVATION AND ITS BRICK NEIGHBOURS ARE RUBBER GASKETS. A PERFORATED, CENTRAL METAL STRIP PROVIDES VENTILATION. THE HOUSE IS OPEN-PLAN ON THREE FLOORS.

PROJECT 002

HOUSE 26

1975

COCKPIT

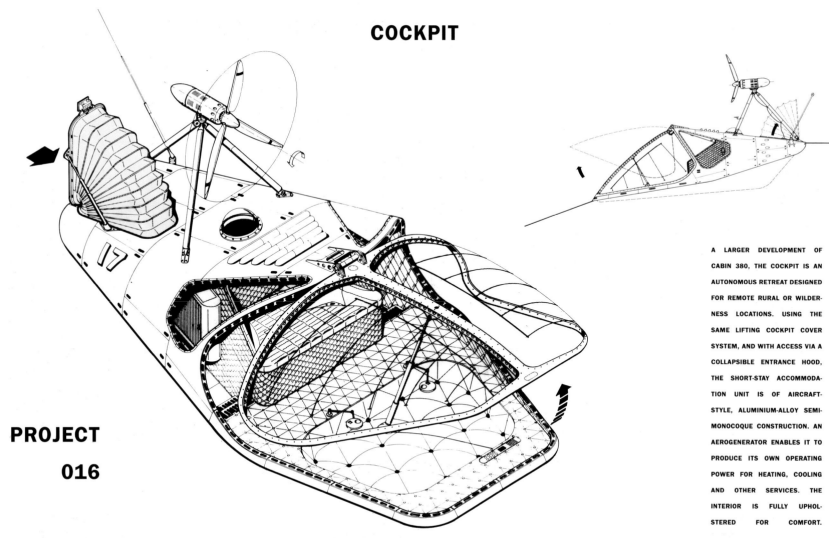

PROJECT 016

A LARGER DEVELOPMENT OF CABIN 380, THE COCKPIT IS AN AUTONOMOUS RETREAT DESIGNED FOR REMOTE RURAL OR WILDERNESS LOCATIONS. USING THE SAME LIFTING COCKPIT COVER SYSTEM, AND WITH ACCESS VIA A COLLAPSIBLE ENTRANCE HOOD, THE SHORT-STAY ACCOMMODATION UNIT IS OF AIRCRAFT-STYLE, ALUMINIUM-ALLOY SEMI-MONOCOQUE CONSTRUCTION. AN AEROGENERATOR ENABLES IT TO PRODUCE ITS OWN OPERATING POWER FOR HEATING, COOLING AND OTHER SERVICES. THE INTERIOR IS FULLY UPHOLSTERED FOR COMFORT.

1979

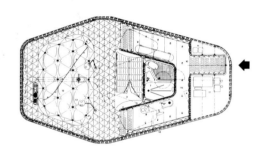

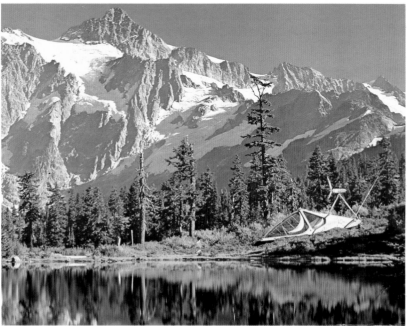

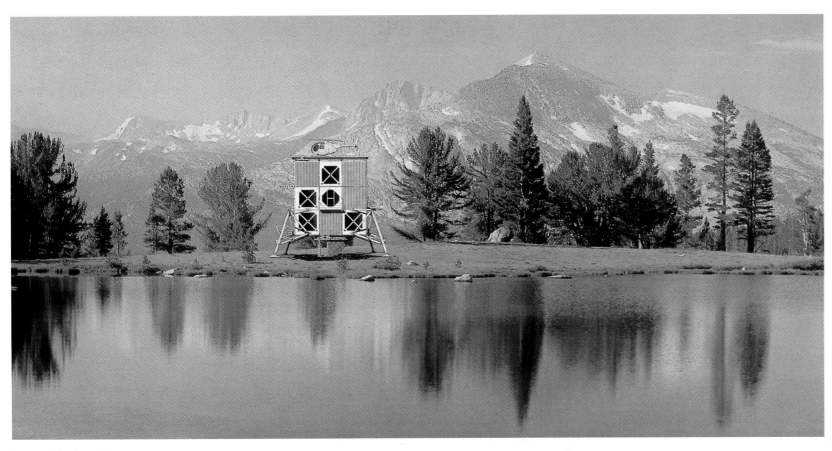

HOUSE FOR A HELICOPTER PILOT

PROVIDING THREE-STOREY FAMILY ACCOMMODATION WITH A DOUBLE CARPORT AND HELICOPTER PAD INCORPORATED INTO THE DESIGN, PROJECT 015 IS ONE OF THE LARGEST OF THE SERIES OF WILDERNESS RETREATS THAT KAPLICKY HAS DESIGNED OVER A PERIOD OF YEARS. DESIGNED TO BE AIR-TRANSPORTABLE, THE HOUSE IS ASSEMBLED FROM LIGHTWEIGHT ALLOY SANDWICH PANELS SO THAT THE ENTIRE STRUCTURE OPERATES AS A GEODESIC BOX RESTING UPON ADJUSTABLE HYDRAULIC LEGS. RELOCATED TO A SUBURBAN SETTING, THIS PROJECT WAS PUBLISHED IN THE LONDON *SUNDAY TIMES* IN 1985 AS A 'NON-TRADITIONAL' HOME FOR THE THEN PRIME MINISTER, MARGARET THATCHER.

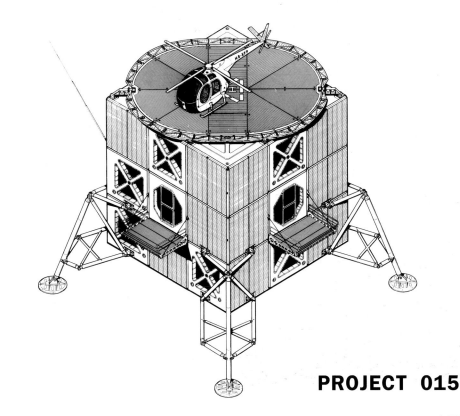

1979

PROJECT 015

WEEKEND
RETREAT
FOR
MISS B

CLEARLY SHOWING ITS DERIVATION FROM THE SEMINAL CABIN 380, THIS WEEKEND RETREAT EMBODIES ADDED REFINEMENTS. WITH ITS ADJUSTABLE TRIPOD ENABLING IT TO ADAPT TO VARIABLE TERRAIN, THE MAIN LIVING POD, TOO, CAN CHANGE ITS ORIENTATION AND EXTEND OR RETRACT.

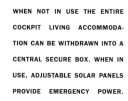

WEEK-END

1980

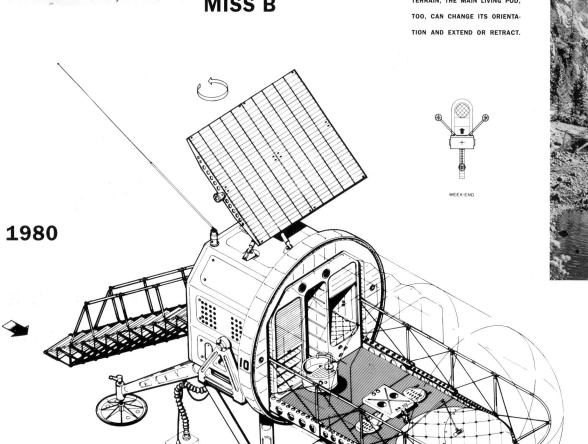

WHEN NOT IN USE THE ENTIRE COCKPIT LIVING ACCOMMODATION CAN BE WITHDRAWN INTO A CENTRAL SECURE BOX. WHEN IN USE, ADJUSTABLE SOLAR PANELS PROVIDE EMERGENCY POWER.

WEEK-DAY

PROJECT 005

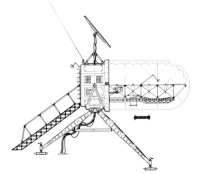

VEHICLE

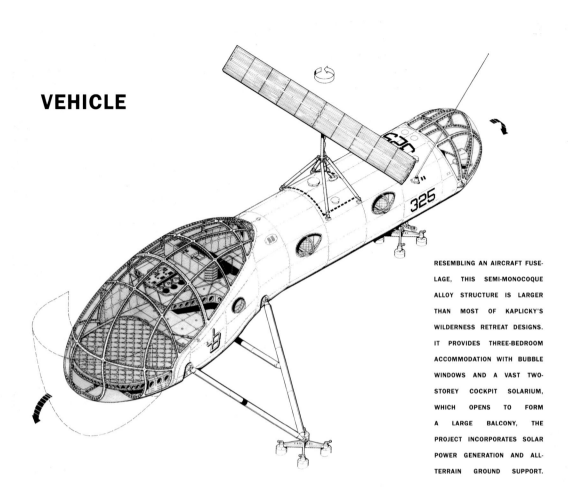

RESEMBLING AN AIRCRAFT FUSE-LAGE, THIS SEMI-MONOCOQUE ALLOY STRUCTURE IS LARGER THAN MOST OF KAPLICKY'S WILDERNESS RETREAT DESIGNS. IT PROVIDES THREE-BEDROOM ACCOMMODATION WITH BUBBLE WINDOWS AND A VAST TWO-STOREY COCKPIT SOLARIUM, WHICH OPENS TO FORM A LARGE BALCONY. THE PROJECT INCORPORATES SOLAR POWER GENERATION AND ALL-TERRAIN GROUND SUPPORT.

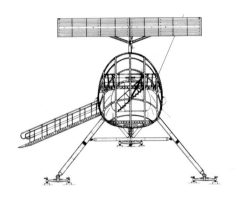

SEMI-MONOCOQUE

STRUCTURE

PROJECT 018

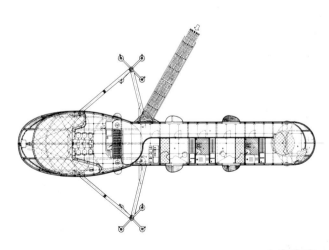

1980

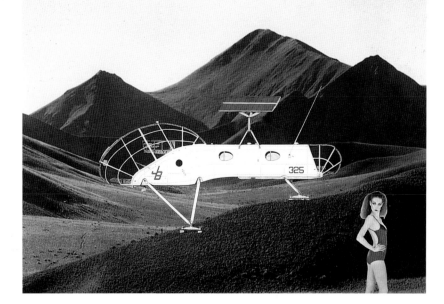

LIGHTHOUSE

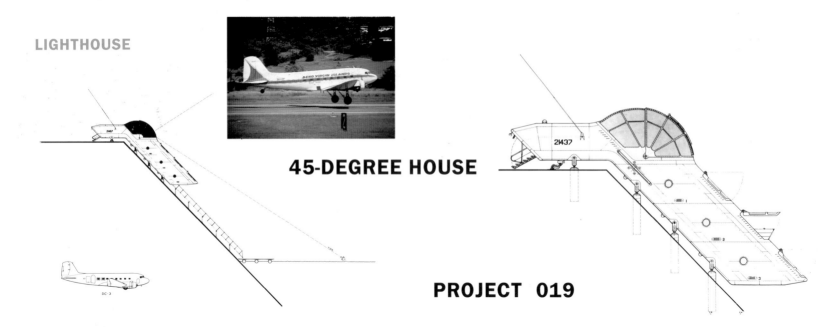

45-DEGREE HOUSE

PROJECT 019

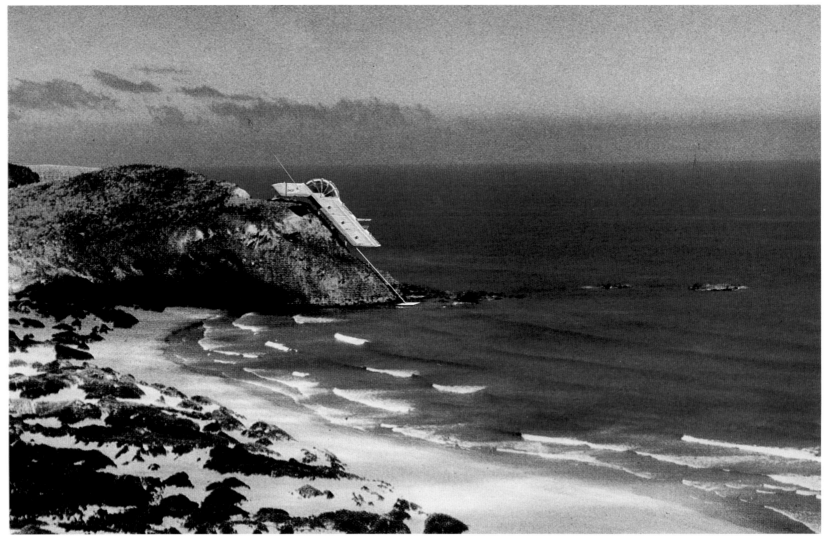

1981

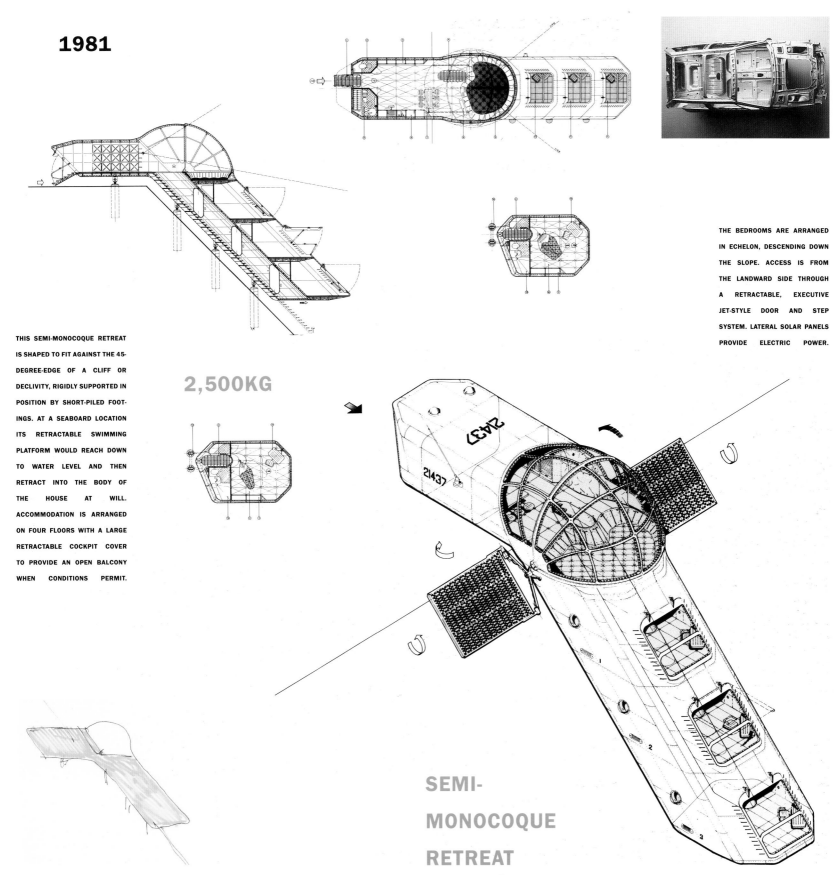

THE BEDROOMS ARE ARRANGED IN ECHELON, DESCENDING DOWN THE SLOPE. ACCESS IS FROM THE LANDWARD SIDE THROUGH A RETRACTABLE, EXECUTIVE JET-STYLE DOOR AND STEP SYSTEM. LATERAL SOLAR PANELS PROVIDE ELECTRIC POWER.

THIS SEMI-MONOCOQUE RETREAT IS SHAPED TO FIT AGAINST THE 45-DEGREE-EDGE OF A CLIFF OR DECLIVITY, RIGIDLY SUPPORTED IN POSITION BY SHORT-PILED FOOTINGS. AT A SEABOARD LOCATION ITS RETRACTABLE SWIMMING PLATFORM WOULD REACH DOWN TO WATER LEVEL AND THEN RETRACT INTO THE BODY OF THE HOUSE AT WILL. ACCOMMODATION IS ARRANGED ON FOUR FLOORS WITH A LARGE RETRACTABLE COCKPIT COVER TO PROVIDE AN OPEN BALCONY WHEN CONDITIONS PERMIT.

2,500KG

SEMI-MONOCOQUE RETREAT

KEW GARDENS CENTRE

PROJECT

113

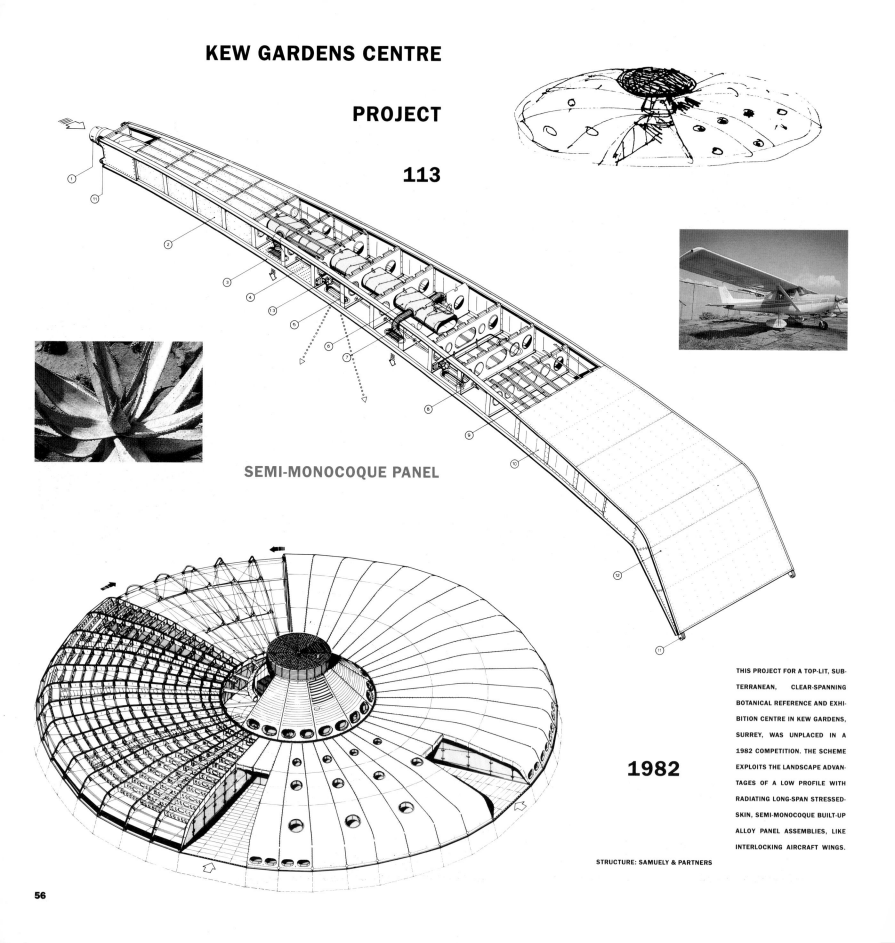

SEMI-MONOCOQUE PANEL

1982

THIS PROJECT FOR A TOP-LIT, SUB-TERRANEAN, CLEAR-SPANNING BOTANICAL REFERENCE AND EXHIBITION CENTRE IN KEW GARDENS, SURREY, WAS UNPLACED IN A 1982 COMPETITION. THE SCHEME EXPLOITS THE LANDSCAPE ADVANTAGES OF A LOW PROFILE WITH RADIATING LONG-SPAN STRESSED-SKIN, SEMI-MONOCOQUE BUILT-UP ALLOY PANEL ASSEMBLIES, LIKE INTERLOCKING AIRCRAFT WINGS.

STRUCTURE: SAMUELY & PARTNERS

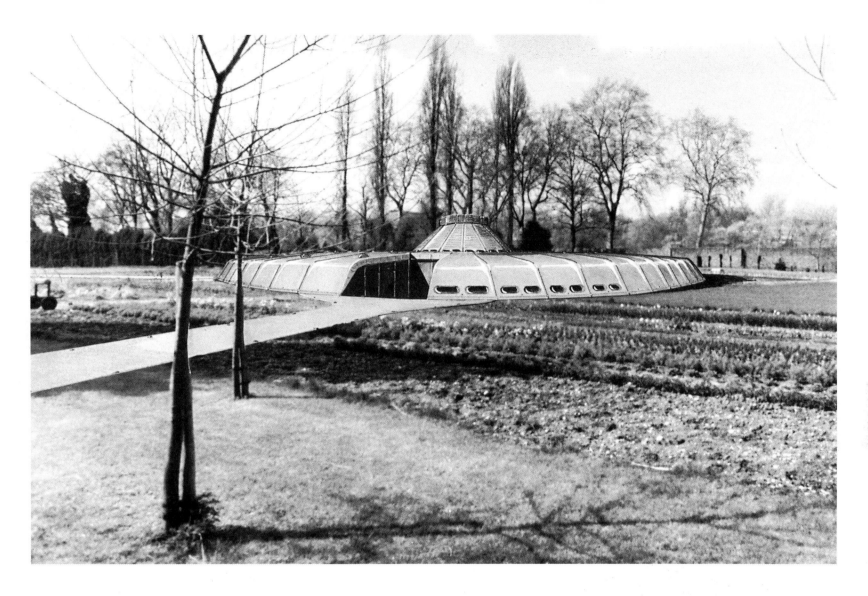

SPAN 16.8M

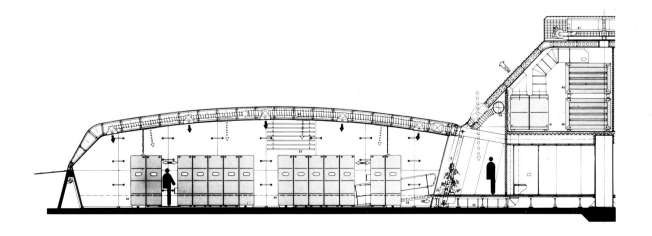

ACCESS TO THE CENTRE IS BY RAMPS LEADING DOWN BENEATH TWO SHORT PANELS. THE CENTRAL TOWER HOUSES THE AIR-CONDITIONING PLANT, WITH AIR DISTRIBUTION THROUGH A SYSTEM OF DUCTS INCORPORATED INTO THE ROOF PANELS.

ALUMINIUM

STRUCTURE: SAMUELY & PARTNERS

PROJECT 118

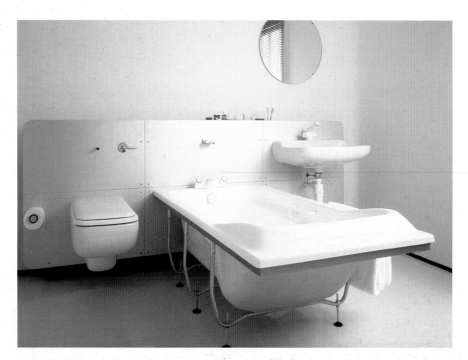

THIS MODERNISATION OF THE
THIRD FLOOR OF A NORTH LONDON
HOUSE INVOLVED THE CREATION
OF A SERVICE AND ACCESS AREA
GIVING ONTO FOUR MAIN
SPACES, LINKED BY NEW WALL
OPENINGS OF A UNIQUE FORM
DESIGNED TO FACILITATE THE
CARRIAGE OF TRAYS OR OTHER
WIDE OBJECTS. EACH SPACE
HAS AN OFFICE-STYLE RAISED
FLOOR CONCEALING ALL HEATING,
PLUMBING, ELECTRICAL AND
COMMUNICATIONS SERVICES.
TENSILE FABRIC, SUSPENDED
CEILINGS WERE ENVISAGED TO
COMPLETE THE TRANSFORMATION
OF THE ORIGINAL ROOMS.

DS FLAT

1983

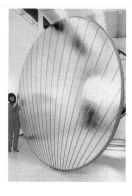

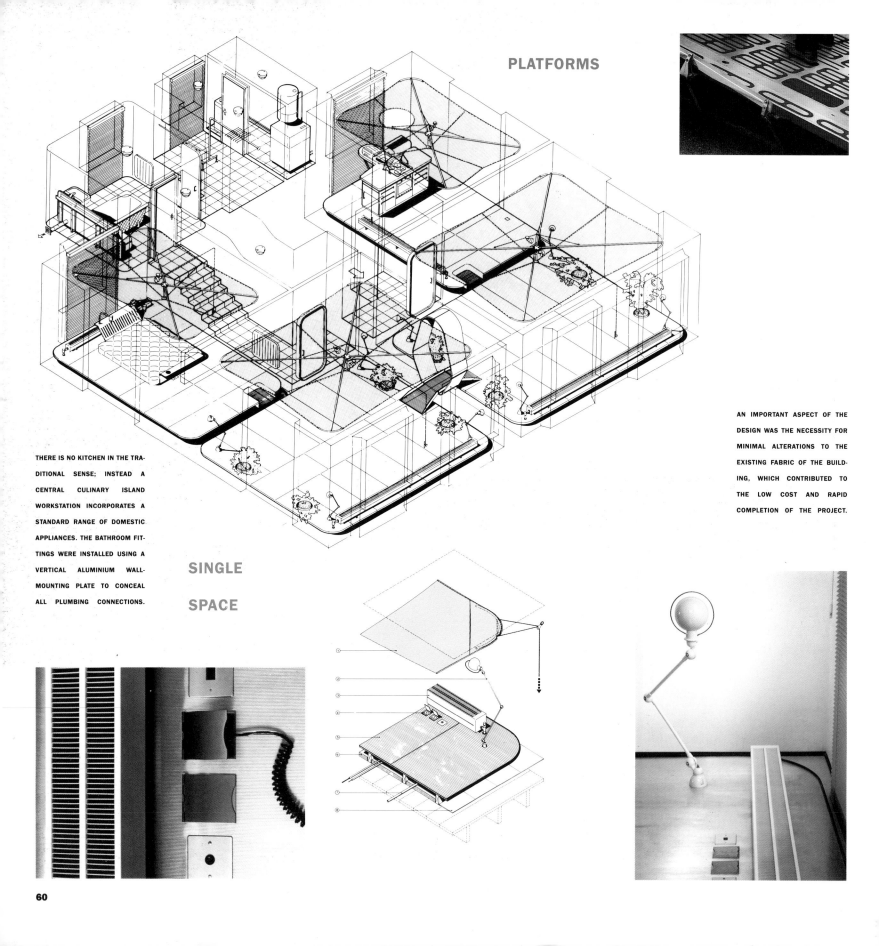

PLATFORMS

THERE IS NO KITCHEN IN THE TRA-
DITIONAL SENSE; INSTEAD A
CENTRAL CULINARY ISLAND
WORKSTATION INCORPORATES A
STANDARD RANGE OF DOMESTIC
APPLIANCES. THE BATHROOM FIT-
TINGS WERE INSTALLED USING A
VERTICAL ALUMINIUM WALL-
MOUNTING PLATE TO CONCEAL
ALL PLUMBING CONNECTIONS.

SINGLE

SPACE

AN IMPORTANT ASPECT OF THE
DESIGN WAS THE NECESSITY FOR
MINIMAL ALTERATIONS TO THE
EXISTING FABRIC OF THE BUILD-
ING, WHICH CONTRIBUTED TO
THE LOW COST AND RAPID
COMPLETION OF THE PROJECT.

BEFORE

AFTER

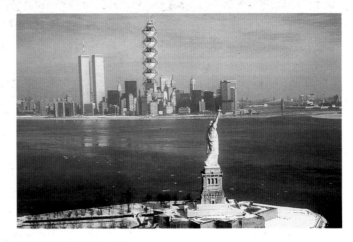

COEXISTENCE IS A MASSIVE, VERTICAL STRUCTURE CONSISTING OF SEVEN SUPERIMPOSED, CLIMATE-CONTROLLED ISLANDS SET BETWEEN A CENTRAL STRUCTURAL AND SERVICE CORE, AND AN OUTER GEODESIC FRAMEWORK OF STRUCTURAL MEMBERS. EACH ISLAND COMBINES LIVING AND WORKING ACCOMMODATION WITH A LARGE SOUTH-FACING 'SKYPARK' ENCLOSABLE BY LARGE TRANSPARENT SHIELDS. IN OPERATION, THE DAYTIME POPULATION OF A COEXISTENCE 'MOTHER STRUCTURE' COULD REACH 10,000 PEOPLE.

650M HIGH

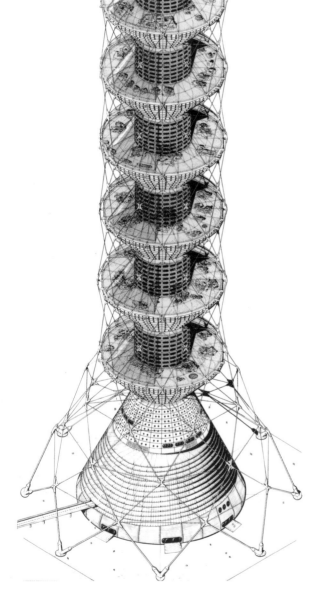

THIS GIANT PROJECT FOR A 150-STOREY SKYSCRAPER INCORPORATING 672 APARTMENTS AND 285,000M2 OF OFFICE FLOORSPACE WAS DEVELOPED WITH THE AID OF A GRAHAM FOUNDATION GRANT. ITS AIM IS TO DEMONSTRATE THE INADEQUACY OF MUCH CONTEMPORARY URBAN THINKING BY SHOWING THE SCALE OF ARCHITECTURAL RESPONSE THAT IS REALLY NECESSARY TO ACCOMMODATE CURRENT UNITED NATIONS' PROJECTIONS FOR THE EXPLOSIVE GROWTH OF URBAN POPULATIONS IN THE 21ST CENTURY.

PROJECT 112

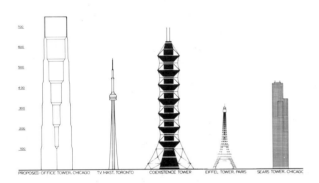

PROPOSED OFFICE TOWER, CHICAGO T.V. MAST, TORONTO COEXISTENCE TOWER EIFFEL TOWER, PARIS SEARS TOWER, CHICAGO

TALL STRUCTURE

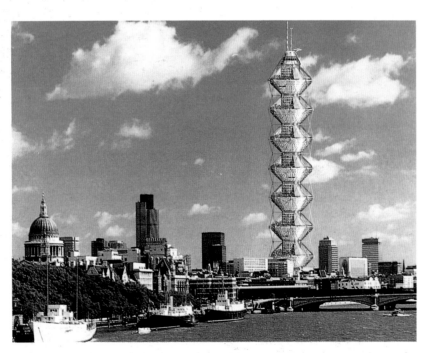

1984

LONDON

ERECTION SEQUENCE

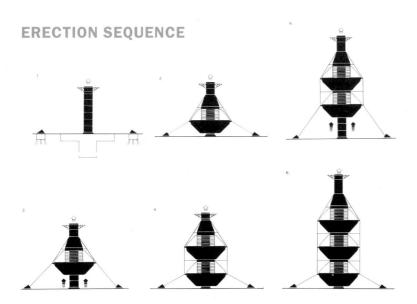

PLAN

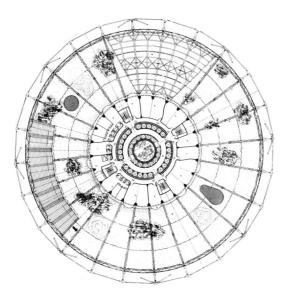

COEXISTENCE

STRUCTURE: OVE ARUP & PARTNERS

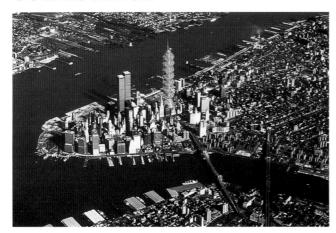

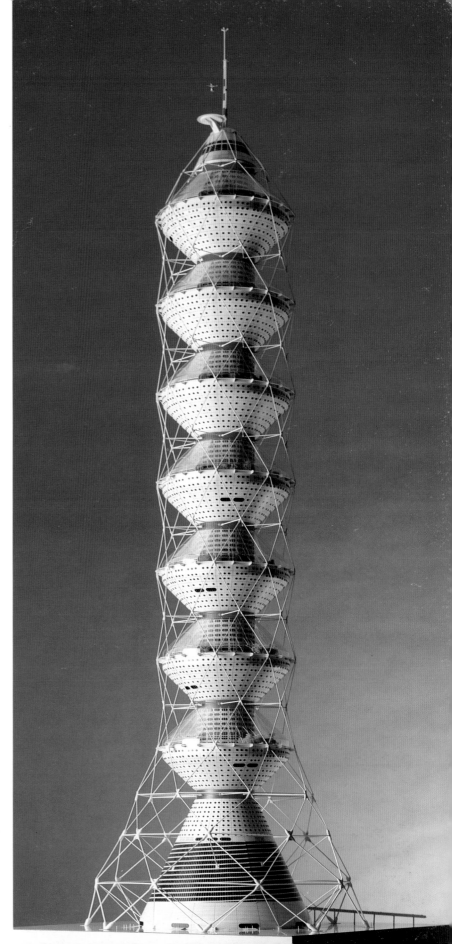

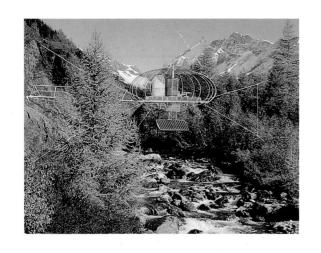

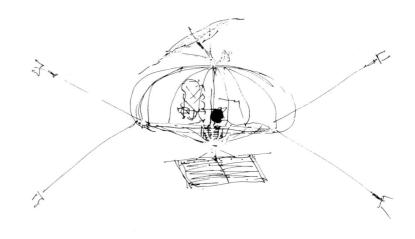

PROJECT 117 BUBBLE 1983

ANOTHER IN THE SERIES OF WILDERNESS RETREAT PROJECTS. THE TRANSPARENT, INFLATABLE BUBBLE IS INTENDED AS SHORT-STAY, TWO-PERSON ACCOMMODATION SUSPENDED BY FOUR TENSION CABLES SO THAT IT APPEARS TO FLOAT ABOVE THE GROUND. OF A COMPRESSED SPHERICAL FORM, THE UPPER PART OF THE ENVELOPE IS ALUMINISED TO REDUCE SOLAR GAIN. THE RIGID FLOOR UNIT IS AN ALUMINIUM SPACE FRAME SURFACED WITH A TRANSLUCENT FLOOR.

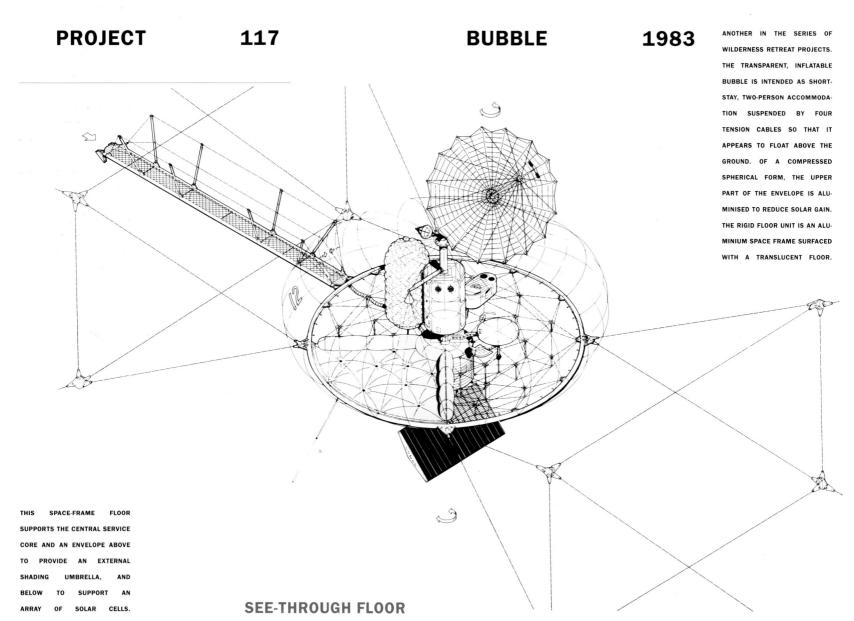

THIS SPACE-FRAME FLOOR SUPPORTS THE CENTRAL SERVICE CORE AND AN ENVELOPE ABOVE TO PROVIDE AN EXTERNAL SHADING UMBRELLA, AND BELOW TO SUPPORT AN ARRAY OF SOLAR CELLS.

SEE-THROUGH FLOOR

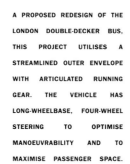

A PROPOSED REDESIGN OF THE LONDON DOUBLE-DECKER BUS, THIS PROJECT UTILISES A STREAMLINED OUTER ENVELOPE WITH ARTICULATED RUNNING GEAR. THE VEHICLE HAS LONG-WHEELBASE, FOUR-WHEEL STEERING TO OPTIMISE MANOEUVRABILITY AND TO MAXIMISE PASSENGER SPACE.

LONDON BUS

1983

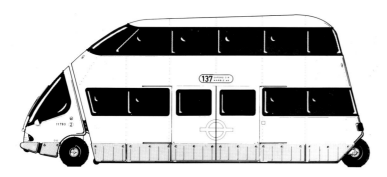

PROJECT
119

WIDE DOUBLE DOORS PROVIDE EASY ACCESS, AND THE OVERALL HEIGHT OF THE BUS IS REDUCED BY PROVIDING SEATING ONLY ON THE UPPER DECK. WITH THE EXCEPTION OF A SMALL NUMBER OF SEATS FOR AGED OR DISABLED PEOPLE, THE LOWER DECK IS STANDING ONLY. THE DRIVER'S CAB IS PART OF A FRONT-WHEEL DRIVE, CONTROL AND POWER MODULE, WHICH DETACHES FOR EASE OF SERVICING AND MAINTENANCE.

PROJECT 116

CUDDLE

ELEGANT **NEW**

FOLDABLE **SOFT**

MOVABLE **ADJUSTABLE**

A FURNITURE DESIGN COMPETITION ENTRY, THIS PROJECT IS FOR A TRIANGULAR UPHOLSTERED ALUMINIUM-FRAMED RECLINER WITH BUILT IN DRINKS SHELVES, RADIO, TV AND ADJUSTABLE LIGHTING. ROLLING EASILY ON LARGE SECTION PNEUMATIC TYRES, CUDDLE CONCERTINAS TO PASS THROUGH DOORWAYS AND CAN BE ADJUSTED TO NUMEROUS CONFIGURATIONS.

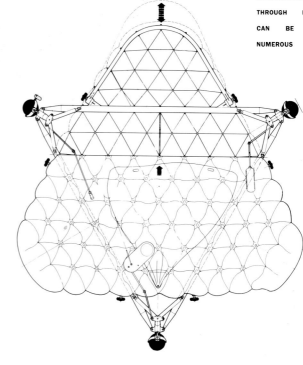

1983

UNE PETITE MAISON

1982

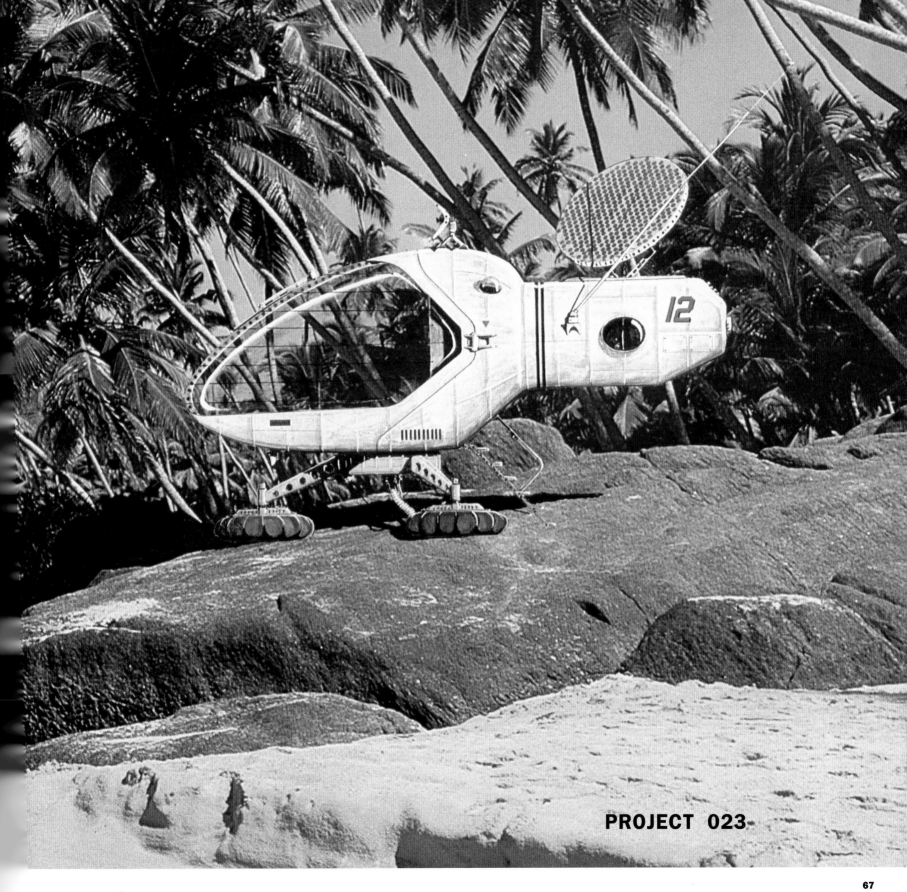

PROJECT 023

PROJECT 133

THIS REFURBISHMENT OF THE 3,500M² FOURTH FLOOR OF HARRODS DEPARTMENT STORE IN LONDON WAS CARRIED OUT JOINTLY WITH JIRICNA-KERR ASSOCIATES. REPLANNING THE ENTIRE FLOOR AS A SEPARATE UNIT FOR YOUNGER CUSTOMERS, THE ARCHITECTS STARTED WITH A MATT BLACK BACKGROUND AND INTRODUCED NEW, PERIMETER WALL PANELS IN VACUUM-FORMED ALUMINIUM TOGETHER WITH FREESTANDING DISPLAY FRAMES AND A DIRECTIONAL TUBULAR SUSPENDED CEILING.

WITH

JIRICNA-KERR ASSOCIATES

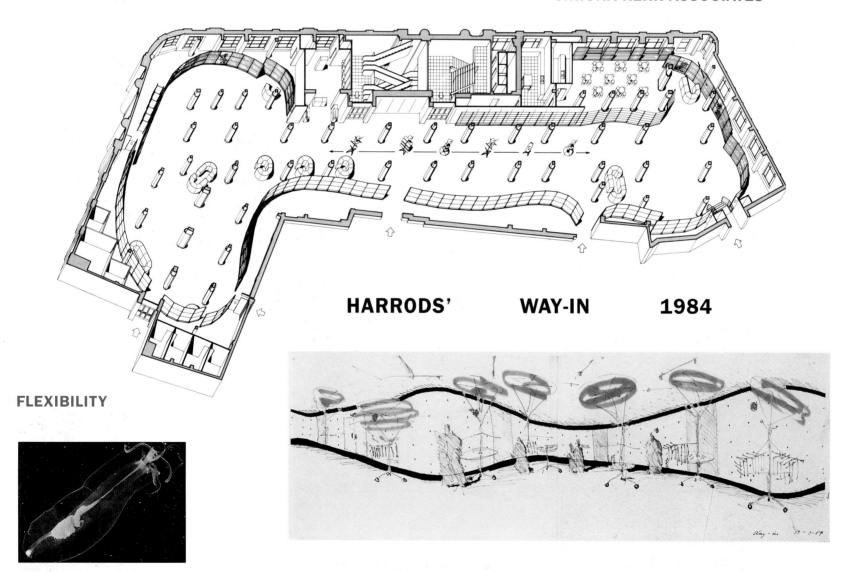

HARRODS' WAY-IN 1984

FLEXIBILITY

ALUMINIUM

DISPLAY

ELEMENTS

THE DESIGN TASK ALSO INCLUDED THE DEVELOPMENT OF OVER 150 MOBILE ALUMINIUM DISPLAY UNITS OF MODULAR DESIGN, INCORPORATING INTERCHANGEABLE SHELVES, HANGING RAILS AND MIRRORS, AND A LOW-VOLTAGE LIGHTING SYSTEM. IN RESPONSE TO THE NEED FOR A NEW RETAIL IDENTITY, THE ARCHITECTS ALSO UNDERTOOK A COMPLETE REDESIGN OF THE WAY-IN HOUSE STYLE, RANGING FROM THE SHOP LOGO TO SHOPPING BAGS, RESTAURANT MENUS, COSMETICS PACKAGING, CLOTHES HANGERS AND PHOTOGRAPHIC WALL DECORATIONS USED IN THE STORE.

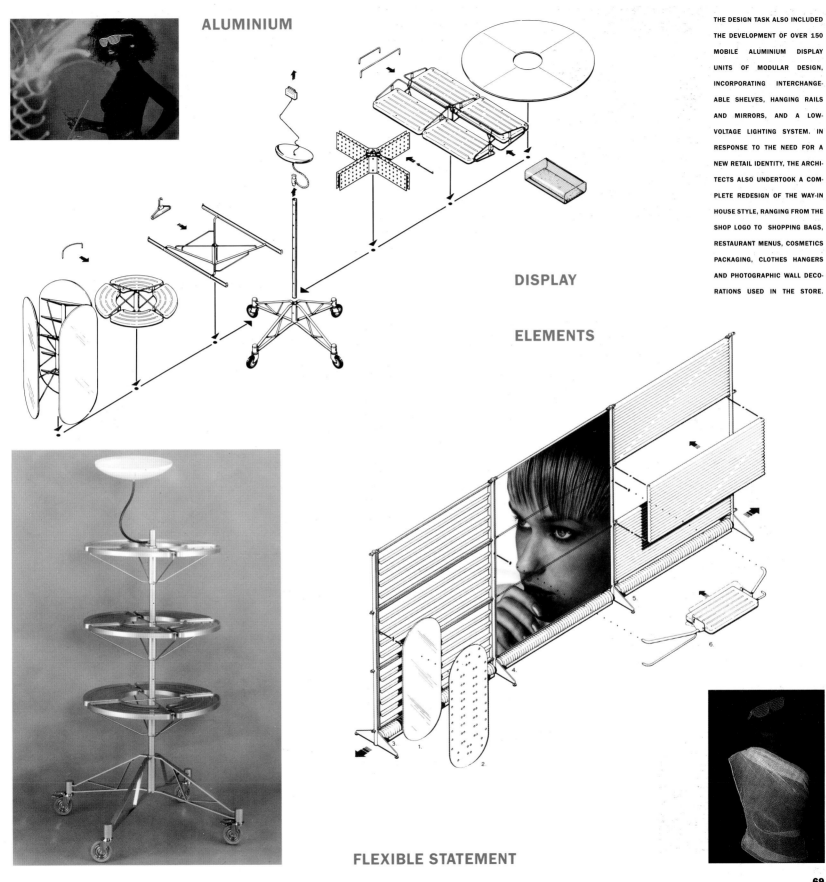

FLEXIBLE STATEMENT

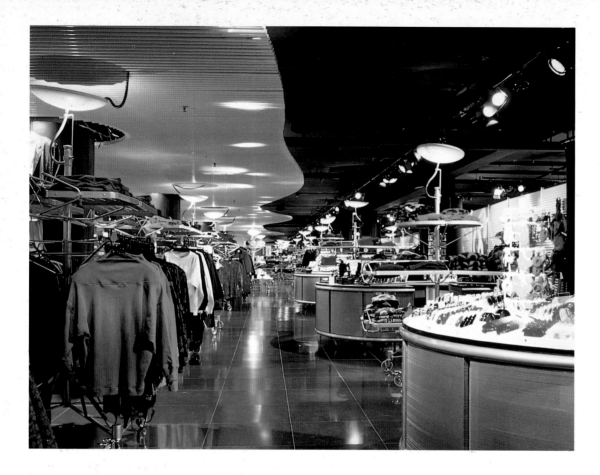

GRAPHICS SYSTEM

RESTAURANT

SHOPPING BAG

STRUCTURE: OVE ARUP & PARTNERS

SERVICES: USHER & PARTNERS

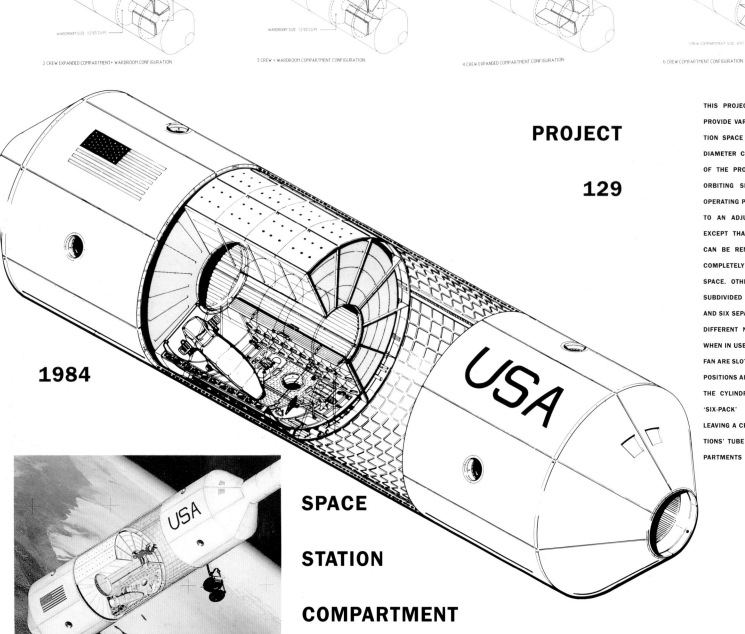

CREW COMPARTMENT SIZE 6.47 CU.M

WARDROOM SIZE 12.93 CU.M

2 CREW EXPANDED COMPARTMENT + WARDROOM CONFIGURATION

CREW COMPARTMENT SIZE 4.31 CU.M

WARDROOM SIZE 12.93 CU.M

3 CREW + WARDROOM COMPARTMENT CONFIGURATION

CREW COMPARTMENT SIZE 6.47 CU.M

4 CREW EXPANDED COMPARTMENT CONFIGURATION

CREW COMPARTMENT SIZE 4.31 CU.M

6 CREW COMPARTMENT CONFIGURATION

PROJECT

129

1984

SPACE

STATION

COMPARTMENT

THIS PROJECT IS DESIGNED TO PROVIDE VARIABLE ACCOMMODATION SPACE WITHIN THE 4.20M-DIAMETER CREW COMPARTMENT OF THE PROJECTED 1996 NASA ORBITING SPACE STATION. THE OPERATING PRINCIPLE IS SIMILAR TO AN ADJUSTABLE AXIAL FAN EXCEPT THAT ALL ITS 'BLADES' CAN BE REMOVED TO LEAVE A COMPLETELY CYLINDRICAL SPACE. OTHERWISE, IT CAN BE SUBDIVIDED INTO BETWEEN TWO AND SIX SEPARATE CUBICLES FOR DIFFERENT NUMBERS OF CREW. WHEN IN USE THE BLADES OF THE FAN ARE SLOTTED INTO DIFFERENT POSITIONS AROUND THE WALLS OF THE CYLINDRICAL MODULE IN A 'SIX-PACK' CONFIGURATION LEAVING A CENTRAL COMMUNICATIONS' TUBE BETWEEN THE COMPARTMENTS FORE AND AFT.

FIGURES BASED ON 6 COMPARTMENTS @ 4.25 CU.M. EACH

3000 CLEAR BETWEEN BULKHEADS

1300 AISLE CLEAR. Ø

3750 MODULE CLEAR INT. Ø

1225 USABLE VOLUME DEPTH

NASA RFP CREW QUARTERS PROGRAM VOLUME REQUIREMENT

12 FIXED LINER PANELS CONFORM TO BULKHEAD PANEL INCREMENTS

PERIMETER CLOSURE PANEL LAYOUT

6 MOVABLE PARTITIONS ALIGN WITH ANY BULKHEAD PANEL INCREMENT

RADIAL COMPARTMENT PARTITION LAYOUT

12 x 30° PANEL INCREMENTS OF ARC

BULKHEAD COMPARTMENT PARTITION LAYOUT

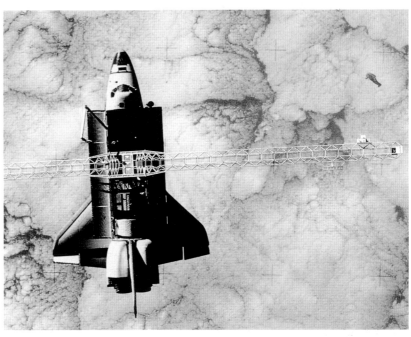

PROJECT

131

THIS DESIGN FOR A WEIGHTLESS ENVIRONMENT, SELF-ASSEMBLING STRUCTURAL BEAM TO BE TRANSPORTED AND DEPLOYED BY THE SPACE SHUTTLE, WAS SUBMITTED AS A RESEARCH PROPOSAL TO NASA UNDER THE SMALL BUSINESS INNOVATION RESEARCH PROGRAMME. THE COLLAPSIBLE OCTAGONAL BEAM IS INTENDED TO SERVE AS A 'BUILDING BLOCK' FOR THE ASSEMBLY OF LARGE ORBITING PLATFORMS FOR SOLAR ARRAYS, SCIENTIFIC EXPERIMENTS OR SPACE STATION STRUCTURAL ELEMENTS.

1985

SECTION A

SECTION B

SECTION C

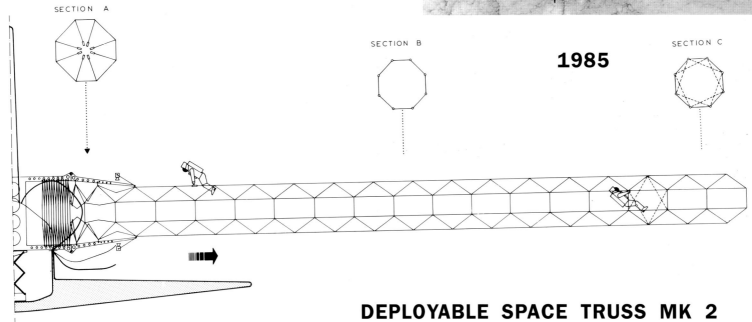

DEPLOYABLE SPACE TRUSS MK 2

KINETIC LIVING

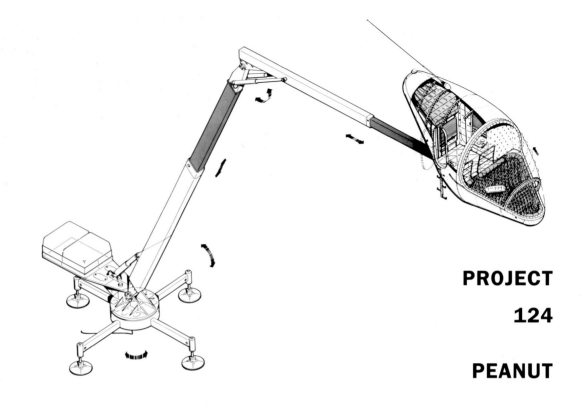

PROJECT
124

PEANUT

REPRESENTING IN MANY WAYS THE ULTIMATE DEVELOPMENT OF THE WILDERNESS RETREAT SERIES, THIS SMALL TWO-PERSON DWELLING CAPSULE USES AN ARTICULATED HYDRAULIC ARM TO ENABLE IT TO ADOPT A HUGE VARIETY OF ORIENTATIONS AND POSTURES.

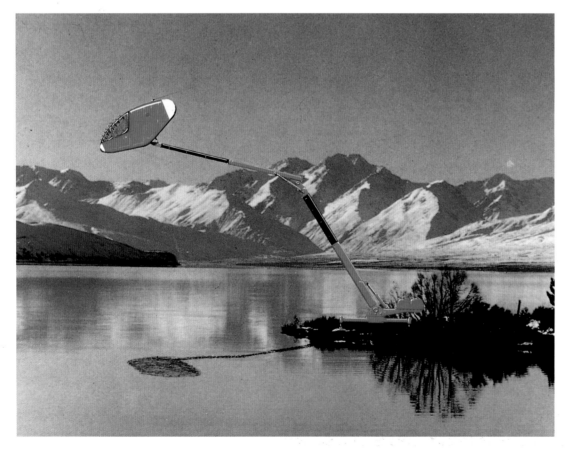

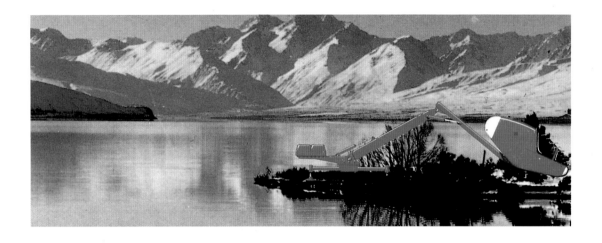

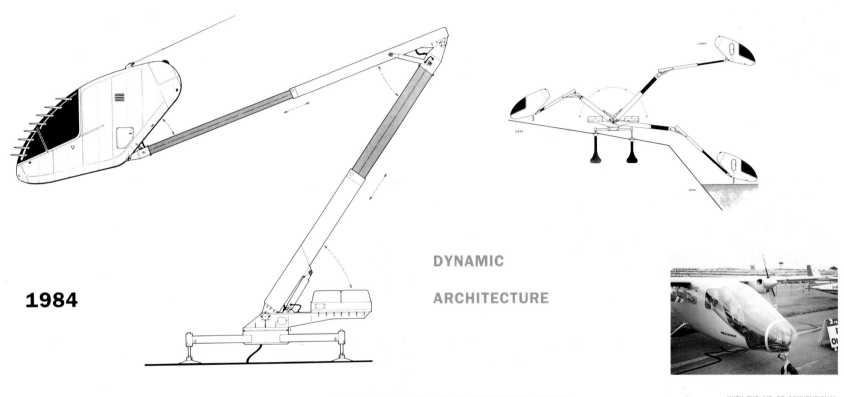

DYNAMIC

ARCHITECTURE

1984

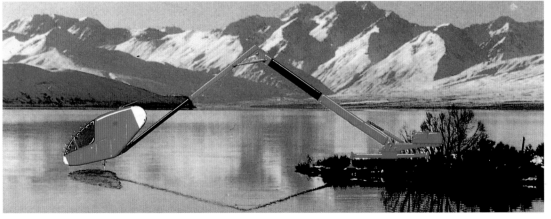

WITH THE AID OF CONVENTIONAL BRIDGE AND BUILDING MAINTENANCE TECHNOLOGY THE PEANUT CAPSULE OVERCOMES THE LIMITATIONS OF THE FIXED VIEWPOINT, WHICH IS THE PRINCIPAL PERCEPTUAL LIMITATION OF THE STATIC DWELLING – AS OPPOSED TO THE MOTOR CAR OR THE AIRCRAFT. THE DWELLING CAN SIMULATE THE VIEWPOINT OF BUILDINGS OF DIFFERENT HEIGHTS AND DIFFERENT LOCATIONS AT WILL.

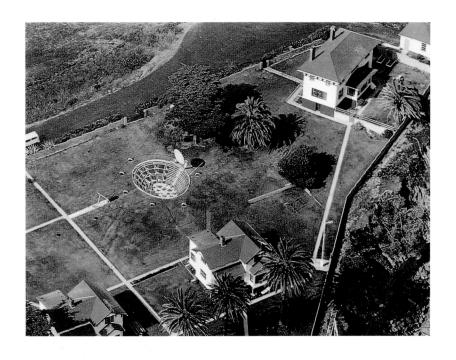

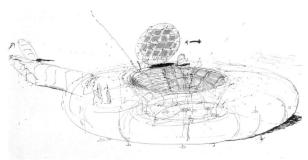

DOUGHNUT
HOUSE

DESIGNED FOR USE IN AREAS OF OUTSTANDING NATURAL BEAUTY OR HISTORICAL SITES WHERE ABOVE-GROUND STRUCTURES WOULD INTERFERE WITH ANCIENT SETTINGS, THE DOUGHNUT HOUSE IS A STRESSED-SKIN, CIRCULAR TORUS SHAPE. IT IS MADE UP FROM RADIAL STRUCTURAL ELEMENTS TO FORM A COMPLETELY EARTH-INTEGRATED CIRCULAR DWELLING VIRTUALLY INVISIBLE AT GROUND LEVEL. DAYLIGHTING IS VIA THE GLAZED INCLINED WALLS OF THE CENTRAL COURTYARD, WHILE A TRACKING SOLAR MIRROR AND SHADE SYSTEM ENSURE THAT ALL PARTS OF THE HOUSE CAN RECEIVE DIRECT OR REFLECTED SUNLIGHT.

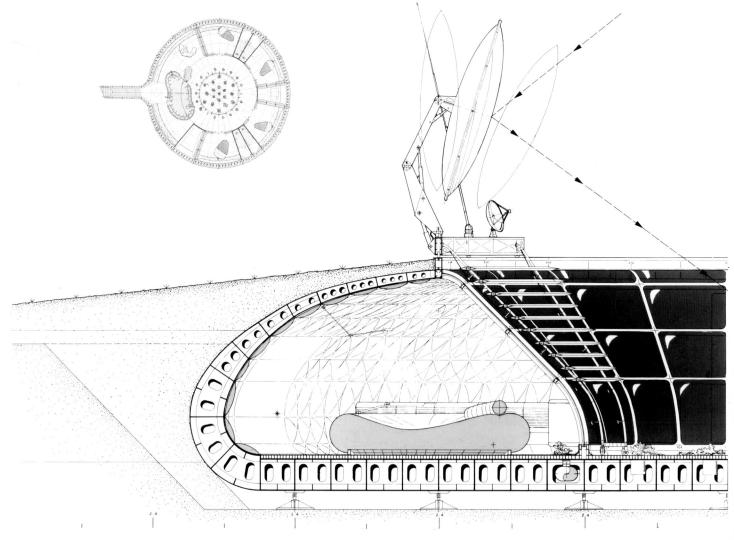

PROJECT
130

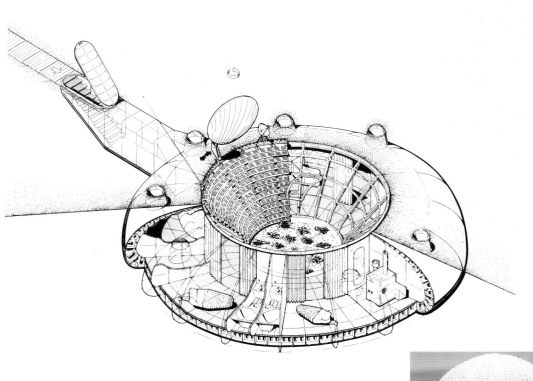

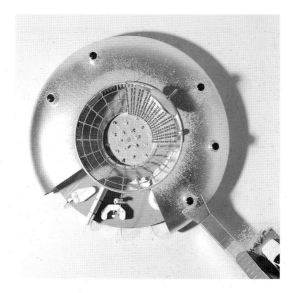

1985

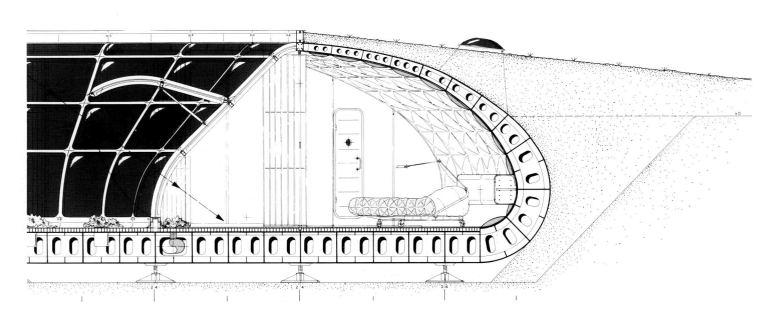

EARTH-

INTEGRATED

CIRCULAR

DWELLING

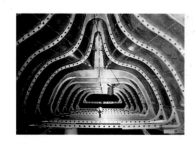

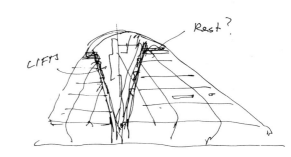

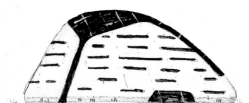

THIS IMPORTANT PROJECT ORIGI-
NATED AS A COMPETITION ENTRY
FOR A TRAFALGAR SQUARE SITE
BUT WAS NOT SUBMITTED. THE
CURVILINEAR SHAPE OF THE
BUILDING PROCEEDS FROM THE
SHAPE OF THE SITE AND THE
RESTRICTING LIGHT ANGLES
GENERATED BY NEIGHBOURING
BUILDINGS. THE STRUCTURE
COMPRISES A DOUBLE SKIN,
WHICH IS INTERNALLY THREE-
DIMENSIONALLY TRUSSED TO
PROVIDE A COMPLETE ENCLOSURE
FROM TOP TO BOTTOM.

BLOB

PROJECT 135

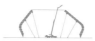
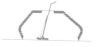

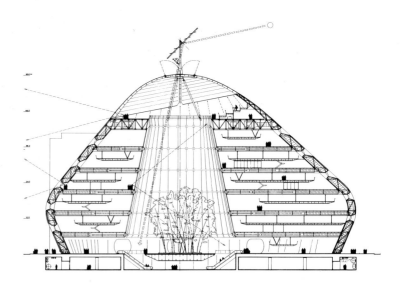

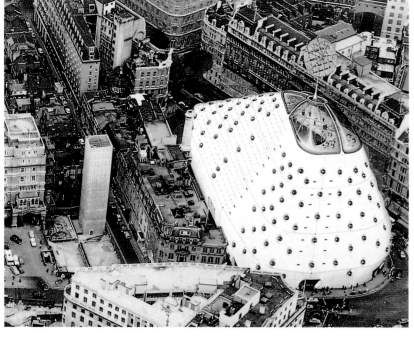

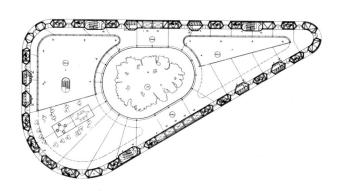

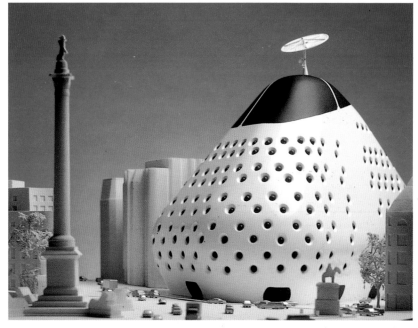

RADICAL

URBANISM

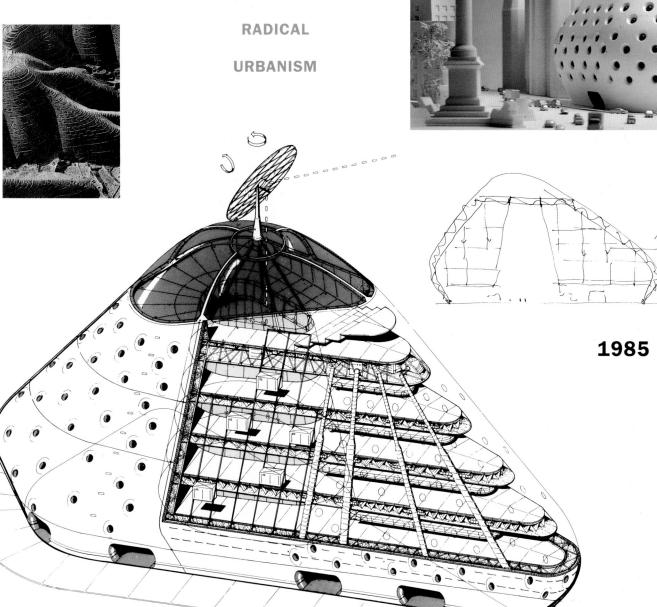

STRUCTURE: SAMUELY & PARTNERS

SERVICES: YRM ENGINEERS

1985

EXTERNALLY, THE OUTER SKIN IS FINISHED IN SELF-CLEANING, WHITE CERAMIC TILES WITH RECESSED RAINWATER CHANNELS. INTERNALLY, A DEEP TRUSSED DECK BENEATH THE LARGE ASTRODOME SUPPORTS THE RADIALLY SPANNING FLOOR DECKS. ALL AIR-CONDITIONING EQUIPMENT, UTILITY ROOMS, TOILETS AND MOST SERVICE RUNS ARE INSTALLED BETWEEN THE INNER AND OUTER SKINS OF THE BUILDING. CONCEPTUALLY, THE BUILDING IS AN INTERIOR ENVIRONMENT FOCUSED ON A LARGE CENTRAL ATRIUM. THERE ARE EXTENSIVE RETAIL AND PEDESTRIAN FACILITIES AT GROUND LEVEL AND THERE IS A RESTAURANT BENEATH THE ASTRODOME. ADJUSTABLE COMMUNICATIONS AND SOLAR ANTENNAE CAN BE MOUNTED ABOVE THE ASTRODOME.

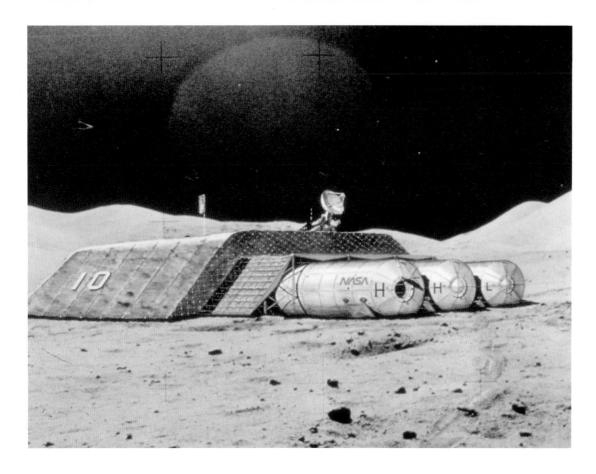

LUNAR BASE STUDY

PROJECT 136

A SHIELDING SYSTEM FOR A LUNAR BASE CONSISTING OF THREE ORBITING SPACE STATION MODULES. THIS PROJECT IS BASED ON A LIGHTWEIGHT GRID OF GRAPHITE–EPOXY BEAMS AND STRUTS, DESIGNED TO RETAIN A 2M-DEPTH OF LUNAR SOIL ABOVE THE MODULES, THIS DEPTH OF SOIL HAVING BEEN JUDGED SUFFICIENT TO PROTECT THE LUNAR BASE FROM SOLAR-FLARE RADIATION AND MICRO-METEOROID IMPACT. A FINELY WOVEN, GRAPHITE FIBRE MESH STRETCHES OVER THIS INNER STRUCTURE TO SUPPORT THE SOIL MASS ABOVE.

GRAPHITE–EPOXY BEAMS AND STRUTS

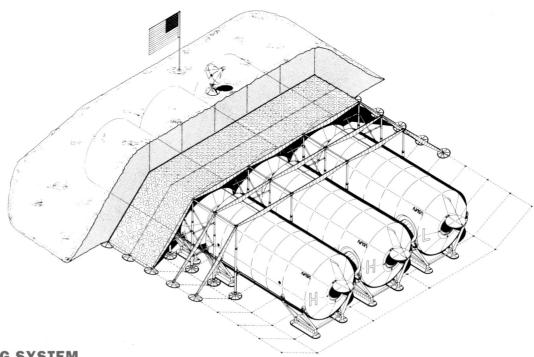

SHIELDING SYSTEM

1985

TRANSPORT

1985

PROJECT 139

SHELTER

DEVELOPED WITH THE ENCOURAGEMENT OF THE SAVE THE CHILDREN FUND DURING THE 1985 ETHIOPIAN FAMINE, THIS SCHEME INVISAGES A LARGE, LOW-COST DEPLOYABLE ENVELOPE FOR USE AS SHELTER BY UP TO 200 PEOPLE IN THE EVENT OF NATURAL DISASTERS. THE FORM OF THE SHELTER IS SIMILAR TO AN UMBRELLA WITH 12 RADIAL RIBS JOINED BY MEMBRANE PANELS OF LIGHTWEIGHT PVC-COATED POLYESTER. THE WHITE OUTER SURFACE OF THESE MEMBRANE PANELS REFLECTS UP TO 80 PER CENT OF SOLAR HEAT IN TROPICAL LATITUDES. INTERNALLY THE SURFACE OF THE MEMBRANE IS METALLISED TO REDUCE HEAT LOSS THROUGH RADIATION. THROUGH VENTILATION IS ACHIEVED WITH PERIMETER SLOTS AND HIGH-LEVEL EXITS AT THE HUB AND THROUGH FLAPS.

STRUCTURE: ATELIER 1

SERVICES: OVE ARUP & PARTNERS

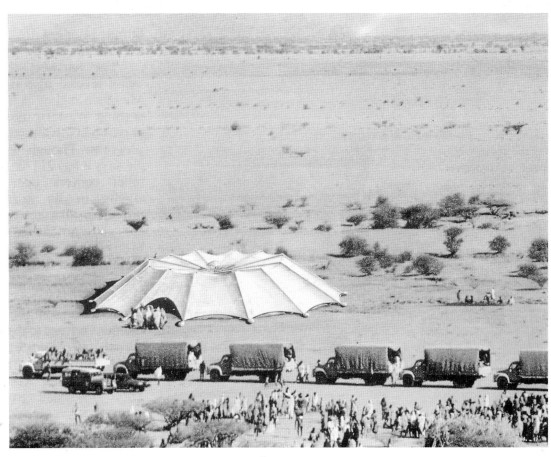

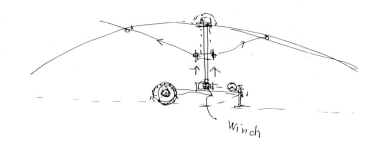

Winch

12 PEOPLE　　　　**30 MINUTES**

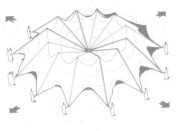

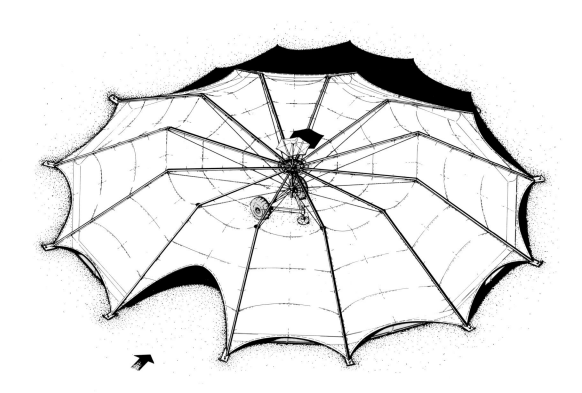

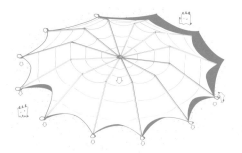

CAPACITY 200 PEOPLE

1. 6MM CONTINUOUS INTERLOCKING SECTION ABS
2. HIGH TENSILE POLYESTER ROPE EDGE
3. KEDAR CUFF WITH MIN 20MM WELDS
4. PVC MEMBRANE

IN ITS COLLAPSED FORM THE
STRUCTURE AND ENVELOPE
CAN BE TRANSPORTED BY AIR
AND DELIVERED BY PARACHUTE,
OR TRAILED BEHIND A TRUCK
ON ITS OWN WHEELED UNDER-
CARRIAGE. IT CAN BE ASSEMBLED
BY 12 UNSKILLED PEOPLE IN
30 MINUTES, THE OUTER
EXTREMITY OF EACH RIB
BEING GROUND-ANCHORED OR
WEIGHED DOWN WITH SANDBAGS.

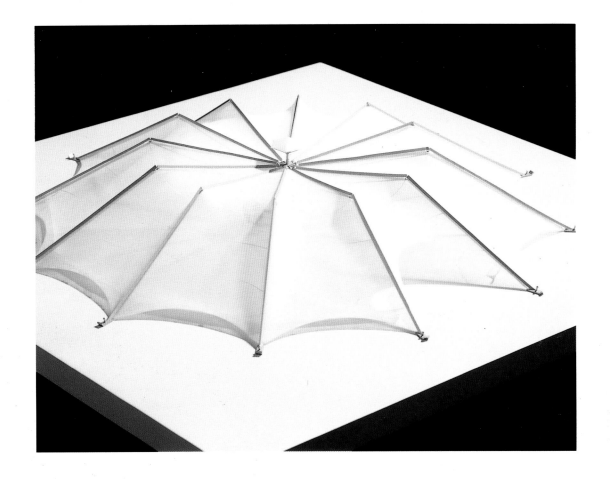

UMBRELLA

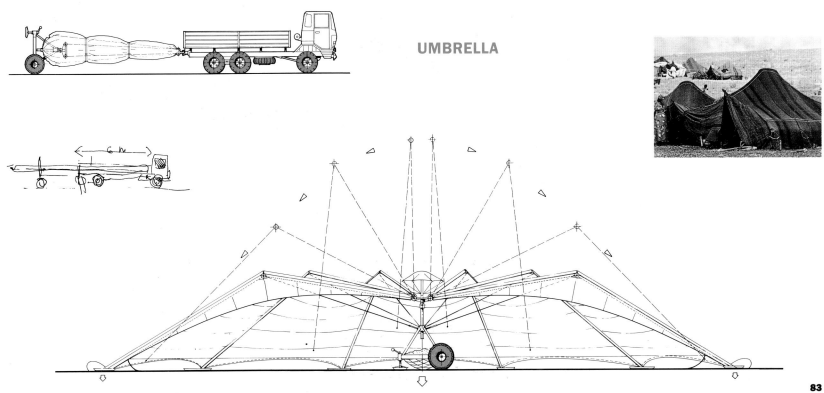

PROJECT 144

NASA

SPACE STATION

BOARDROOM

TABLE

THIS ZERO-GRAVITY MEETING AND DINING TABLE FOR USE BY UP TO EIGHT PEOPLE IN A SPACECRAFT, WAS DESIGNED FOR EVENTUAL FLIGHT TESTING IN THE NASA SHUTTLE ORBITER. INTENDED TO BE DEPLOYED IN ORBIT AND NOT SUBJECTED TO LAUNCH LOADS, THE TABLE COMPLIES WITH THE DEMANDS OF AN ENVIRONMENT IN WHICH ALL OBJECTS MUST BE RESTRAINED, INCLUDING THE HUMAN USERS, WHOSE FEET ARE LOCATED IN 'STIRRUPS'. ACCOMMODATION OF DIFFERENT NUMBERS OF PARTICIPANTS IS ACHIEVED BY A SYSTEM OF ARTICULATED-TRAY TABLES SIMILAR TO THOSE FOUND IN COMMERCIAL AIRCRAFT.

FLEXIBILITY

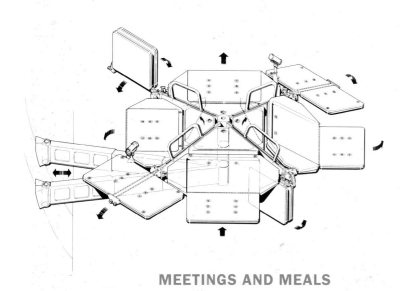

MEETINGS AND MEALS

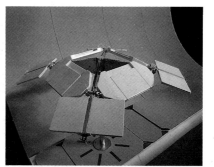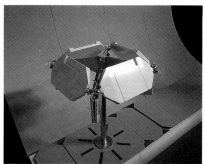

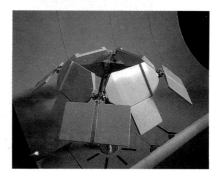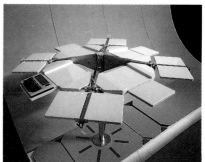

PROJECT

143

CHAISE

LONGUE

A NEW TYPE OF LIGHTWEIGHT CHAIR FOR DOMESTIC OR COMMERCIAL USE. THE BASIC FORM IS BUILT UP FROM SEVERAL SUPERFORM ALUMINIUM PANELS. THE OUTERMOST SOFT COVERING IS A SINGLE FOAM-RUBBER BLANKET WITH A SPRAYED-PVC, WASHABLE FINISH. THE CHAIR IS EASILY MANOEUVRED ON ITS PNEUMATIC WHEELS AND IS DIMENSIONED TO PASS THROUGH DOMESTIC DOORWAYS. EQUIPMENT OF VARIOUS TYPES, SUCH AS A DRINKS TRAYS OR TASK LIGHTING, CAN BE FITTED TO THE BASIC CHAIR AS A RANGE OF ACCESSORIES.

SUPERFORM ALUMINIUM

1986

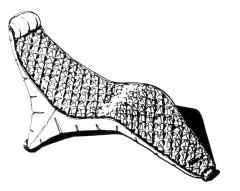

OUTSIDE INSIDE

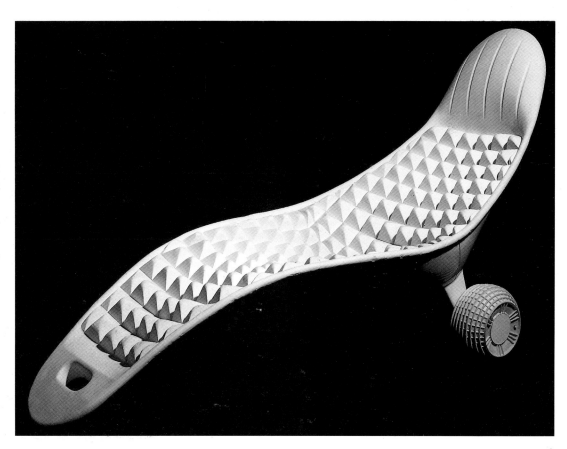

THIS INTERIOR REMODELLING WAS
CARRIED OUT ON AN APARTMENT
IDENTICAL TO THE SUBJECT OF
PROJECT 017. EXECUTED WITH A
VERY LIMITED BUDGET, THE
DESIGN CALLED FOR WHITE
RUBBER FLOORING WITH CARPET
INSERTS; CIRCULAR CEILING
PANELS DECORATED WITH PHOTO-
MONTAGES OF CLOUDS; A
MOBILE KITCHEN CORE UNIT, CON-
NECTED ONLY BY POWER SUPPLY
CABLES AND THE ADDITION OF
MUCH NEW INTERNAL STORAGE
SPACE WITH ALUMINISED-PLASTIC
ROLLER BLIND CLOSURES.

MB FLAT

PROJECT

138

1985

MOBILE

KITCHEN

NASA SLEEP
RESTRAINT

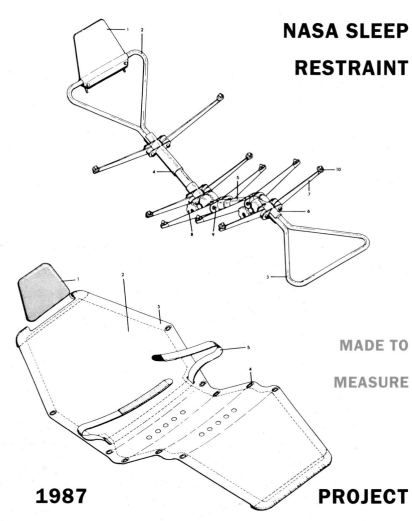

MADE TO

MEASURE

1987

PROJECT

148

BONE AND MUSCLE WASTAGE FOL-
LOWING PROLONGED EXPOSURE
TO WEIGHTLESS CONDITIONS
IS ONE OF THE MOST SERIOUS
CONSEQUENCES OF SPACE
FLIGHT. THIS ARTICULATED,
ALLOY-FRAMED, ADJUSTABLE
SLEEP RESTRAINT WAS DESIGNED
TO ENABLE ASTRONAUTS TO
RELAX AND SLEEP IN THE
SEMI-CROUCHED POSITION THAT
RESEARCH HAD SHOWN TO BE
LEAST CONDUCIVE TO LONG-
TERM DAMAGE. THE FRAME,
SYNTHETIC FABRIC BODY
SUPPORT AND ATTACHABLE
QUILTED SLEEPING BAG ARE ALL
ADJUSTABLE FOR DIFFERENCES
IN THE HEIGHT AND BUILD
OF INDIVIDUAL ASTRONAUTS.

SECOND PRIZE-WINNER IN A 1987 COMPETITION ORGANISED BY THE MAGAZINE *JAPAN ARCHITECT* TO ILLUSTRATE THE CONCEPT OF A BRIDGE OF THE FUTURE, THIS PROJECT IS DESIGNED FOR A SITE OCCUPIED BY A TEMPORARY PEDESTRIAN BRIDGE LINKING THE TUILERIES WITH THE MUSEE D'ORSAY IN PARIS.

1987

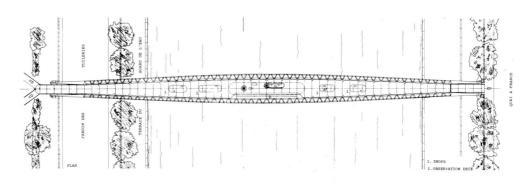

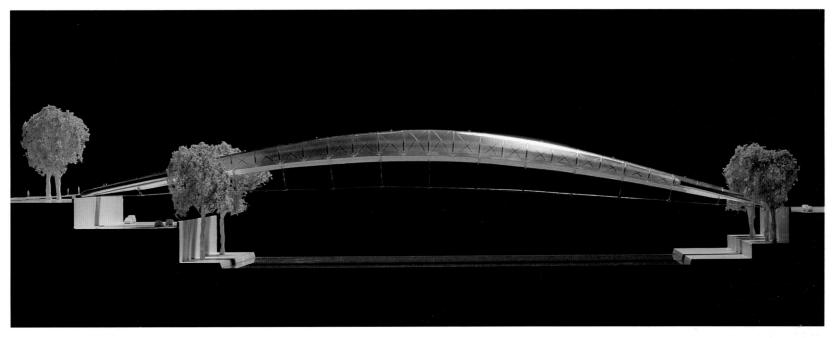

PARIS BRIDGE

PROJECT

157

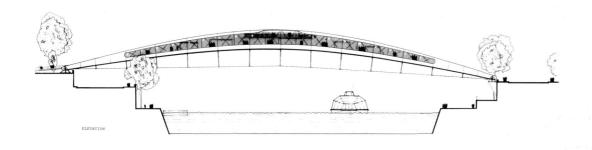

ELEVATION

STRUCTURE: ELMS ROOKE PARTNERSHIP

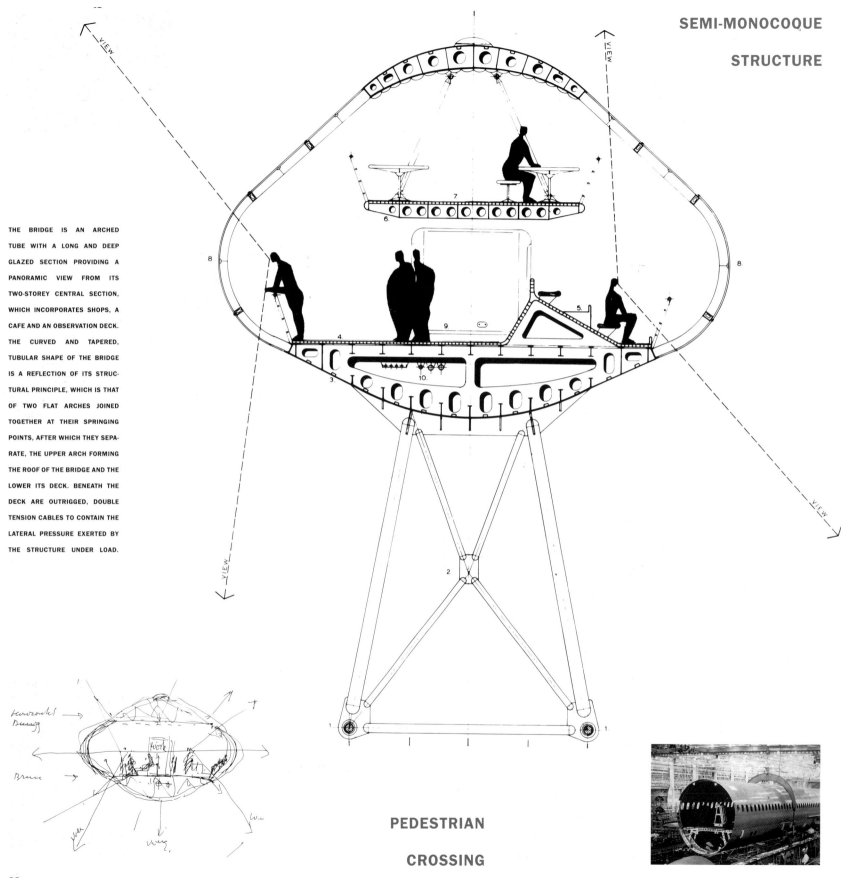

THE BRIDGE IS AN ARCHED
TUBE WITH A LONG AND DEEP
GLAZED SECTION PROVIDING A
PANORAMIC VIEW FROM ITS
TWO-STOREY CENTRAL SECTION,
WHICH INCORPORATES SHOPS, A
CAFE AND AN OBSERVATION DECK.
THE CURVED AND TAPERED,
TUBULAR SHAPE OF THE BRIDGE
IS A REFLECTION OF ITS STRUC-
TURAL PRINCIPLE, WHICH IS THAT
OF TWO FLAT ARCHES JOINED
TOGETHER AT THEIR SPRINGING
POINTS, AFTER WHICH THEY SEPA-
RATE, THE UPPER ARCH FORMING
THE ROOF OF THE BRIDGE AND THE
LOWER ITS DECK. BENEATH THE
DECK ARE OUTRIGGED, DOUBLE
TENSION CABLES TO CONTAIN THE
LATERAL PRESSURE EXERTED BY
THE STRUCTURE UNDER LOAD.

PEDESTRIAN

CROSSING

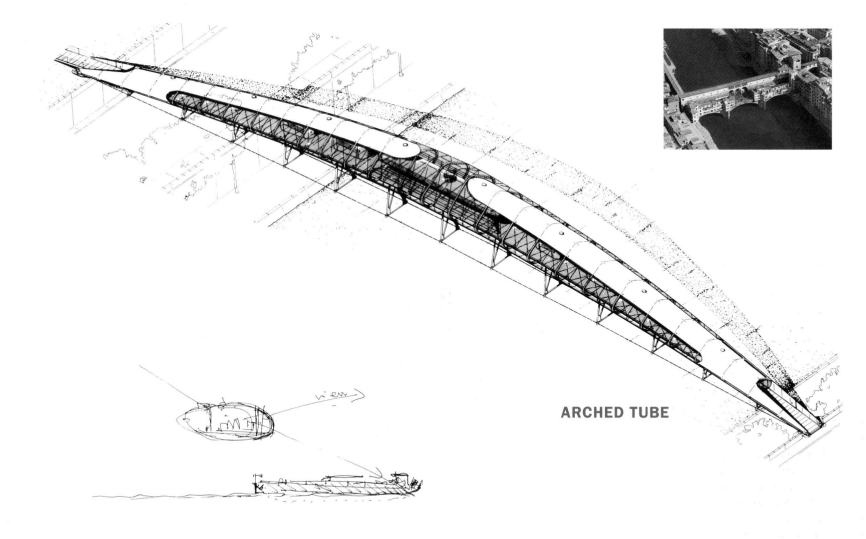

ARCHED TUBE

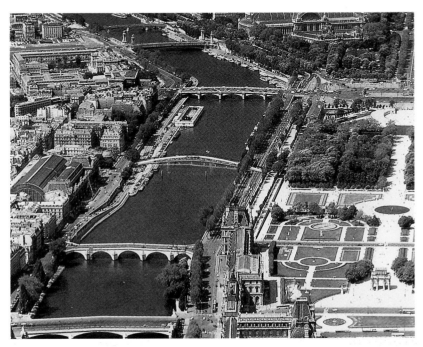

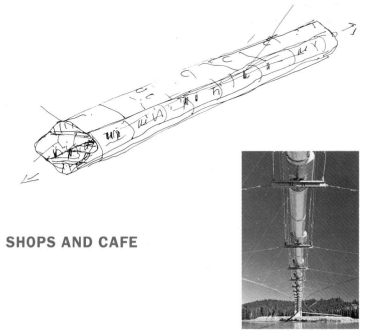

SHOPS AND CAFE

GLASS AND GRASS IS A PROJECT DESIGNED FOR THE BUILDING CENTRE TRUST TO DEMONSTRATE THE POSSIBILITY OF EARTH-INTEGRATED MODULAR CONCRETE TERRACES OF APARTMENTS, GRASSED OVER SO AS TO PRESENT A LANDSCAPED ASPECT CLOSE TO SOUTHWARK CATHEDRAL IN LONDON. THIS SCHEME IS SO DESIGNED THAT THE MAJOR STRUCTURAL ELEMENTS OF THE HOUSES CAN BE MANUFACTURED OFF-SITE.

GLASS AND GRASS

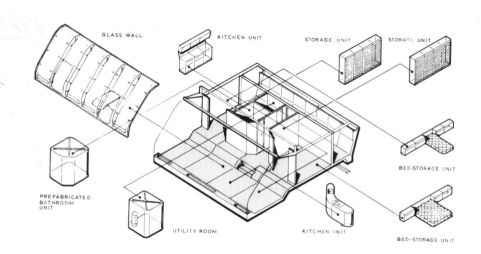

GLASS WALL · KITCHEN UNIT · STORAGE UNIT · STORAGE UNIT · BED-STORAGE UNIT · PREFABRICATED BATHROOM UNIT · UTILITY ROOM · KITCHEN UNIT · BED-STORAGE UNIT

ELEMENTS

PROJECT

157

1988

THAMES · SOUTHWARK CATHEDERAL

SIMPLICITY

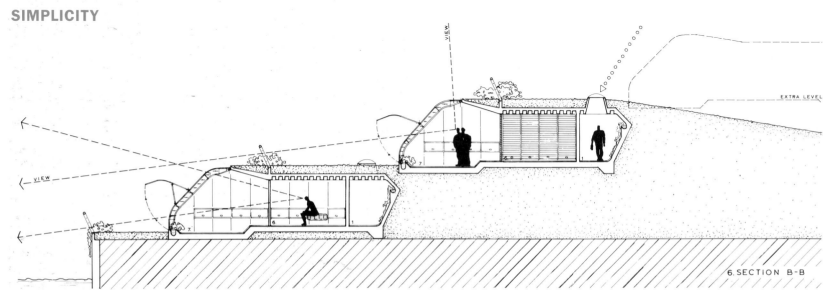

VIEW · EXTRA LEVEL · VIEW · 6. SECTION B-B

THIS EXHIBITION PROJECT FOR THE LONDON INSTITUTE OF CONTEMPORARY ARTS WAS DESIGNED TO CREATE A LONDON LANDMARK TO COMMEMORATE THE YEAR 2000. THE SPIRE TAKES THE FORM OF A 480M, INCLINED MAST WITH OBSERVATION PLATFORMS, BARS AND RESTAURANT AT ITS SUMMIT AND IN THE 16-STOREY BASE STRUCTURE, WHICH ALSO HOUSES SHOPS AND OFFICES.

SPIRE

PROJECT 158

1988

THE MAST ITSELF IS TRIANGULAR IN SECTION AND TAKES THE FORM OF AN ARRAY OF TRUSSED STEEL TUBES THREADED THROUGH WITH PRE-TENSIONED STEEL RODS ANCHORED TO DEEP PILINGS. THE WHOLE STRUCTURAL FRAMEWORK IS ENCLOSED BY A SEMI-MONOCOQUE ALUMINIUM SKIN WITH A HIGH GLOSS CERAMIC FINISH. THE UPPER THIRD OF THE MAST IS PERFORATED IN ORDER TO REDUCE ITS WIND LOADING.

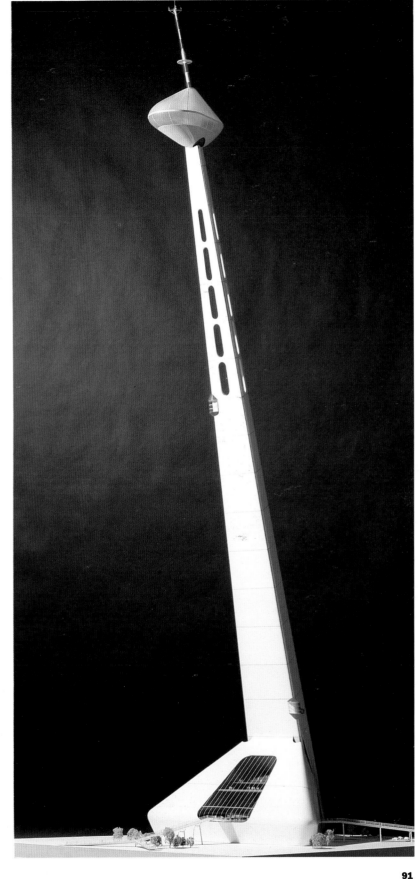

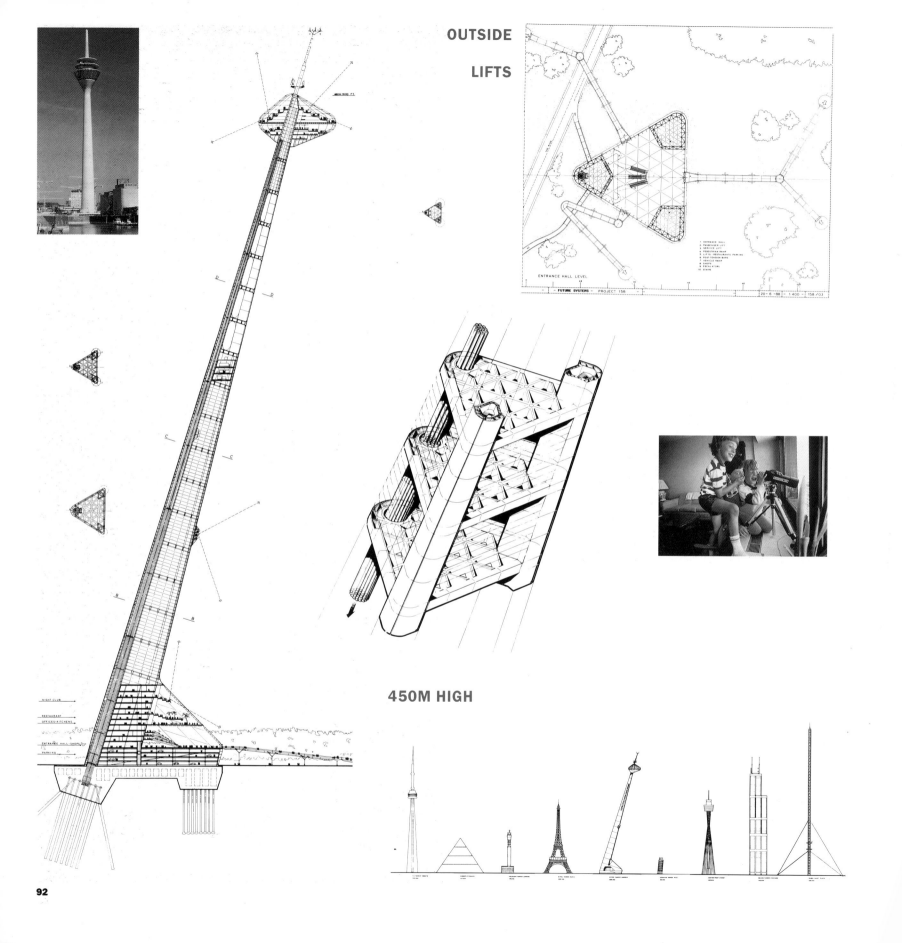

OUTSIDE

LIFTS

450M HIGH

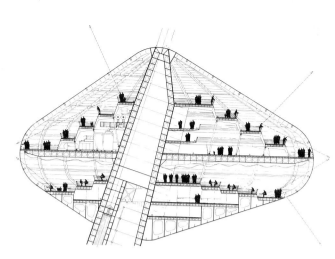

OBSERVATION DECKS

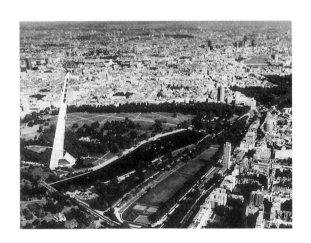

ACCESS TO THE UPPER OBSERVA-
TION PLATFORM COMPLEX IS
BY MEANS OF TRIPLE-DECKER
OBSERVATION LIFTS RUNNING IN
EXTERNAL TRACKS WITH SERVICE
LIFTS INSIDE THE MAST.

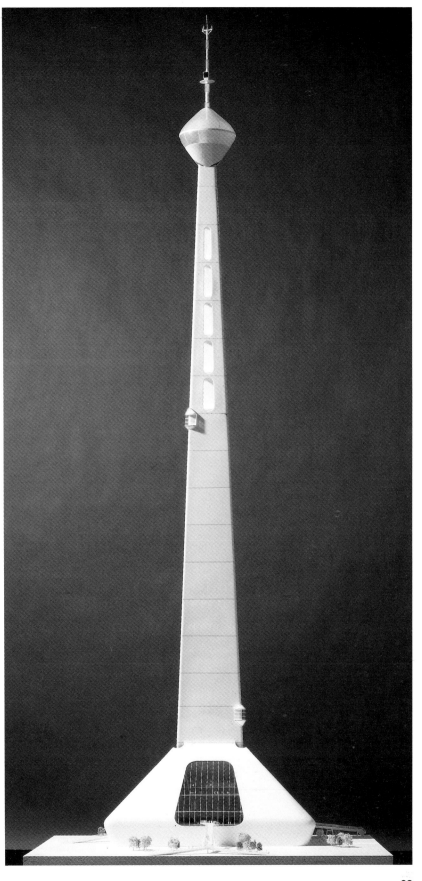

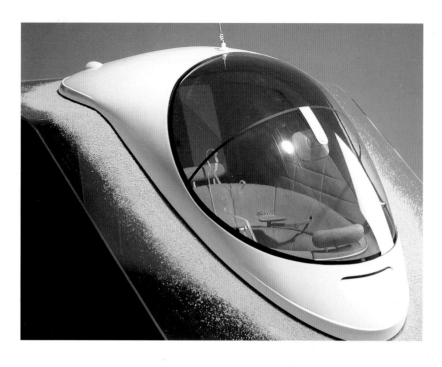

DROP

PROJECT

165

THIS MINIMAL, SELF-SUPPORTING, SHORT-STAY ACCOMMODATION UNIT FOR TWO PEOPLE WAS DESIGNED FOR THE 1989 NAGOYA BIENNALE. DROP IS ONLY 6M LONG AND IS MADE UP OF TWO SEMI-MONO-COQUE SHELLS – ONE CONCAVE AND THE OTHER CONVEX.

6M LONG

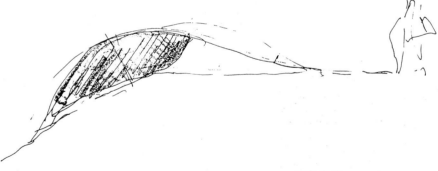

1988

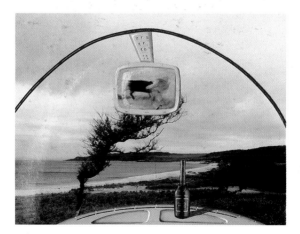

THE TWO SHELLS ARE BONDED TO ENCLOSE STRUCTURAL RIBS AND STRINGERS WITH A FOAMED INSULANT FILLING ALL VOIDS AS IN CONVENTIONAL GRP BOAT CON-STRUCTION. THE COMPLETE UNIT IS DESIGNED TO BE DELIVERED BY TRUCK AND INSTALLED WITH MINIMAL SITE PREPARATION. ONCE IN POSITION THE INTERNAL ENVIRONMENT IS CONTROLLED BY A SMALL AIR-CONDITIONING UNIT RUNNING FROM AN AIR-COOLED REVERSIBLE HEAT PUMP.

SHORT-STAY ACCOMMODATION UNIT

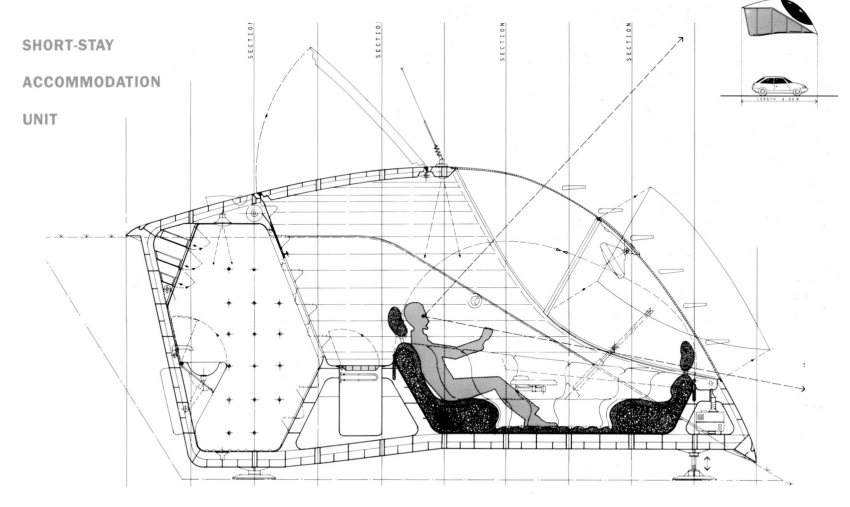

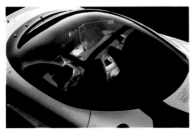

UP TO 50 PER CENT EXTERNAL SHADING IS PROVIDED BY THE HORIZONTAL LOUVRES OUTSIDE THE OPENING COCKPIT CANOPY. ACCOMMODATION INCLUDES MINIMAL BATHROOM AND FOOD PREPARATION FACILITIES, AND A LARGE RELAXATION AREA.

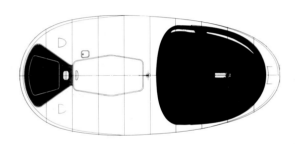

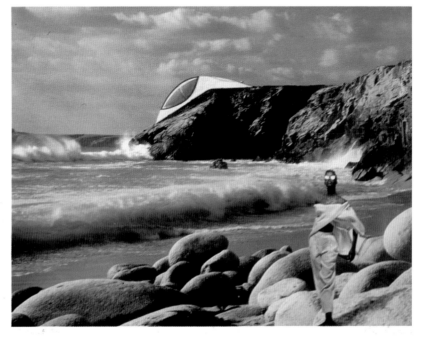

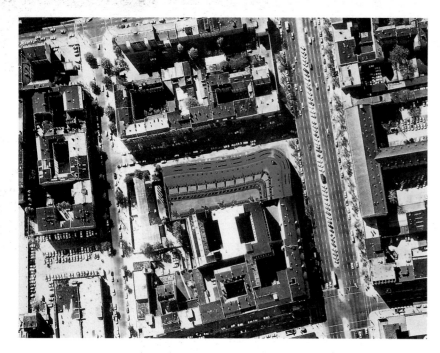

PROJECT 161

HELIOWATT BERLIN

THIS MIXED-USE DEVELOPMENT OF OFFICES, PRODUCTION FACILITIES AND RESIDENTIAL ACCOMMODATION IS FOR A SITE OFF THE BISMARCKSTRASSE IN BERLIN. IT WAS DESIGNED FOR HELIOWATT, A MANUFACTURER OF ELECTRICAL COMPONENTS, IN RESPONSE TO A LIMITED COMPETITION ORGANISED BY THE BERLIN COMPANY.

EXPLOITING ADVANCED CLADDING TECHNOLOGIES, THE CONCEPT IS DRAWN FROM AN UPDATED, DOUBLE-CURVATURE VERSION OF THE CURVED CORNER BUILD-INGS DESIGNED BY ERICH MENDELSOHN. BEHIND THE SLOPED SEMI-MONOCOQUE CERAMIC-FINISHED OUTER ENVE-LOPE THE DIFFERENT ACTIVITIES ARE ARRANGED IN LAYERS. THE BUILDING IS CONCRETE-FLOORED WITH STEEL PRIMARY AND SEC-ONDARY BEAMS AND Y-FORMA-TION COLUMNS. ENVIRONMENTAL CONTROL IS ACHIEVED BY AIR CONDITIONING WITH THE PRIMARY SUPPLY AND EXHAUST DUCTS SET INTO THE THICKNESS OF THE OUTER ENVELOPE.

1988

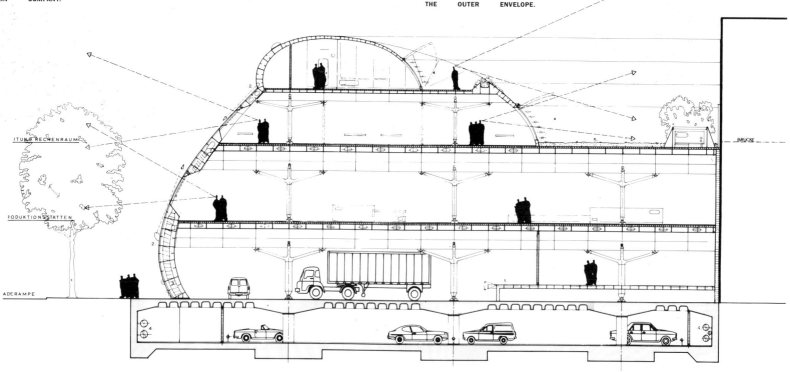

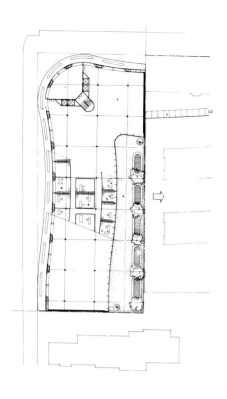

STRUCTURE: YRM ANTHONY HUNT ASSOCIATES

SERVICES: YRM ENGINEERS

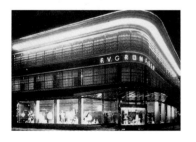

PHASING

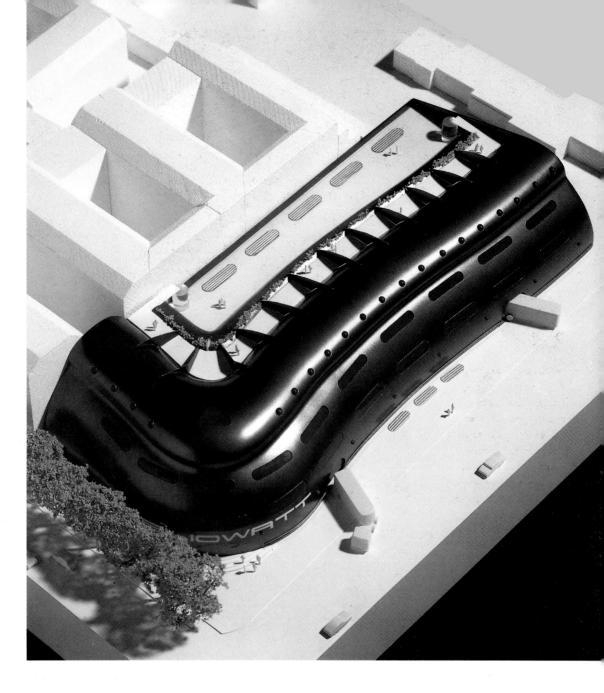

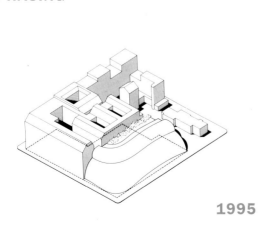

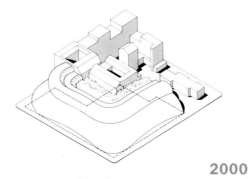

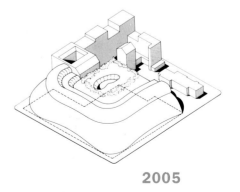

1995 2000 2005

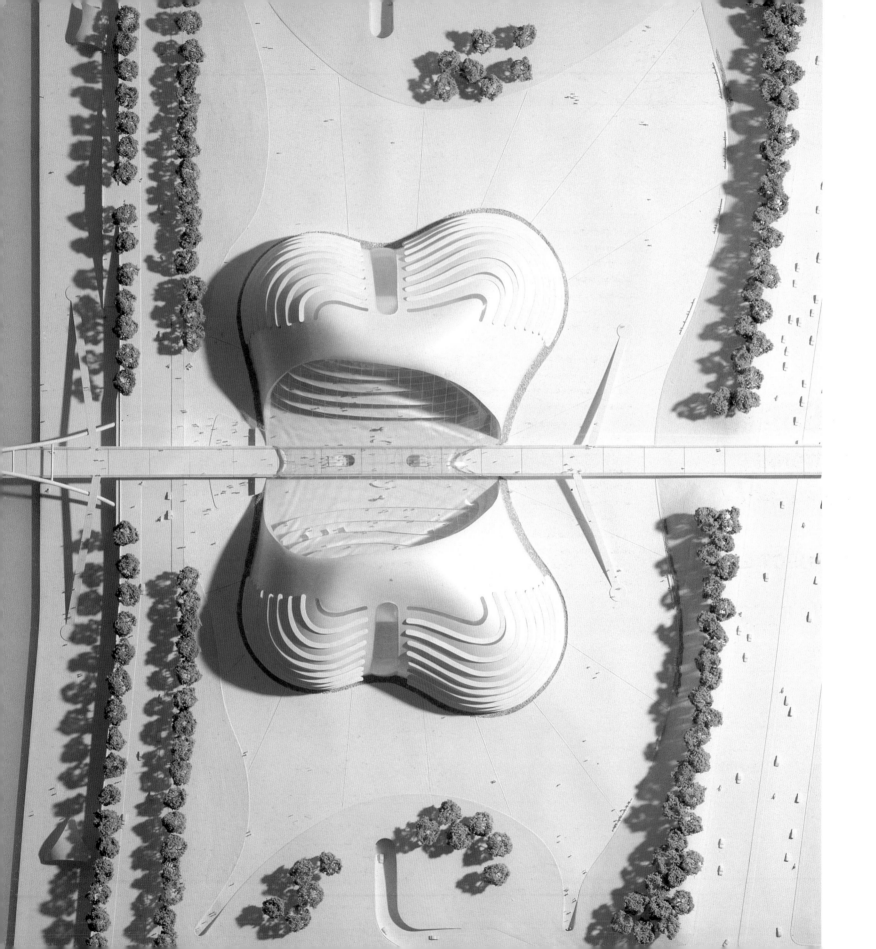

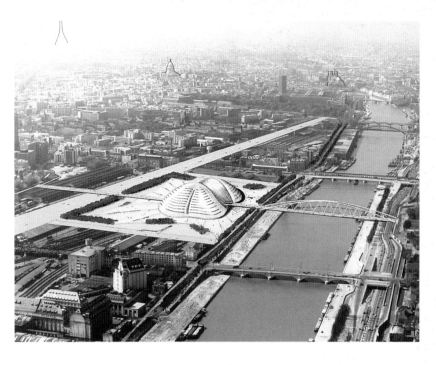

BIBLIOTHEQUE NATIONALE DE FRANCE

PROJECT 171

AWARDED SECOND PLACE OUT OF 230 ENTRANTS IN A COMPETITION TO DESIGN A NEW, £500M NATIONAL LIBRARY OF FRANCE – THE LARGEST LIBRARY IN EUROPE – THIS 200,000M^2 PROJECT WAS DESCRIBED IN THE ASSESSORS' REPORT AS 'A DOOR OPENING UPON THE FUTURE.' ITS TWIN-LOBED COMPOUND-CURVATURE AERODYNAMIC FORM IS UNMATCHED BY THE PROJECT OF ANY OTHER ENTRANT. THE FINAL CHOICE AGAINST IT WAS A MOMENTOUS ONE IN ARCHITECTURAL HISTORY: A CHOICE OF PRINCIPLE BET-WEEN TRADITIONAL TRABEATED BUILDING FORMS AND AN ORGANIC FORMAL CONCEPTION OWING LITTLE OR NOTHING TO ARCHITECTURE'S CLASSICAL ARCHITECTURAL HERITAGE.

STRUCTURE: OVE ARUP & PARTNERS

SERVICES: OVE ARUP & PARTNERS

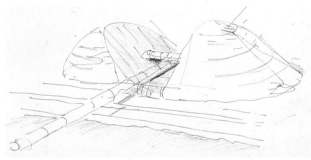

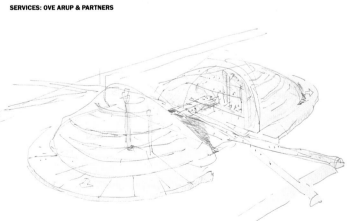

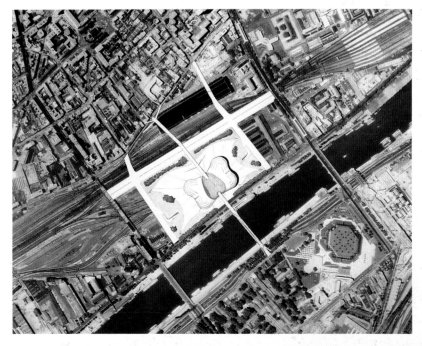

THE LIBRARY OF PARENT AND CHILD

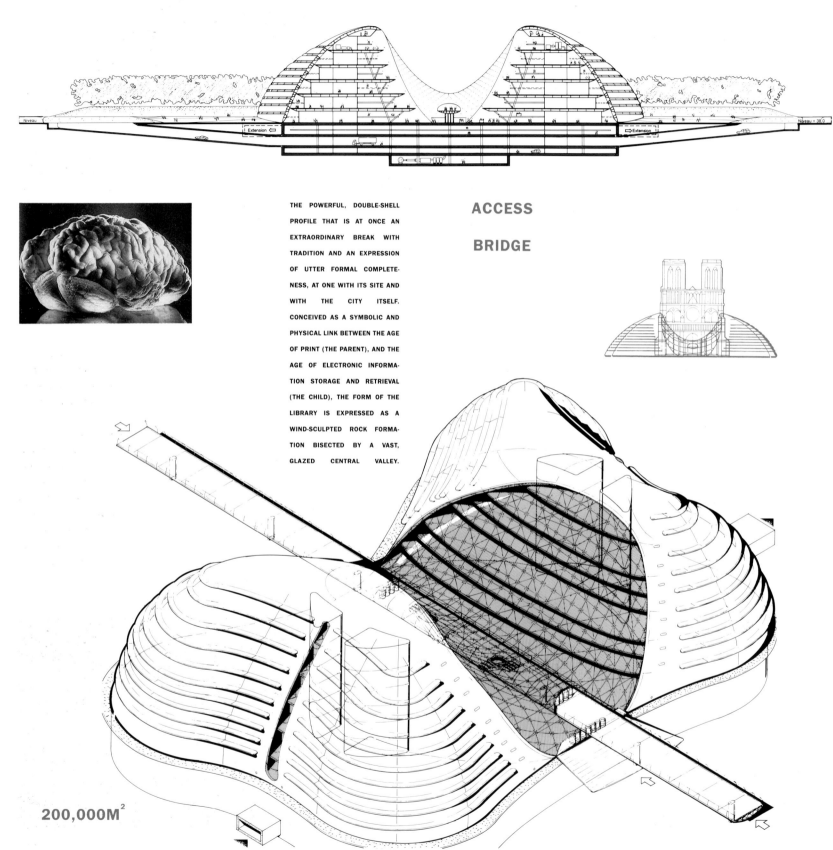

ACCESS

BRIDGE

THE POWERFUL, DOUBLE-SHELL PROFILE THAT IS AT ONCE AN EXTRAORDINARY BREAK WITH TRADITION AND AN EXPRESSION OF UTTER FORMAL COMPLETENESS, AT ONE WITH ITS SITE AND WITH THE CITY ITSELF. CONCEIVED AS A SYMBOLIC AND PHYSICAL LINK BETWEEN THE AGE OF PRINT (THE PARENT), AND THE AGE OF ELECTRONIC INFORMATION STORAGE AND RETRIEVAL (THE CHILD), THE FORM OF THE LIBRARY IS EXPRESSED AS A WIND-SCULPTED ROCK FORMATION BISECTED BY A VAST, GLAZED CENTRAL VALLEY.

200,000M²

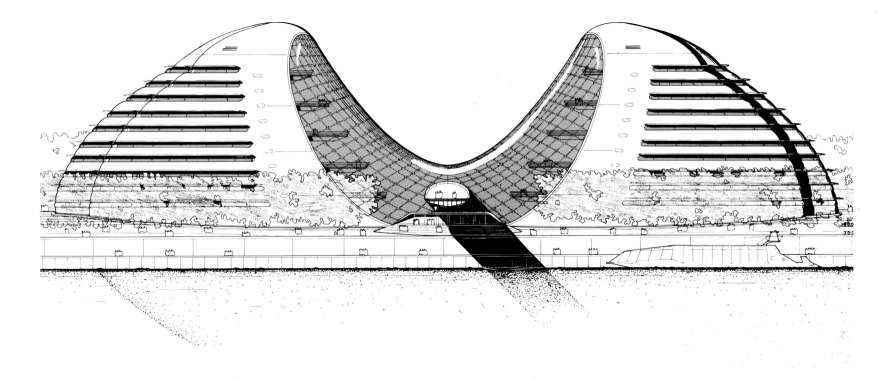

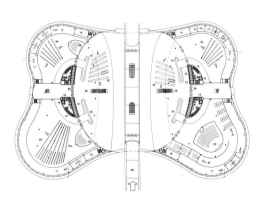

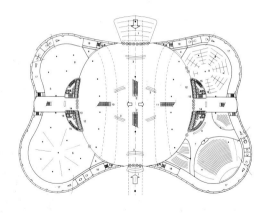

THE 'TOPOGRAPHICAL SADDLE'
PROFILE GROWS ORGANICALLY
FROM THE ENCLOSURE OF FOUR
ATTACHED FUNCTIONAL ACCOM-
MODATION LOBES, TWO EACH
SIDE OF THE CENTRAL AXIS,
WHICH IS ITSELF PENETRATED
BY A NEW, GLAZED PEDESTRIAN
BRIDGE. THE STRUCTURE GEN-
ERATED BY THIS PLAN IS BASED
UPON TWO DOUBLE-COLUMN SIX-
STOREY SERVICE CORES RISING
FROM THE THREE-STOREY BASE-
MENT, BOOK-STORAGE AREA.

FOUR LIBRARIES

OFFICES

STORAGE

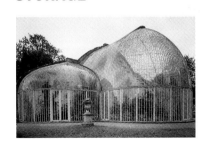

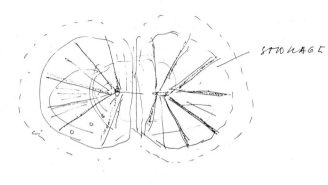

STORAGE

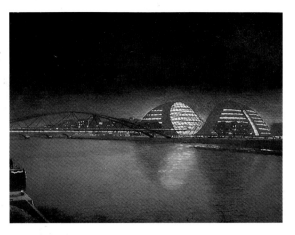

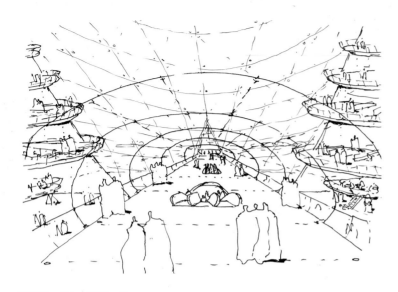

BETWEEN THE CORES IS THE CONCAVE DOUBLE-CURVATURE TENSION CABLE-SUPPORTED GLAZED ROOF, LIGHTING EACH OF THE FOUR LOBES OF THE PLAN: ENCIRCLING THE CORES ON EACH SIDE IS THE CONVEX DOUBLE-CURVATURE EXTERNAL ENVELOPE CLAD IN CERAMIC-FINISHED ALUMINIUM ALLOY. ESCALATORS COMMUNICATE BETWEEN THIS ACCESS BRIDGE-LEVEL AND LIBRARY LOBBY. THE READING ROOMS HAVE A PANORAMIC, LATERAL VIEW OF THE GLAZED VALLEY AREA FROM ALL FLOORS.

INTERIORS

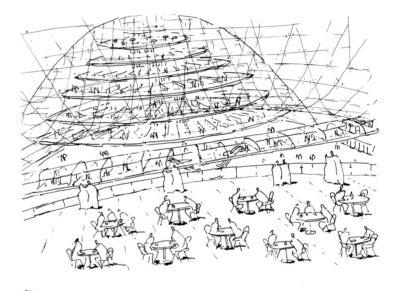

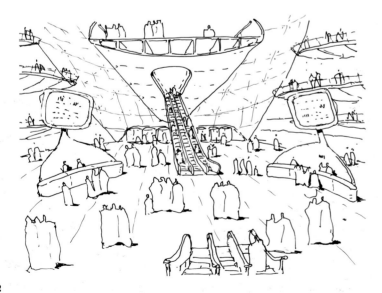

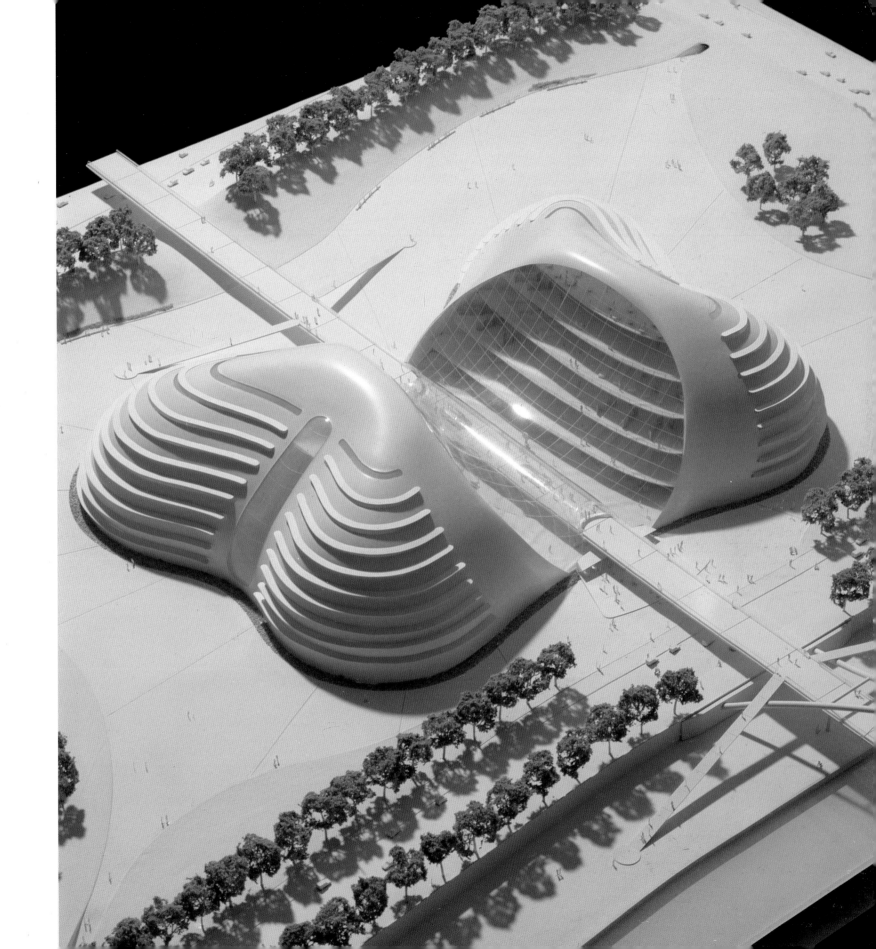

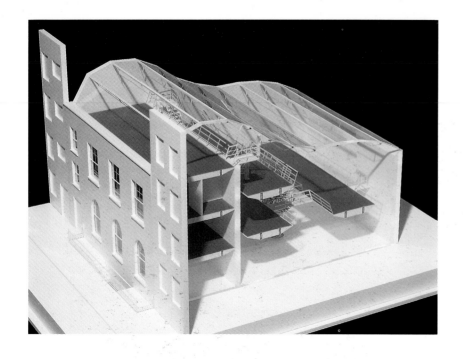

PROJECT 167

STRUCTURE: OVE ARUP & PARTNERS

SERVICES: OVE ARUP & PARTNERS

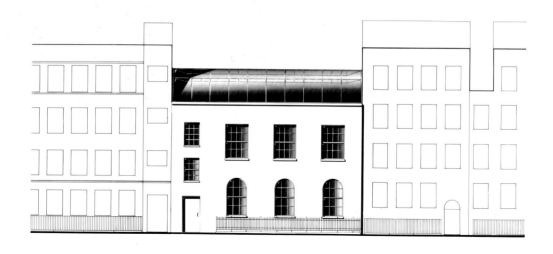

CONSIDERED A MARGINAL PROPO-SITION FROM THE OUTSET BECAUSE NO ALTERATION TO THE 18TH-CENTURY LONDON STREET FACADE WAS PERMITTED, THIS DESIGN EVENTUALLY BECAME THE FIRST EXERCISE IN CONTEXTUAL COMPROMISE THAT THE PRACTICE HAD EVER UNDERTAKEN.

1990

BY GUTTING THE ENTIRE BUILDING BEHIND THE FACADE, INSERTING NEW, SUSPENDED STEEL FLOORS LINKED BY METAL BRIDGES AND STAIRS, AND COVERING THE WHOLE WITH AN UNDULATING FULLY GLAZED ROOF, THE ARCHITECTS' DESIGN CREATES A NEW INTERNAL ENVIRONMENT UTTERLY AT VARIANCE WITH THE STREET ELEVATION WHICH, IN TURN, BECOMES A KIND OF CAMOUFLAGE FOR THE STATE-OF-THE-ART NATURALLY-LIT OFFICES WITHIN. THIS PROJECT RECEIVED PLANNING PERMISSION IN 1989 BUT WAS DISCONTINUED FOR ECONOMIC REASONS.

OLD AND NEW

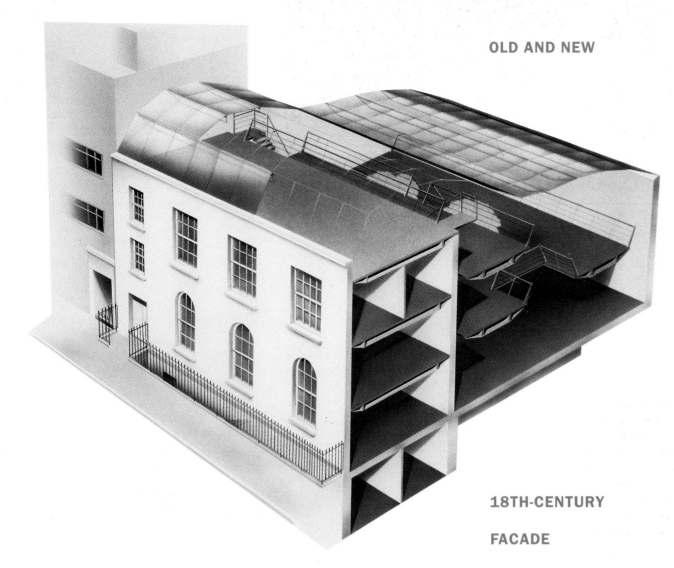

18TH-CENTURY

FACADE

GOSFIELD STREET

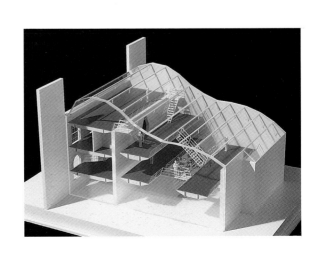

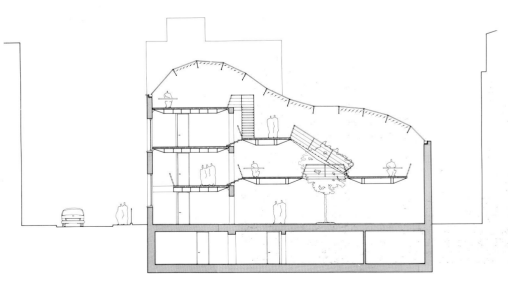

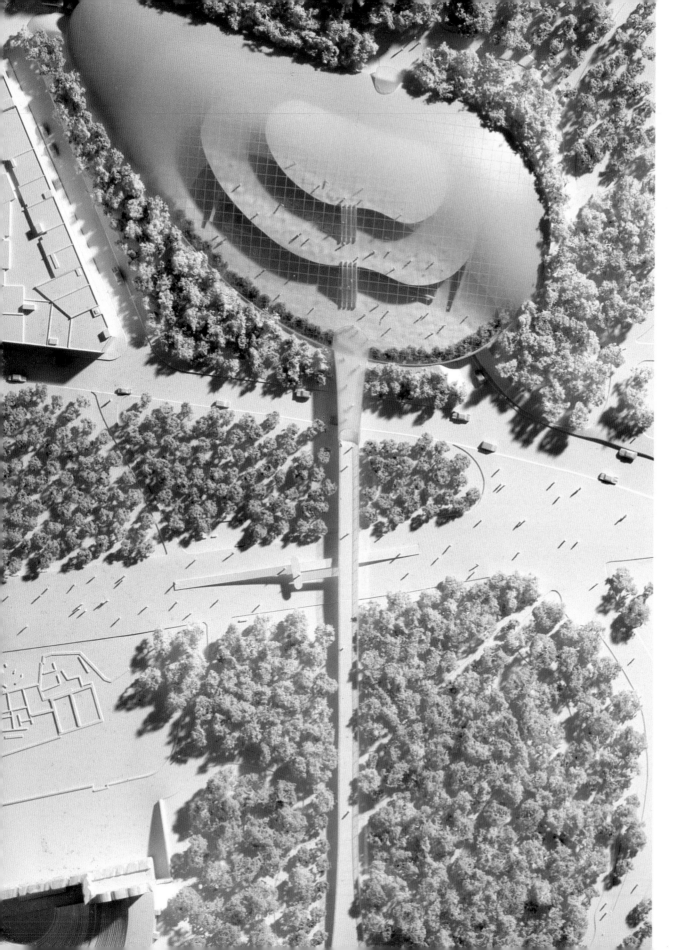

PROJECT 172

THIS FUTURE SYSTEMS ENTRY FOR THE GREEK MINISTRY OF CULTURE COMPETITION FOR A NEW MUSEUM OF THE ACROPOLIS IS ONE OF 400 SCHEMES DISCARDED AT THE FIRST STAGE. DESPITE THIS INAUSPICIOUS RESULT, IT ATTRACTED CONSIDERABLE CRITICAL ATTENTION AND WAS WIDELY PUBLISHED. THE PROJECT IS UNIQUE IN ITS USE OF TOPOGRAPHY AND LANDSCAPE RATHER THAN ARCHITECTURE: THE MUSEUM IS SITED ON THE WOODED NORTH SLOPE OF THE PHILOPAPPOS HILL WITH A CLEAR VIEW OF THE ACROPOLIS ITSELF. THE MUSEUM IS A LARGE, LOW, TRANSPARENT, SINGLE-SPAN, GRID-SHELL STRUCTURE OF AMOEBOID SHAPE, SUPPORTED AT ITS PERIMETER BY A COMPRESSION RING BEAM. THE GRID SHELL IS A TWO-LAYERED GEODESIC STRUCTURE OF THIN, TUBULAR STEEL ELEMENTS GLAZED WITH INCREMENTAL DEGREES OF OPACITY DEPENDENT UPON ORIENTATION. A THIN, PEDESTRIAN, RIBBON SUSPENSION BRIDGE SPANS 180M OVER THE INTERVENING VALLEY.

NEW

MUSEUM

OF THE

ACROPOLIS

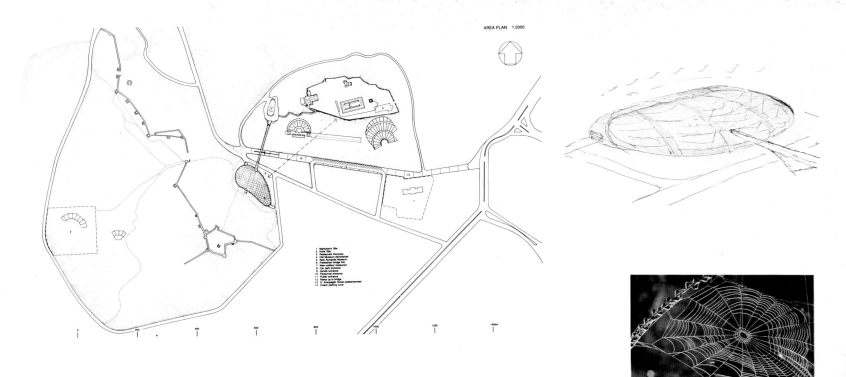

AREA PLAN 1:2000

1 Markyianni Site
2 Kolle Site
3 Restaurant Dionysos
4 Old Museum demolished
5 New Acropolis Museum
6 Pedestrian bridge link
7 New outdoor restaurant
8 Car park entrance
9 Goods entrance
10 Personnel entrance
11 Public entrance
12 Ramp up to bridge
13 Areopagitic Street pedestrianised
14 Coach parking zone

MUSEUM WITHOUT WALLS

1990

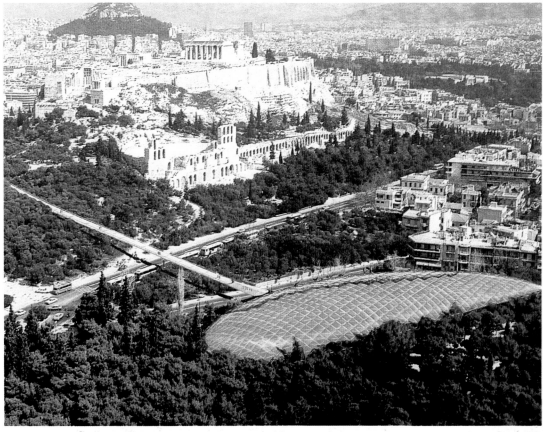

STRUCTURE: YRM ANTHONY HUNT ASSOCIATES

SERVICES: OVE ARUP & PARTNERS

107

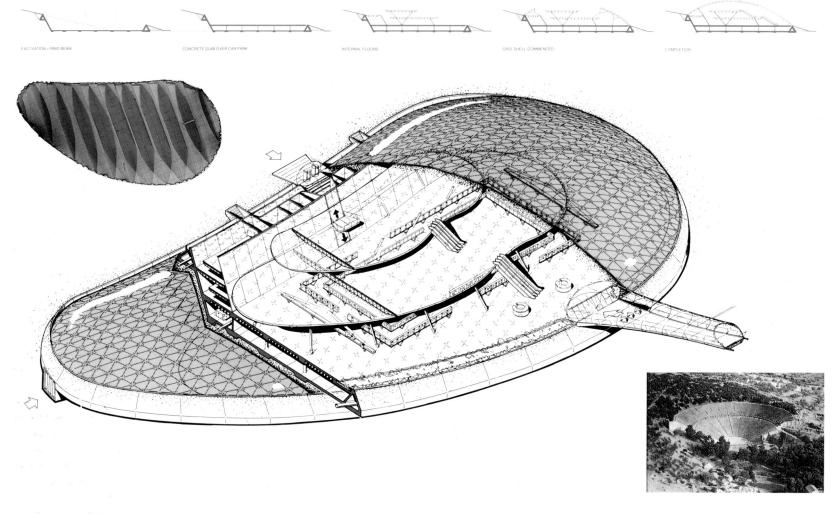

EXCAVATION + RING BEAM CONCRETE SLAB OVER CAR PARK INTERNAL FLOORS GRID SHELL COMMENCED COMPLETION

NO BUILDING BUILDING

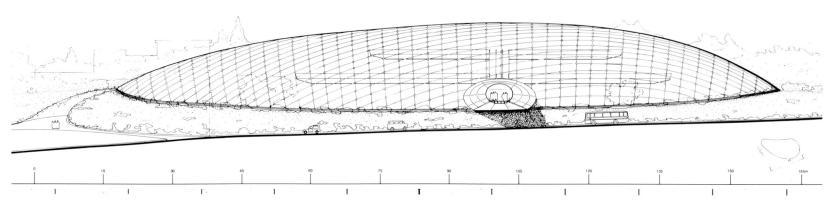

0 15 30 45 60 75 90 105 120 135 150 165m

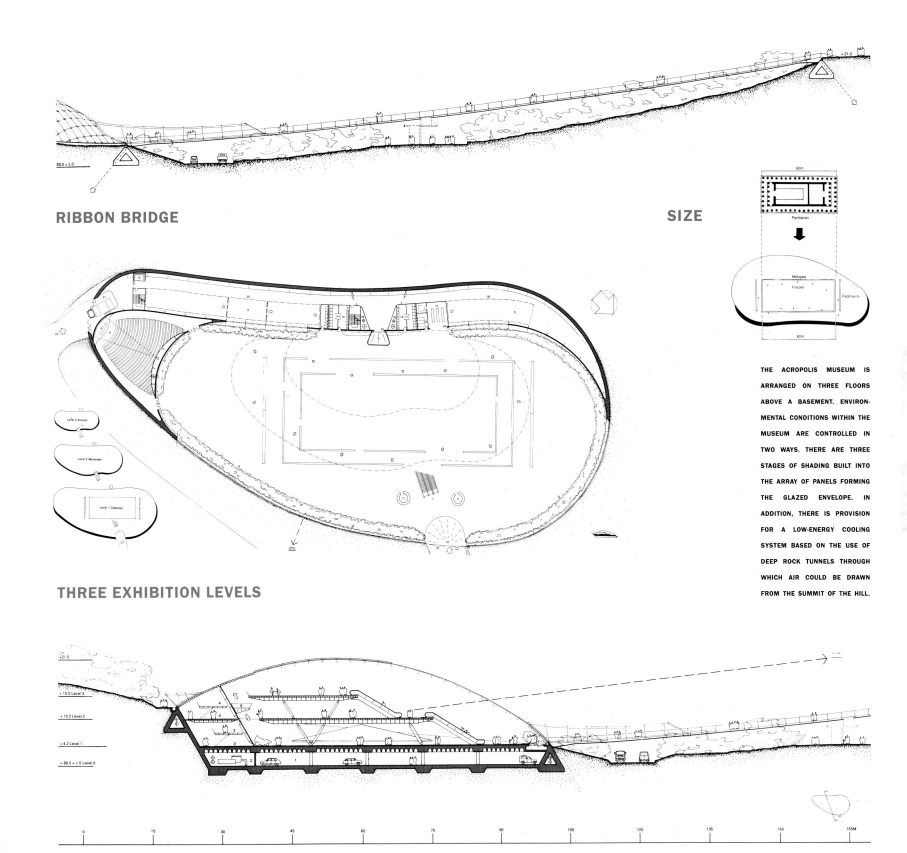

RIBBON BRIDGE

SIZE

THREE EXHIBITION LEVELS

THE ACROPOLIS MUSEUM IS ARRANGED ON THREE FLOORS ABOVE A BASEMENT. ENVIRONMENTAL CONDITIONS WITHIN THE MUSEUM ARE CONTROLLED IN TWO WAYS. THERE ARE THREE STAGES OF SHADING BUILT INTO THE ARRAY OF PANELS FORMING THE GLAZED ENVELOPE. IN ADDITION, THERE IS PROVISION FOR A LOW-ENERGY COOLING SYSTEM BASED ON THE USE OF DEEP ROCK TUNNELS THROUGH WHICH AIR COULD BE DRAWN FROM THE SUMMIT OF THE HILL.

THE ACROPOLIS MUSEUM IS DESIGNED TO BE LARGE ENOUGH TO ACCOMMODATE A FULL-SIZE REPRESENTATION OF THE PLAN OF THE PARTHENON AS WELL AS OFFICES, AN AUDITORIUM AND OTHER FACILITIES. LOCATED BY THIS CORRECTLY ORIENTATED REPRESENTATION OF THE PLAN OF THE PARTHENON, AND BY DIRECT VISUAL REFERENCE TO THE ORIGINAL ACROSS THE VALLEY, THE FRAGMENTARY EXHIBITS FROM THE ACROPOLIS HELD IN THE MUSEUM WILL BE READILY IDENTIFIABLE.

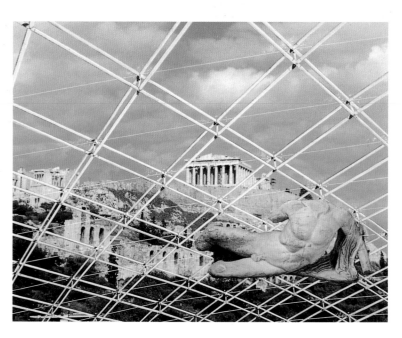

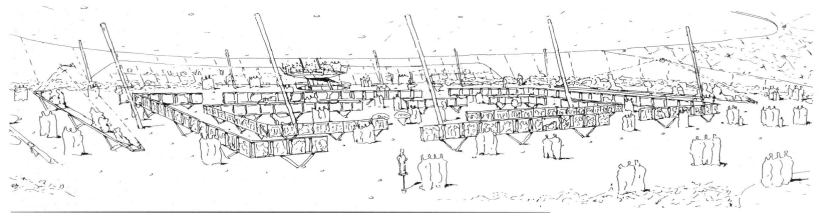

AN INNOCENT BUILDING

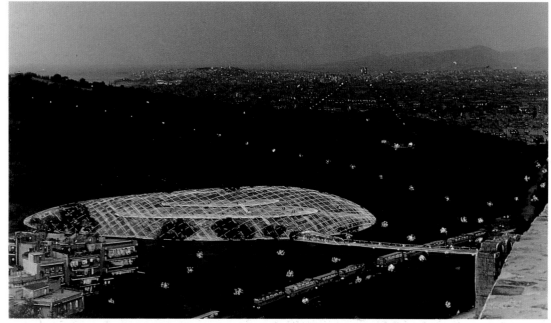

VISITORS TO THE MUSEUM, WHETHER THEY PASS ALONG THE RIBBON BRIDGE TO THE HISTORIC SITE ITSELF OR NOT, WOULD ENCOUNTER A POWERFUL, REMOTE INTERPRETATION OF THE HELLENIC TRADITION, AN INTERPRETATION MADE POSSIBLE ONLY BY THE UNOBTRUSIVE USE OF ADVANCED CONSTRUCTION AND IMAGING TECHNOLOGY.

DISPLAY

ATLANTA TOWER

PROJECT 176

1989

THIS SKETCH PROJECT DEVELOPED OUT OF INTEREST EXPRESSED BY AN AMERICAN CONSORTIUM IN AN ADAPTATION OF THE SPIRE (PROJECT 158) TO SERVE AS A LANDMARK FOR THE 1996 OLYMPICS IN ATLANTA. THE DESIGN USES THE SAME STRUCTURAL TECHNIQUE BUT WITH A DOUBLE INCLINATION THAT PRODUCES A 450M 'A' FOR ATLANTA. RENTABLE FLOORSPACE INCLUDES OFFICES AND A SHOPPING CENTRE AT THE BASE OF THE STRUCTURE, A RESTAURANT SET IN THE CROSSBAR OF THE 'A', AND A LEASABLE COMPLEX OF MICROWAVE COMMUNICATIONS ANTENNAE AT THE APEX.

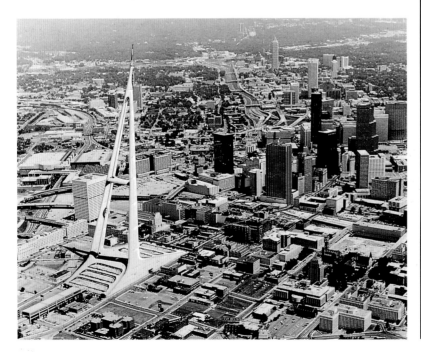

BASED ON A PARISIAN ORIGINAL, THIS PROJECT IS FOR THE LOW-COST CONVERSION OF THAMES RIVER BARGES INTO SLEEPING ACCOMMODATION FOR HOMELESS PEOPLE AT PERMANENT CITY-CENTRE MOORINGS. PROVISION IS MADE FOR UP TO 200 SINGLE-PERSON, FOAM MATTRESS AND SLEEPING BAG EQUIPPED, TRANSVERSELY MOUNTED CUBICLES, WITH AN OUTBOARD WINDOW AND INBOARD ACCESS HATCH. PROVISION IS ALSO MADE FOR HEATING, WASHING AND LAUNDRY FACILITIES. THE STRUCTURE ENVISAGED IS PLYWOOD, EXTERNALLY INSULATED AND WATERPROOFED WITH A SINGLE PLASTIC MEMBRANE.

BOATEL

150

BEDS

1990

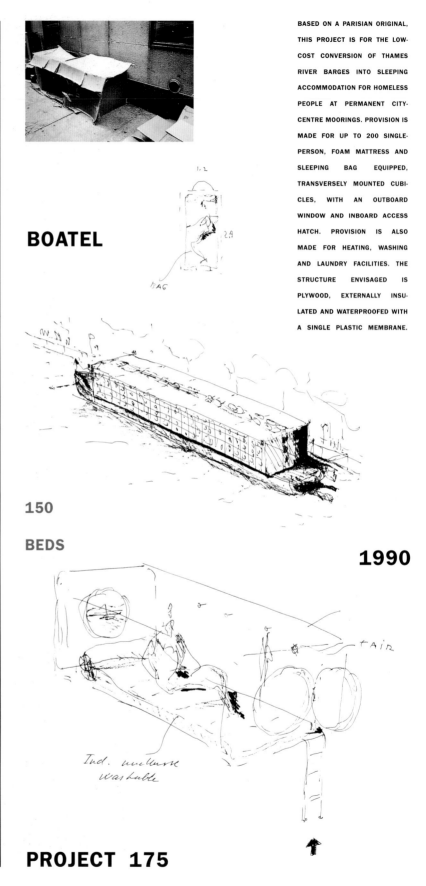

PROJECT 175

DESIGNED AND BUILT FOR THE IVY
RESTAURANT IN COVENT GARDEN,
LONDON, THE TROLLEY IS SHAPED
FOR MANOEUVRABILITY SO
THAT IT WILL SLIP EASILY
BETWEEN RESTAURANT TABLES.
THE TRADITIONAL LOWER SHELF IS
ELIMINATED BECAUSE PROVISION
HAS BEEN MADE FOR CUTLERY
TO BE SUSPENDED BETWEEN
THE LEGS. THE TWO COMPONENTS
OF THE DESIGN, LEG FRAME AND
SERVING PLATE, ARE CUT FROM
A SINGLE 6MM ALUMINIUM
SHEET, ANODISED AND BOLTED
TOGETHER. CHROMED PLASTIC
RIBS ARE INSERTED INTO THE
UPPER WORKING SURFACE TO
PREVENT PLATES FROM RATTLING
AS THE TROLLEY IS MOVED.

1990

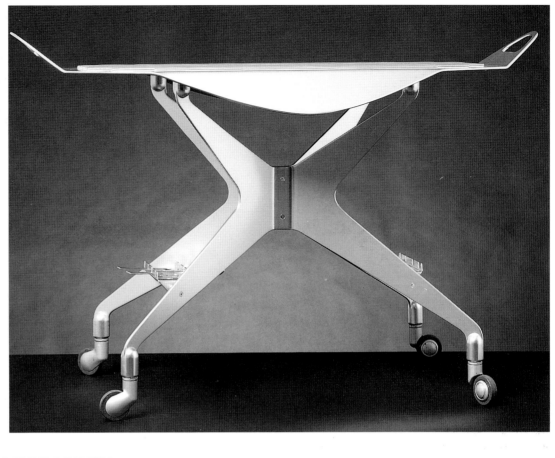

MANOEUVRABILITY

IVY TROLLEY

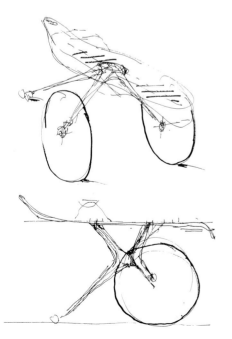

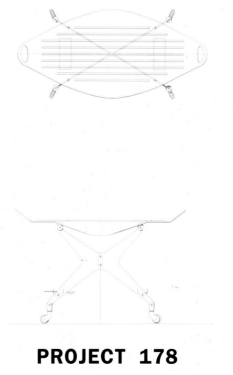

PROJECT 178

GREEN BUILDING

1990

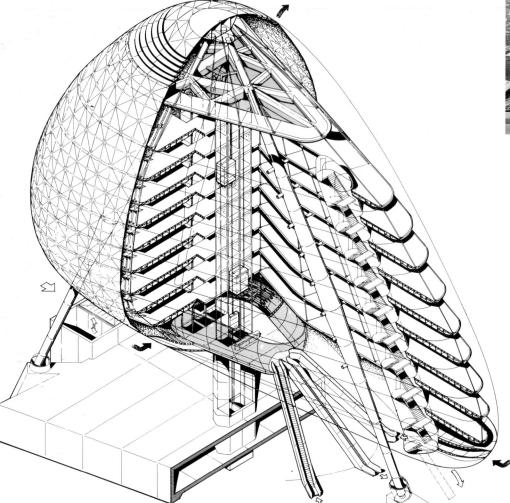

THE DESIGNERS OF MODERN OFFICE BUILDINGS HAVE SEIZED ON OUR MOST SLOVENLY INSTINCTS AND DISTILLED THEM INTO A STANDARD BUILDING SPEC-IFICATION: ACRES OF DEEP-PLAN OFFICE FLOORSPACE WITH YEAR-ROUND AIR CONDITIONING AND MINIMAL ACCESS TO NATURAL LIGHT. WITHIN THIS FRAMEWORK THE WORKING ENVIRONMENT IS SO CLOSELY CONTROLLED THAT ALL EXTERNAL, MODULATING INFLUENCES ARE NEUTRALISED. COMPLEX SYSTEMS ARE REQUIRED TO EXERCISE THIS DEGREE OF ENVIRONMENTAL CONTROL, SYSTEMS THAT CONSUME LARGE AMOUNTS OF ENERGY. THE GREEN BUILDING IS AN EXPERIMENT IN REVERSING THIS TENDENCY: AN ATTEMPT TO ATTAIN 'GREEN GOALS' WITHOUT PRIMITIVE ARCHITECTURE.

GREEN

CONCEPTS

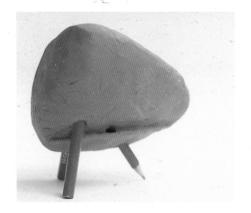

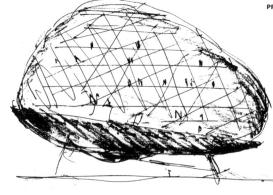

PROJECT 166

STRUCTURE: OVE ARUP & PARTNERS

SERVICES: OVE ARUP & PARTNERS

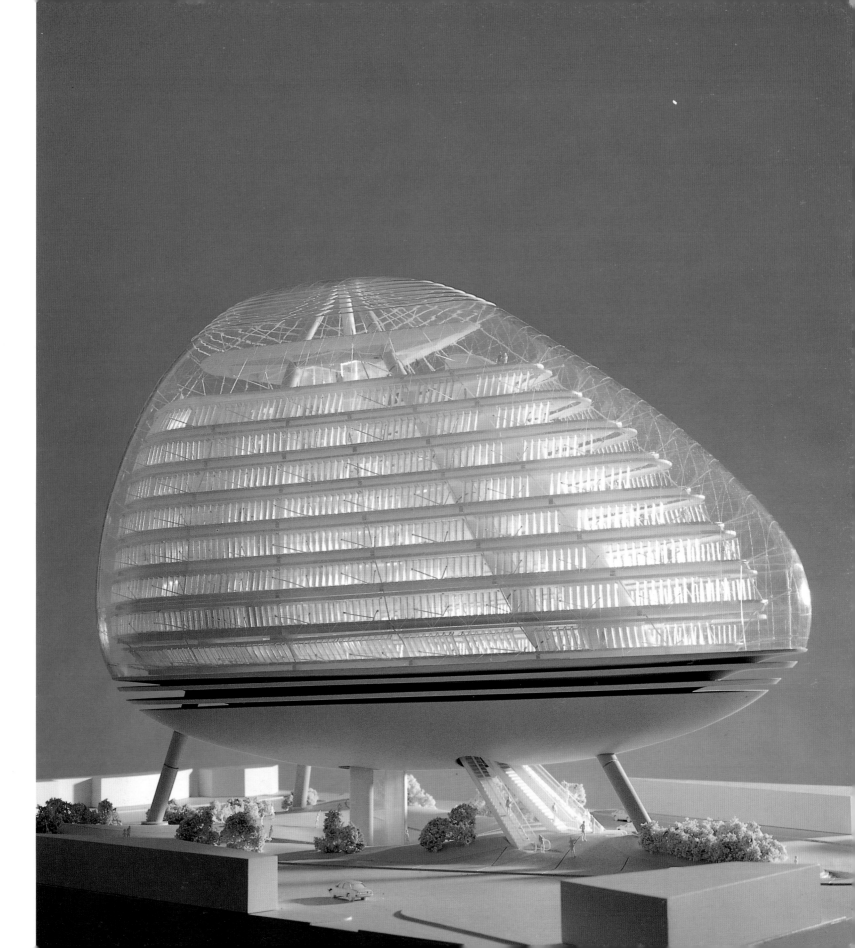

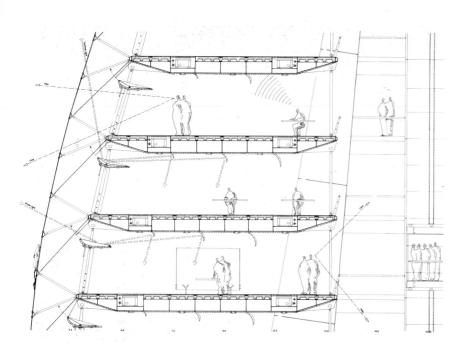

SECOND

SKIN

THE GREEN BUILDING IS AN ASYM-
METRICAL, ENVELOPE SUPPORTED
BY A TRIPOD MEGASTRUCTURE,
WHICH CLEARS THE SITE FOR
USE AS PUBLIC OPEN SPACE. THE
WEIGHT OF THE FLOORS, AS
WELL AS ITS ENCLOSING ENVE-
LOPE, IS SUPPORTED BY THE APEX
OF THE TRIPOD THROUGH A
NUMBER OF SUSPENSION TIES
CONNECTED TO THE INTERNAL
AND EXTERNAL EDGES OF THE
FLOOR PLATES. WIND LOADS
ARE RESISTED DIRECTLY BY
THE BENDING STRENGTH OF
THE TRIPOD LEGS WHICH ARE
TRIANGULATED BELOW GROUND
LEVEL AND ANCHORED TO
LARGE-DIAMETER PILES.

BUILDING SEQUENCE

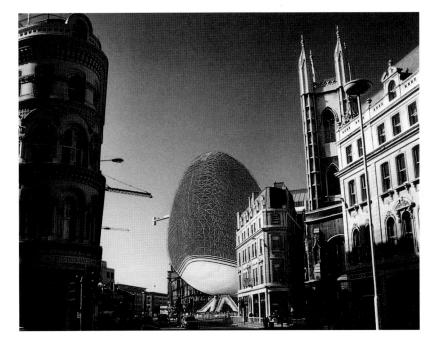

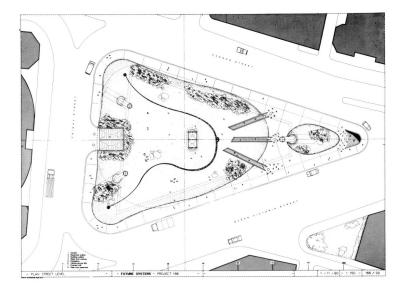

THE SUSPENDED FLOOR DECKS ENCIRCLING THE ATRIUM WITHIN THE ENVELOPE ARE HOLLOW STEEL BOXES WITH INTERNAL STIFFENING WEBS ASSEMBLED IN THE MANNER OF THE PREFABRICATED SECTIONS OF A MODERN BOX GIRDER BRIDGE. THEIR EDGES ARE ANCHORED TO THE BUILDING ENVELOPE BY A SYSTEM OF STRUTS AND TIES PASSING THROUGH THE WIDE VENTILATION SPACE THAT ENCLOSES THE HABITABLE PART OF THE BUILDING. ADDITIONALLY, A NETWORK OF TIES BRACES THE OUTER ENVELOPE WITHIN ITS OWN FACETED CONFIGURATION.

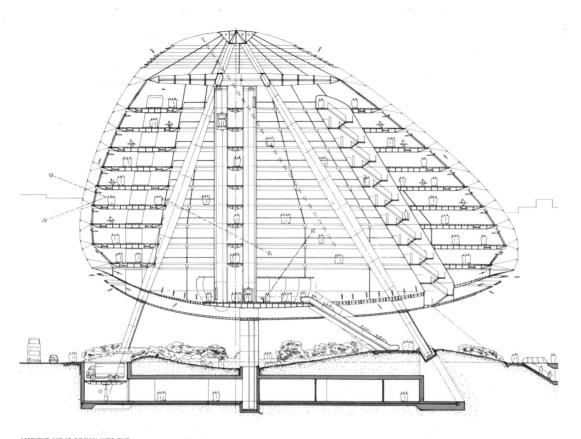

AMBIENT AIR IS DRAWN INTO THE
BUILDING AT THE BASE OF THE
ENVELOPE WHICH IS RAISED 17M
ABOVE GROUND LEVEL TO REDUCE
THE INGESTION OF POLLUTANTS.
AS IT WARMS, THIS AIR RISES
THROUGH THE LARGE-VOLUME
DUCT SPACE BETWEEN THE CON-
TROLLABLE INNER SKIN AND
SEALED OUTER SKIN OF THE
BUILDING BY STACK EFFECT,
FINALLY EXHAUSTING THROUGH
LOUVRES AT ITS APEX. BY
MANIPULATION OF THE VENTS
AND BAFFLES OF THE INNER
SKIN, VARIED CONDITIONS OF
COMFORTABLE AIR MOVEMENT
CAN BE MAINTAINED.

INTERNAL

ORGANISATION

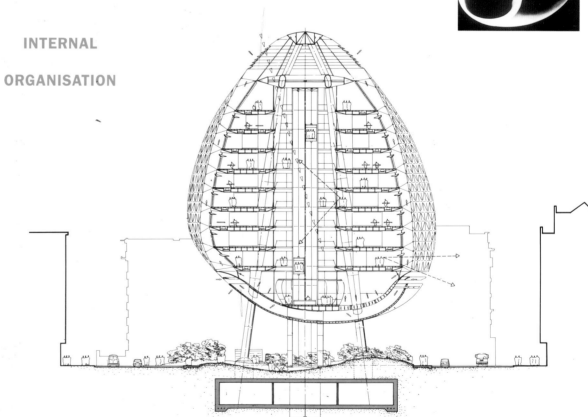

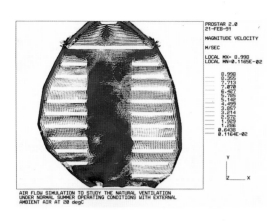

PROSTAR 2.0
21-FEB-91

MAGNITUDE VELOCITY
M/SEC

LOCAL MX= 8.998
LOCAL MN=0.1165E-02

8.998
8.355
7.713
7.070
6.427
5.785
5.142
4.499
3.857
3.214
2.572
1.929
1.286
0.6438
0.1164E-02

AIR FLOW SIMULATION TO STUDY THE NATURAL VENTILATION
UNDER NORMAL SUMMER OPERATING CONDITIONS WITH EXTERNAL
AMBIENT AIR AT 20 degC

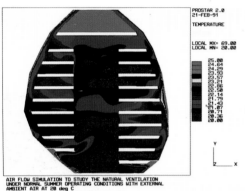

PROSTAR 2.0
21-FEB-91

TEMPERATURE

LOCAL MX= 69.00
LOCAL MN= 20.00

25.00
24.64
24.29
23.93
23.57
23.21
22.86
22.50
22.14
21.79
21.43
21.07
20.71
20.36
20.00

AIR FLOW SIMULATION TO STUDY THE NATURAL VENTILATION
UNDER NORMAL SUMMER OPERATING CONDITIONS WITH EXTERNAL
AMBIENT AIR AT 20 deg C

IN WINTER, HEAT EXCHANGERS ENABLE THE HIGHER TEMPERATURE OF THE EXHAUSTED AIR AT THE TOP OF THE BUILDING TO BE USED TO PRE-HEAT THE COLDER, INCOMING AIR BELOW AND SO REDUCE HEAT LOSS. LOCAL HEATING AND COOLING WILL BE AVAILABLE FOR EXTREME TEMPERATURES USING A HEAT PUMP-DRIVEN, TEPID WATER LOOP. THIS LOOP CAN ALSO COMPENSATE FOR DIFFERENTIAL HEATING AND COOLING EITHER SIDE OF THE BUILDING.

PERFORMANCE DIAGRAMS

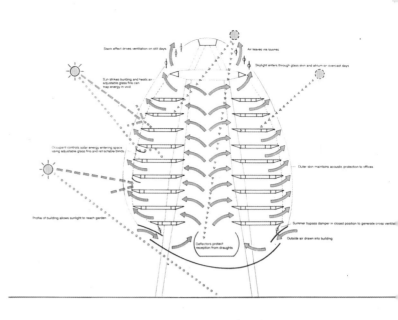

CLIMATE

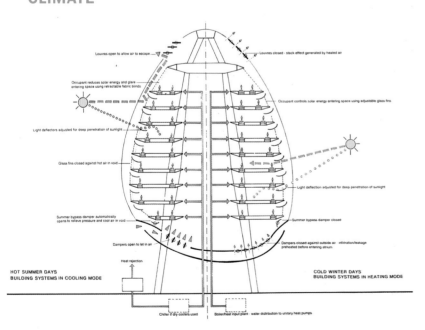

HOT SUMMER DAYS
BUILDING SYSTEMS IN COOLING MODE

COLD WINTER DAYS
BUILDING SYSTEMS IN HEATING MODE

IN ADDITION TO ITS AMBIENT ENERGY SYSTEMS, THE FULLY GLAZED BUILDING MAKES MAXIMUM USE OF DAYLIGHTING TO REDUCE ENERGY CONSUMPTION. SOLAR GLARE AND HEAT GAIN WITHIN THE OFFICES CAN BE CONTROLLED BY FABRIC BLINDS INCORPORATED INTO THE BUILDING'S INNER SKIN. THIS SKIN ALSO CONTAINS FLEXIBLE PLASTIC MIRRORS DESIGNED TO REFLECT DAYLIGHT INTO THE INNERMOST OFFICE SPACES ALONG A HIGH-LEVEL HORIZONTAL PATH THAT IS INTERCEPTED BY CEILING-MOUNTED DIFFUSERS WHERE NECESSARY.

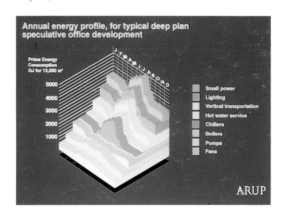

Annual energy profile, for typical deep plan speculative office development

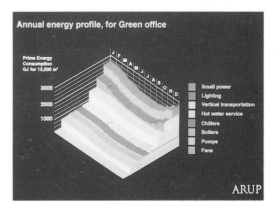

Annual energy profile, for Green office

PROJECT 182

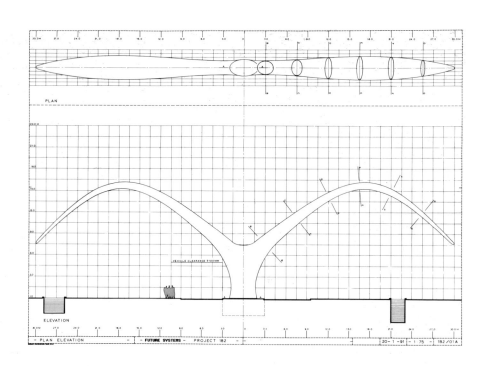

BIRD

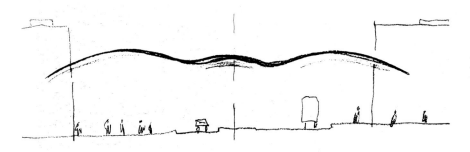

CHISWICK

PARK

ENTRANCE

DESIGNED AS THE ENTRANCE SYMBOL FOR A NEW WEST-LONDON BUSINESS PARK, THIS IS A DOUBLE 24M-CANTILEVER, ALUMINIUM, SEMI-MONOCOQUE STRUCTURE. IT IS BUILT UP FROM THREE SEPARATE ASSEMBLIES OF STRINGERS AND BULKHEADS ENCLOSED BY A SMOOTH-WELDED SKIN – A TECHNIQUE DERIVED FROM THE HULL CONSTRUCTION METHODS USED FOR SOME RACING YACHTS.

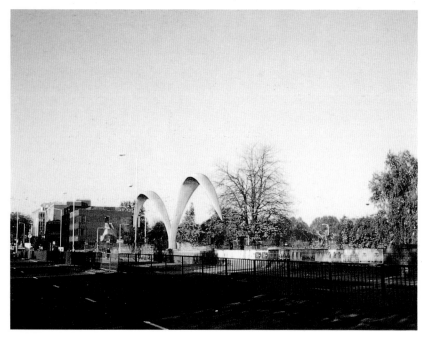

1990

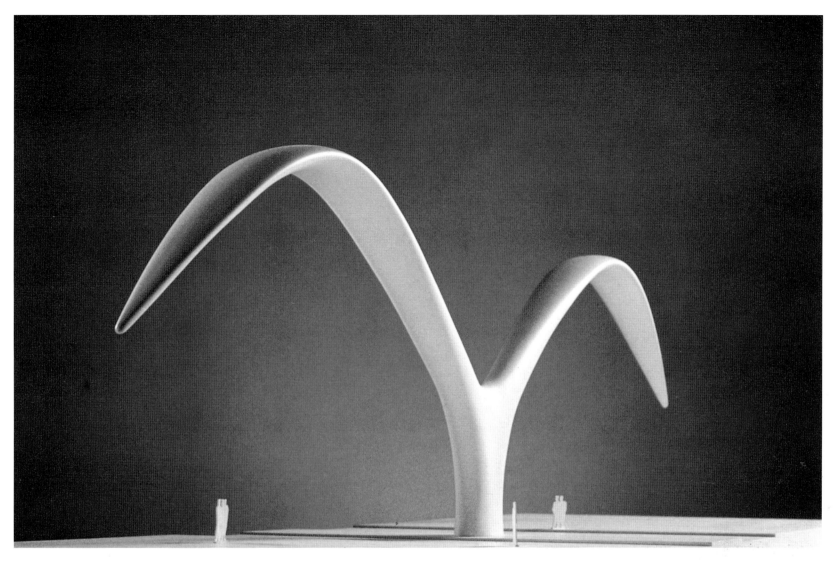

THE THREE SEPARATE 'HULL'
ASSEMBLIES WOULD BE TRANS-
PORTED TO THE SITE BEFORE
BEING WELDED TOGETHER.
THE FINAL HIGHLY POLISHED
ALUMINIUM FINISH WOULD
REQUIRE NO MAINTENANCE.

WING

SPAN

48M

STRUCTURE: OVE ARUP & PARTNERS

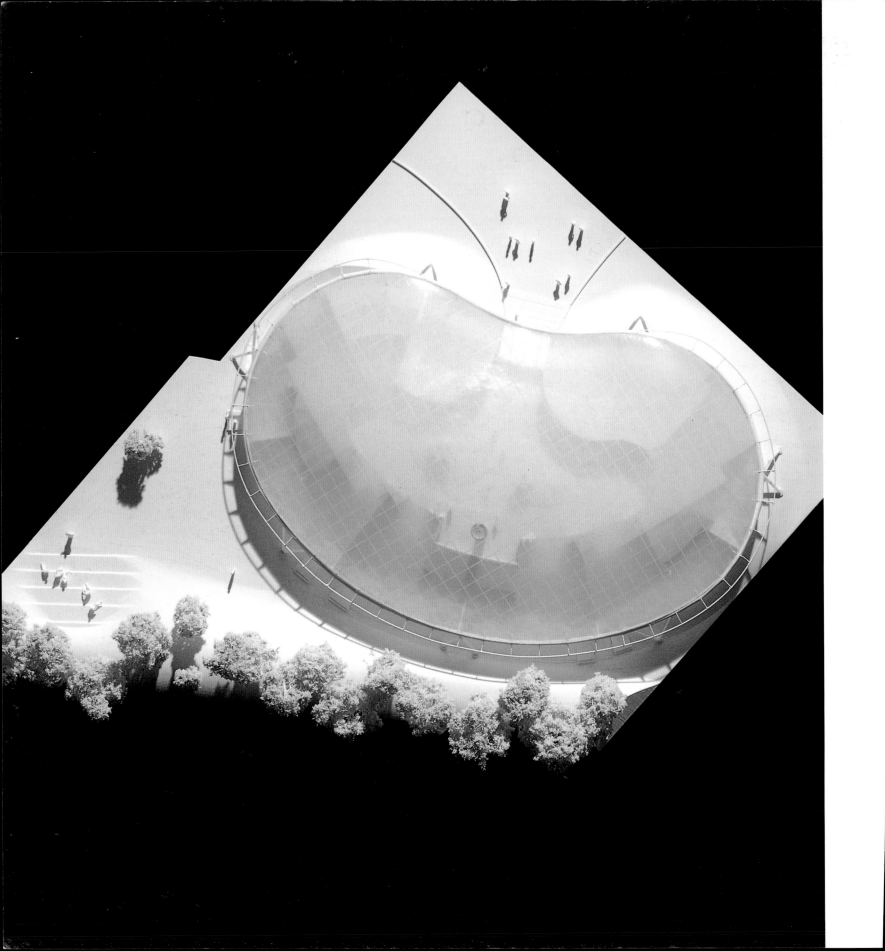

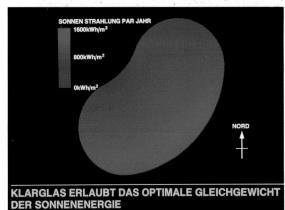

SONNEN STRAHLUNG PAR JAHR
1600kWh/m²

800kWh/m²

0kWh/m²

NORD

KLARGLAS ERLAUBT DAS OPTIMALE GLEICHGEWICHT DER SONNENENERGIE

FRANKFURT
KINDERGARTEN
PROJECT
190

THIS LIMITED COMPETITION ENTRY FOR THE DESIGN OF AN ENERGY-EFFICIENT KINDERGARTEN FOR 100 CHILDREN AGED 3–12 TAKES THE FORM OF A FREE-FORMED BUILDING THAT EMERGES ORGANI-CALLY FROM THE LANDSCAPE, ITS PROFILE REDUCED BY THE USE OF EXCAVATED SOIL TO PROVIDE SHEL-TERING GRASS BANKS. IN ORDER TO MAINTAIN COMFORT CONDI-TIONS WITHOUT HIGH ENERGY COST, A BALANCE HAS BEEN ACHIEVED BETWEEN HEAT GAIN AND HEAT LOSS BY CAREFUL JUX-TAPOSITIONING OF CLEAR AND OPAQUE DOUBLE GLAZING TO COR-RESPOND TO ORIENTATION. THE CLASSROOMS ARE CONCEIVED AS BUILDINGS WITHIN BUILDINGS, WITH A BUFFER ZONE BETWEEN EACH AND THE GLAZED ROOF.

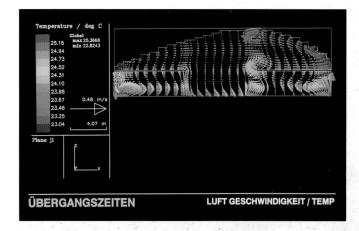

1991

STRUCTURE: OVE ARUP & PARTNERS

SERVICES: OVE ARUP & PARTNERS

LOW-

ENERGY

CONCEPT

Temperature / deg C
Global
max 29.8820
min 24.8015
27.73
27.47
27.20
26.93
26.67
26.40
26.13
25.87 1.04 m/s
25.60
25.33 4.07 m
25.07

Plane j1

HEISSER SOMMER TAG **LUFT GESCHWINDIGKEIT / TEMP**

Temperature / deg C
Global
max 25.3668
min 22.8243
25.15
24.94
24.73
24.52
24.31
24.10
23.88
23.67 0.48 m/s
23.46
23.25 4.07 m
23.04

Plane j1

ÜBERGANGSZEITEN **LUFT GESCHWINDIGKEIT / TEMP**

100 CHILDREN

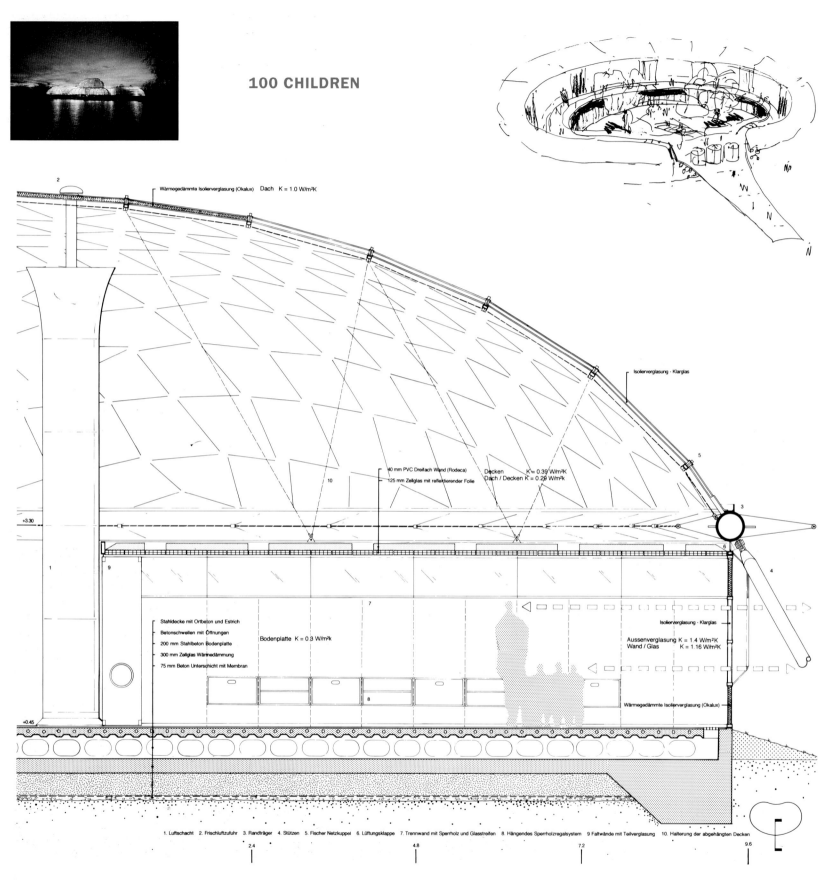

Wärmegedämmte Isolierverglasung (Okalux) Dach K = 1.0 W/m²K

Isolierverglasung - Klarglas

40 mm PVC Dreifach Wand (Rodeca)
125 mm Zellglas mit reflektierender Folie

Decken K = 0.39 W/m²K
Dach / Decken K = 0.29 W/m²k

+3.30

Stahldecke mit Ortbeton und Estrich
Betonschwellen mit Öffnungen
200 mm Stahlbeton Bodenplatte
300 mm Zellglas Wärmedämmung
75 mm Beton Unterschicht mit Membran

Bodenplatte K = 0.3 W/m²k

Isolierverglasung - Klarglas

Aussenverglasung K = 1.4 W/m²K
Wand / Glas K = 1.16 W/m²K

Wärmegedämmte Isolierverglasung (Okalux)

+0.45

1. Luftschacht 2. Frischluftzufuhr 3. Randträger 4. Stützen 5. Fischer Netzkuppel 6. Lüftungsklappe 7. Trennwand mit Sperrholz und Glasstreifen 8. Hängendes Sperrholzregalsystem 9 Faltwände mit Teilverglasung 10. Halterung der abgehängten Decken

2.4 4.8 7.2 9.6

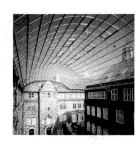

ON WARM DAYS THE CLASSROOMS CAN BE OPENED TO THE 'SUN SPACE' AT THE CENTRE OF THE BUILDING AS WELL AS TO THE OUTSIDE. IN WINTER, RETRACTABLE FABRIC SCREENS PREVENT DOWN-DRAUGHTS, WHILE A THERMAL RECYCLER DRAWS DOWN WARM AIR FROM THE TOP OF THE SUN SPACE AND DISTRIBUTES IT TO THE CLASSROOMS THROUGH A SUB-FLOOR PLENUM.

TRANSPARENCY

OPEN CLASSROOMS

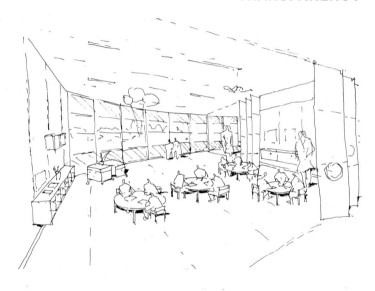

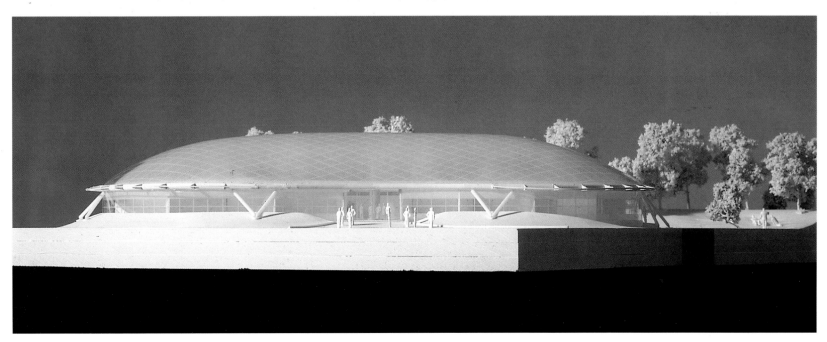

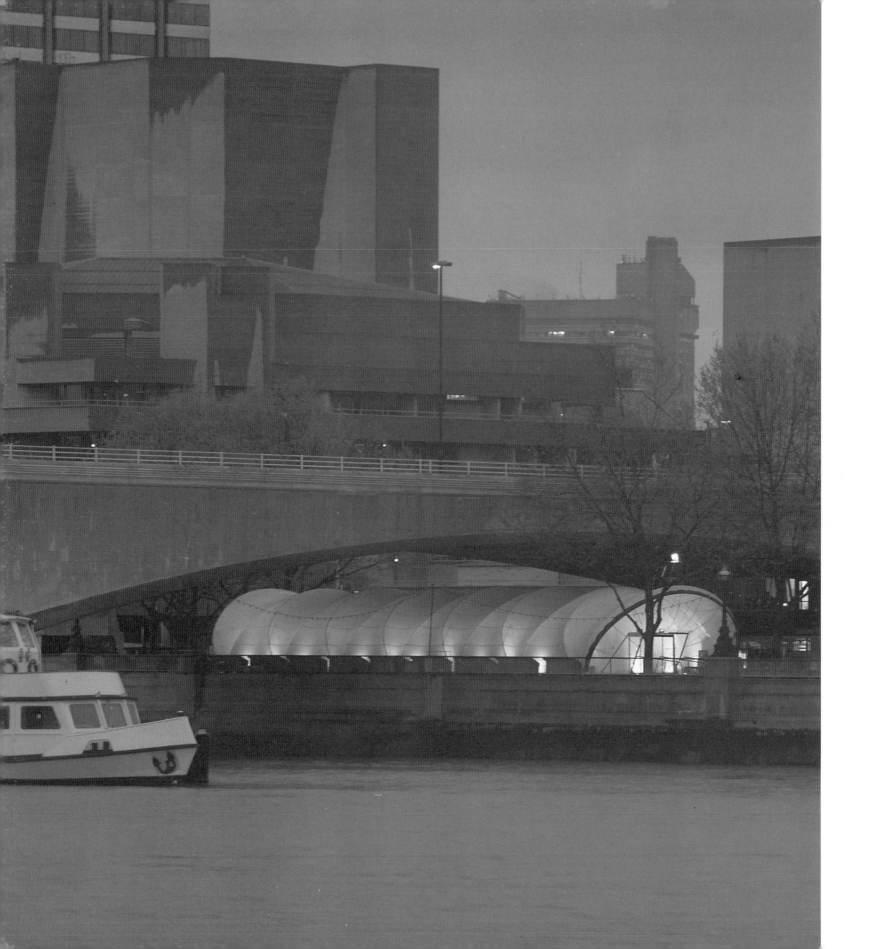

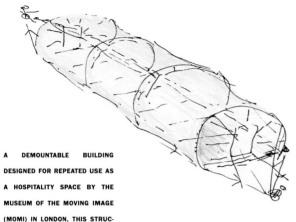

A DEMOUNTABLE BUILDING DESIGNED FOR REPEATED USE AS A HOSPITALITY SPACE BY THE MUSEUM OF THE MOVING IMAGE (MOMI) IN LONDON, THIS STRUCTURE CAN BE ERECTED AND DISMANTLED IN TWO DAYS BY SIX PEOPLE. GENERALLY SITED IN FRONT OF THE NATIONAL FILM THEATRE, OVERLOOKING THE RIVER THAMES, ITS TRANSLUCENT FABRIC SKIN IS PARTICULARLY EFFECTIVE AT NIGHT WHEN ILLUMINATED FROM WITHIN. THE TENT IS RAISED ABOVE GROUND LEVEL BY A SYSTEM OF ALUMINIUM FLOOR PANELS RESTING ON STEEL FLOOR BEAMS LEVELLED BY JACKS. THIS FLOOR ASSEMBLY CONCEALS ALL ELECTRICAL AND OTHER SERVICE FUNCTIONS.

PROJECT 189

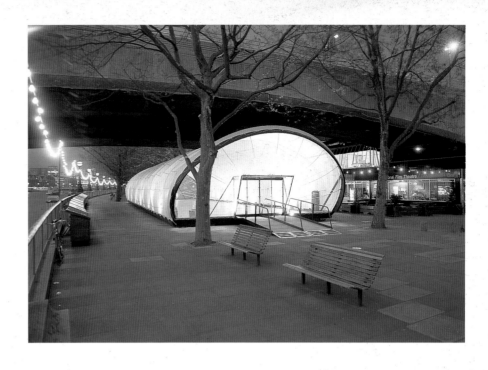

MOMI TENT

STRUCTURE: OVE ARUP & PARTNERS
SERVICES: OVE ARUP & PARTNERS

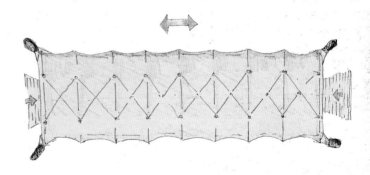

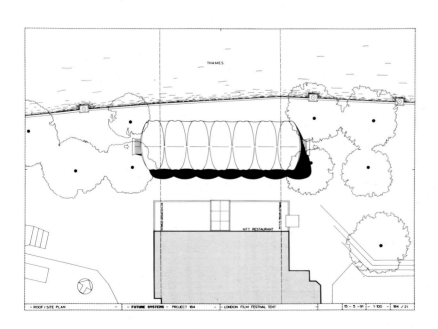

1991

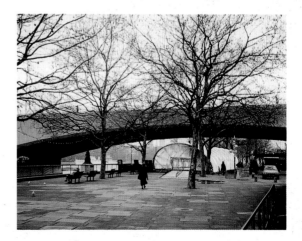

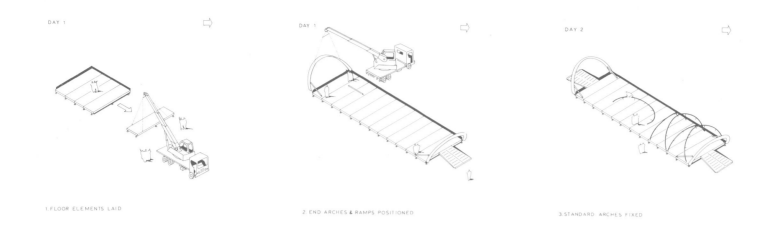

DAY 1 DAY 1 DAY 2

1.FLOOR ELEMENTS LAID 2. END ARCHES & RAMPS POSITIONED 3.STANDARD ARCHES FIXED

TWO DAYS
SIX PEOPLE

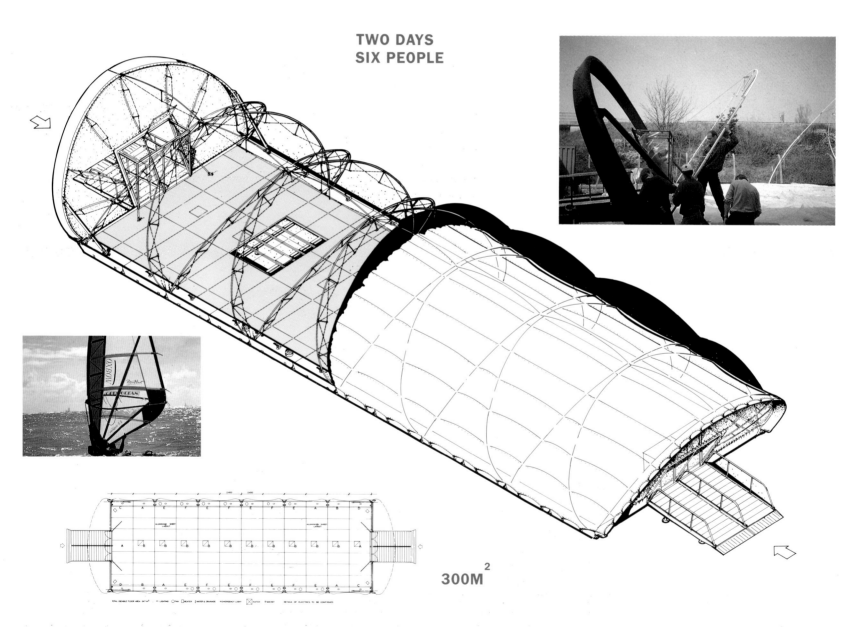

300M²

DAY 2

4 STRUCTURE COMPLETE

DAY 2.

5. FABRIC IN PLACE

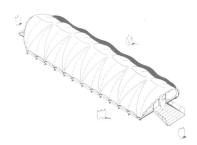

DAY 2.

6 FABRIC SECURED & END WALL COMPLETED

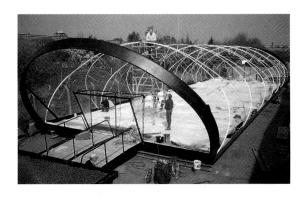

32MM GRP RIBS

THE TENT HAS NO STRUCTURAL MEMBER LARGER THAN 32MM IN DIAMETER. IT IS SEMI-ELLIPTICAL IN SECTION. ITS PTFE FABRIC MEMBRANE IS SUPPORTED ON PAIRS OF INCLINED GRP RIBS WITH A BRACED, INCLINED ARCH AT EACH END THAT STABILISES THE STRUCTURE THROUGH ATTACHMENT TO A STEEL, FLOOR-EDGE BEAM. WHEN IN USE, THE RIBS ARE BRACED INTO POSITION WITH STAINLESS STEEL STRUTS AND OVERLAPPING TENSION CABLES.

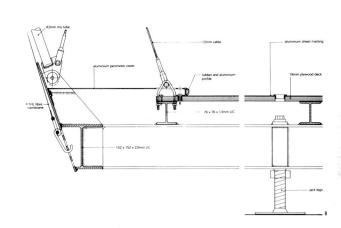

DETAIL

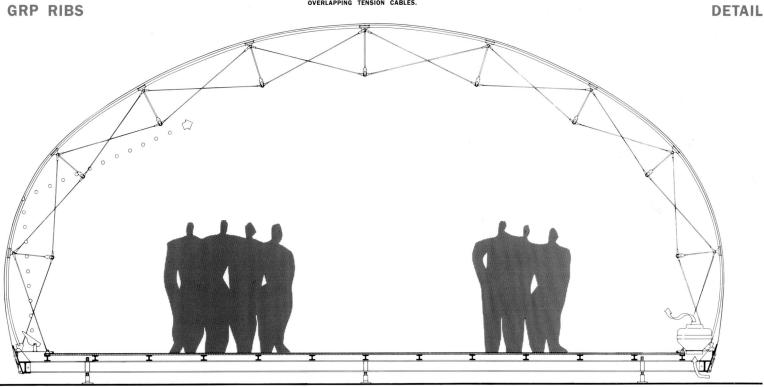

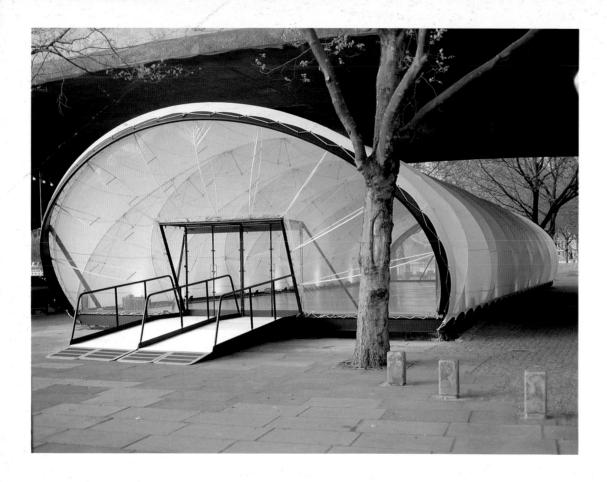

LIGHTING PLAYS AN IMPORTANT PART IN THE DESIGN OF THE MOMI TENT. UPLIGHTERS RECESSED INTO THE FLOOR CREATE THE GLOWING EFFECT OF LIGHT BEING EMITTED THROUGH THE TENARA FABRIC AS THOUGH IT WERE A LAMPSHADE. IN THE SAME WAY, BECAUSE THE STRUCTURE IS LONG AND NARROW AND CAN BE CROWDED WITH PEOPLE, THE FRESH-AIR SUPPLY AND EXTRACT FANS OPERATE THROUGH THE FLOOR NEAR THE CENTRE OF THE TUNNEL. THERE ARE ADJUSTABLE VENTILATION FLAPS ABOVE THE DOORS AT EACH END.

TRANSPARENT FABRIC

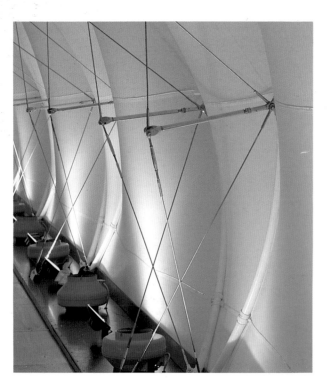

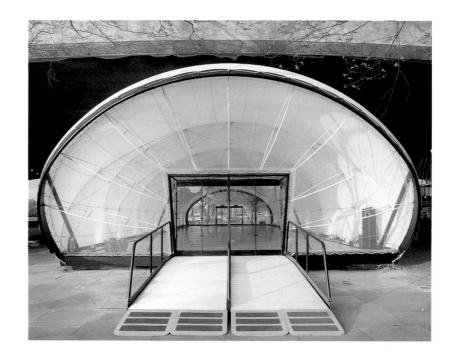

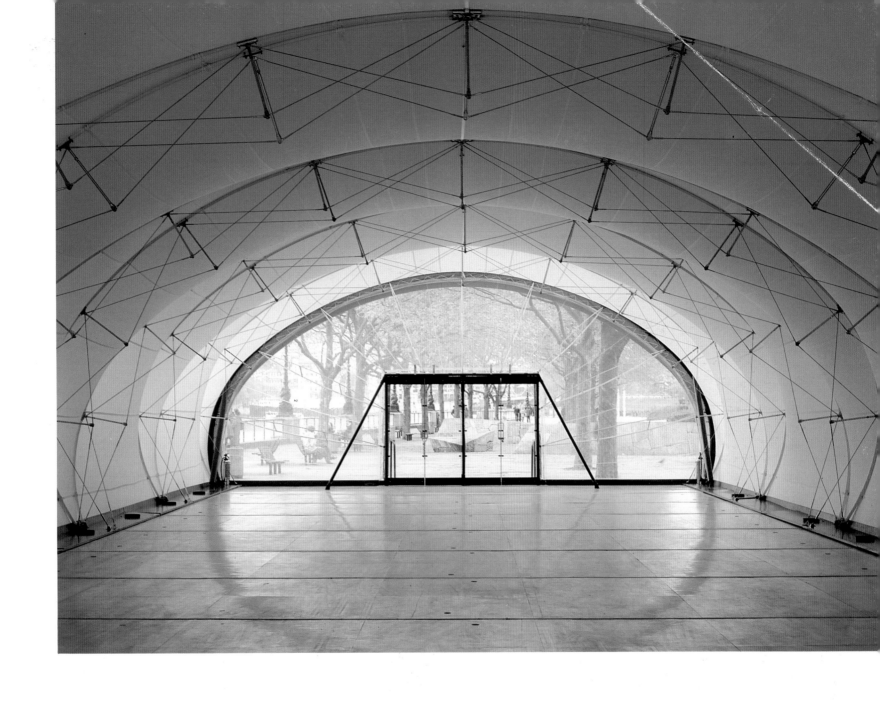

TRANSPORT

PROJECT

186

CARAVAN

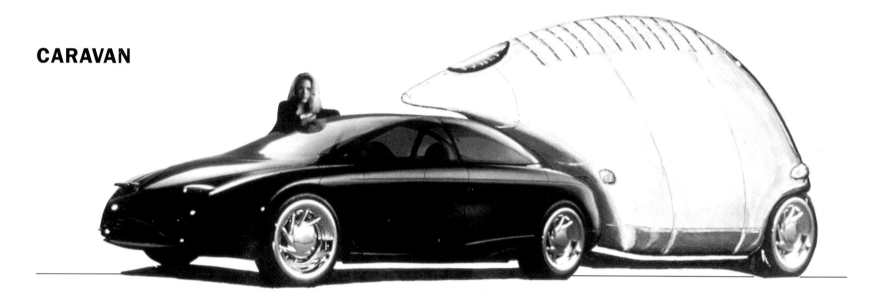

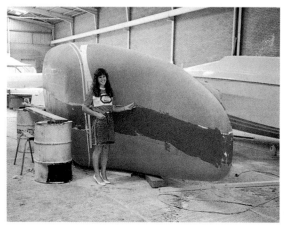

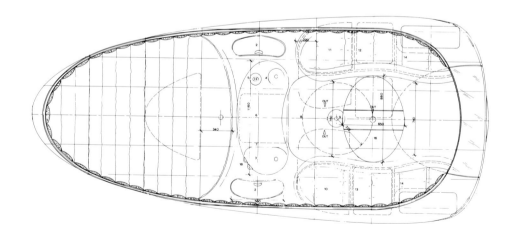

'AUSTRALIAN DREAM'

LIKE A SNAIL'S SHELL, THE
CARAVAN WRAPS OVER THE CAR,
LENGTHENING THE WHEELBASE
BUT REDUCING THE TOTAL LENGTH
OF THE COMBINATION TO ACHIEVE
A SMALL TURNING CIRCLE.
THE AERODYNAMIC EXTERIOR
ACHIEVES A LOW DRAG COEFFI-
CIENT. THE LOW AXLE WEIGHT
REDUCES TRACTIVE EFFORT. ALL
THESE FACTORS MAKE THE
CARAVAN MORE FUEL-EFFICIENT,
ADAPTABLE AND ADVANCED THAN
TRADITIONAL COUNTERPARTS.

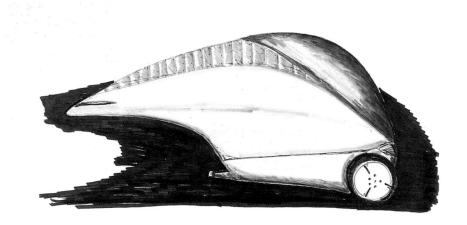

1991

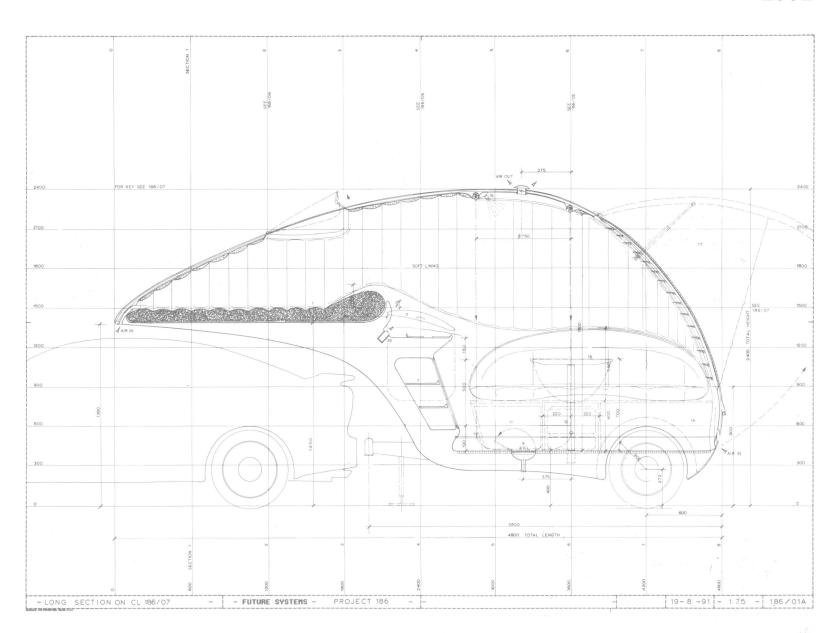

- LONG SECTION ON CL 186/07 - | - FUTURE SYSTEMS - PROJECT 186 - | - | | 19-8-91 | - 1:7.5 - | 186/01A

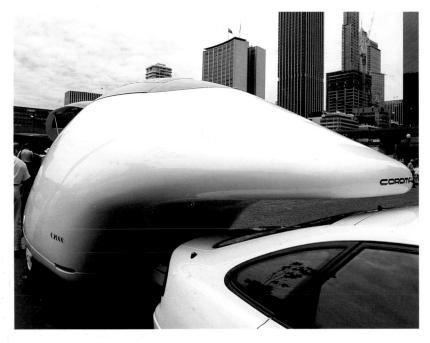

25MM SEMI-MONOCOQUE SHELL

THERE IS COMPLETE UNITY BETWEEN THE INTERIOR AND THE EXTERIOR OF THIS MOBILE STRUCTURE. THE SHELL OF THE CARAVAN IS A SEMI-MONOCOQUE, 25MM-THICK GRP SANDWICH, BUILT LIKE A BOAT HULL. ROOF-MOUNTED SOLAR PANELS GENERATE ELECTRICITY FOR ITS LIFE-SUPPORT SYSTEMS.

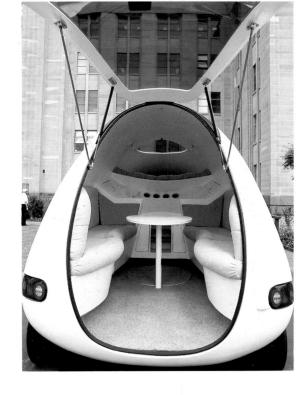

CAR

CARAVAN

UNITY

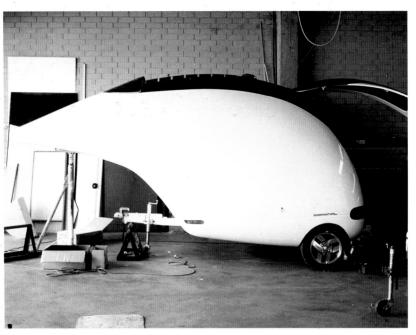

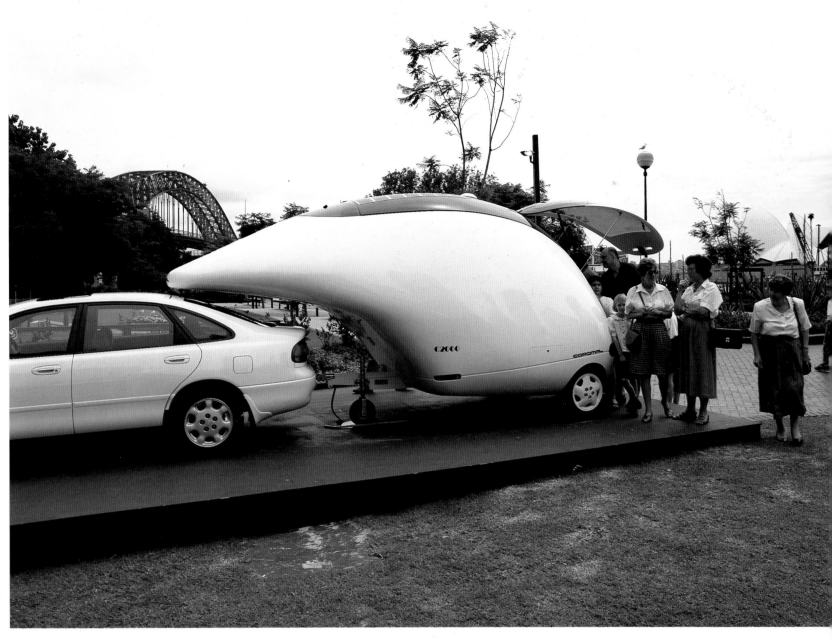

THIS CARAVAN DESIGN, ONE OF FIVE WINNERS IN A COMPETITION ORGANISED BY THE SYDNEY MUSEUM OF CONTEMPORARY ARTS, WAS PROTOTYPED AND DEMONSTRATED IN AUSTRALIA IN 1992. IN TERMS OF ITS INNOVATIVE FORM AND DESIGN, IT REPRESENTS A DEPARTURE IN TRAILER DESIGN THAT IS REMINISCENT OF THE ADVENT OF THE AIRSTREAM CARAVAN OF 60 YEARS AGO.

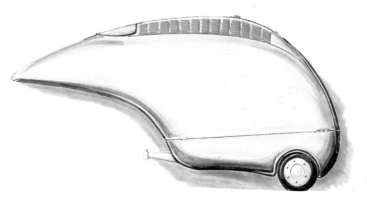

1990

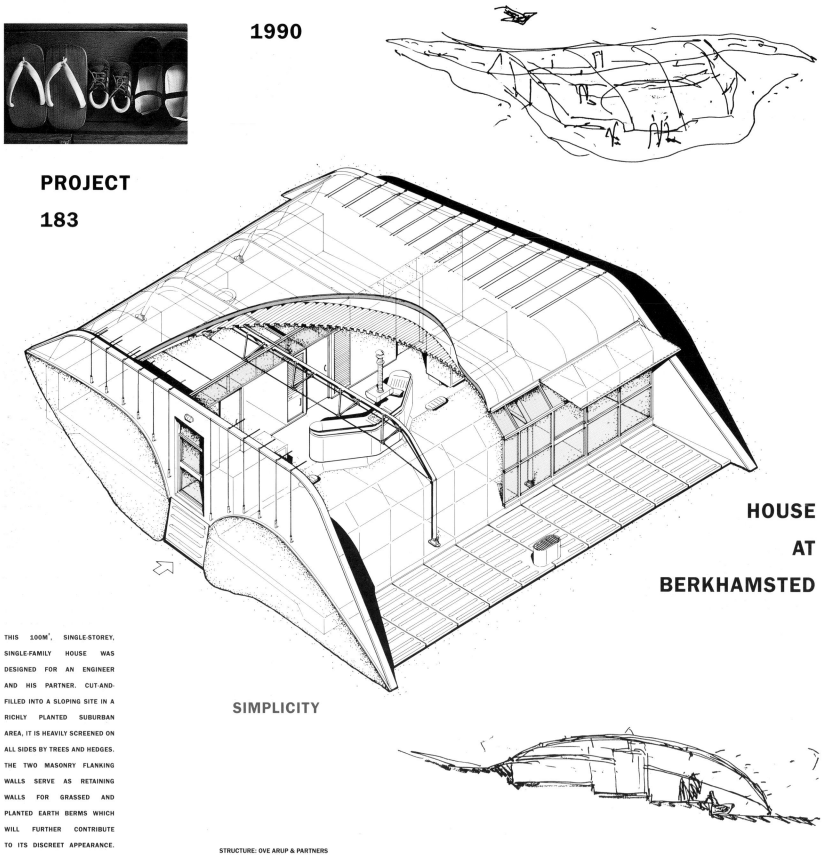

PROJECT

183

HOUSE

AT

BERKHAMSTED

THIS 100M², SINGLE-STOREY, SINGLE-FAMILY HOUSE WAS DESIGNED FOR AN ENGINEER AND HIS PARTNER. CUT-AND-FILLED INTO A SLOPING SITE IN A RICHLY PLANTED SUBURBAN AREA, IT IS HEAVILY SCREENED ON ALL SIDES BY TREES AND HEDGES. THE TWO MASONRY FLANKING WALLS SERVE AS RETAINING WALLS FOR GRASSED AND PLANTED EARTH BERMS WHICH WILL FURTHER CONTRIBUTE TO ITS DISCREET APPEARANCE.

SIMPLICITY

STRUCTURE: OVE ARUP & PARTNERS

SERVICES: OVE ARUP & PARTNERS

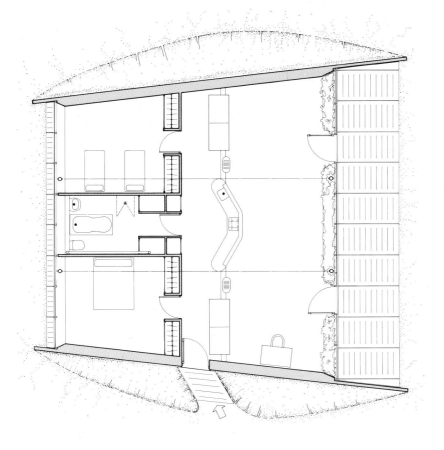

TEAM

ON TWO

LEVELS

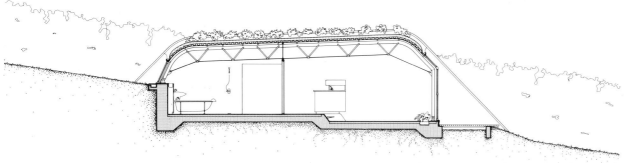

THE FAN-SHAPED DWELLING EXPANDS TOWARDS THE SOUTH-FACING LIVING AREA IN PLAN AND SECTION – WITH THE GREAT-EST HEADROOM AND WIDTH ADJA-CENT TO THE GLAZED FRONT AND TERRACE – AND CONTRACTS TOWARDS THE BEDROOMS AND BATHROOM AT THE REAR. THE FOOD PREPARATION AREA IS CEN-TRALLY LOCATED AT THE CHANGE IN FLOOR LEVEL. THE ENTIRE HOUSE IS CLEAR-SPANNED. THE PROFILED STEEL ROOF DECKING IS SUPPORTED BY THE CROSS-WALLS AND TWO EXPOSED CABLE-STIFFENED STEEL TRUSSES RUNNING FROM FRONT TO BACK.

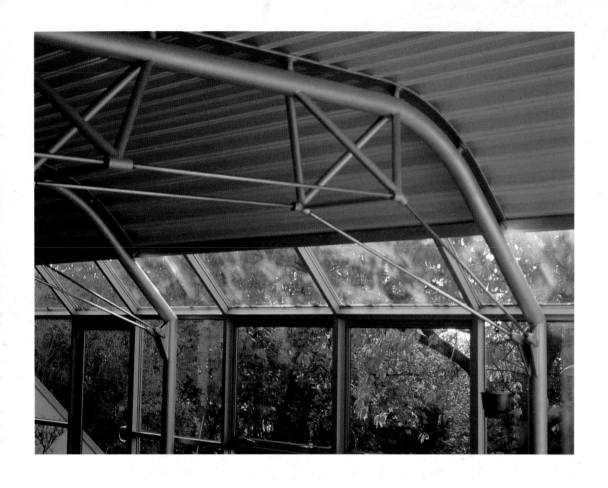

COMPLETED IN SEPTEMBER 1992, THE HOUSE IS OF SIMPLE CONSTRUCTION. ONLY THE MAIN ENTRANCE DOOR TO ONE SIDE BREAKS THE SYMMETRY OF THE DESIGN WHEN VIEWED FROM THE SOUTH. THE CONCEPTUAL EVOLUTION FROM THE MUCH EARLIER ILE DE CAVALLO DESIGN (PROJECT 020) IS STRIKING, BUT AS THESE EARLY PHOTOGRAPHS SHOW, THE MORE RELAXED DEFORMALISATION OF PLAN AND SECTION, AND THE ENTIRELY NEW RELATIONSHIP BETWEEN HOUSE AND LAND SCAPE, HAVE TRANSFORMED THE EARLIER IMAGE.

SLICED INTO LANDSCAPE

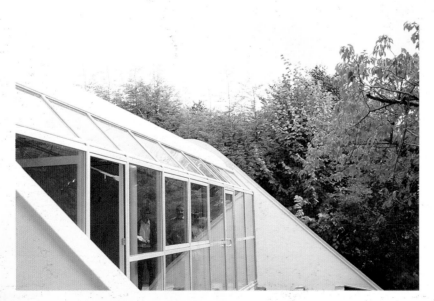

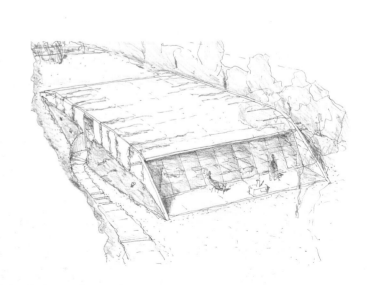

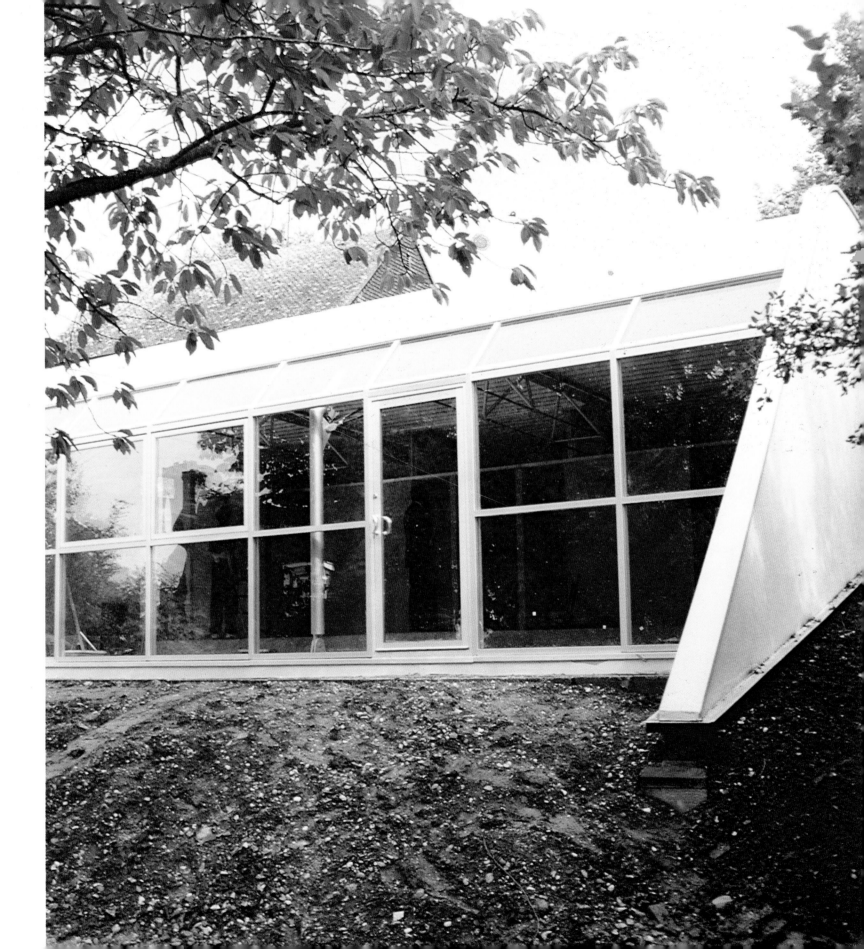

CHAMPAGNE

BUCKET

PROJECT

188

1991

THREE

BOTTLES

SHAPED LIKE AN OVER-SIZED CHAMPAGNE GLASS, THIS TABLE-SIDE HOLDER FOR THREE CHAMPAGNE BOTTLES WAS DESIGNED FOR THE CAPRICE RESTAURANT IN LONDON. IT WAS DEVELOPED FROM AN ANALYSIS OF THE OPTIMUM ANGLE OF BOTTLES LYING IN ICE; THE CAST-ALUMINIUM ENVELOPE THAT ENCLOSES THE RESULTANT FORM IS NOT ONLY HEAVY ENOUGH TO BE STABLE, DESPITE ITS NARROW PROFILE, BUT ALSO OFFERS MINIMAL OBSTRUCTION TO FREE CIRCULATION BETWEEN TABLES.

PROJECT 180
1992

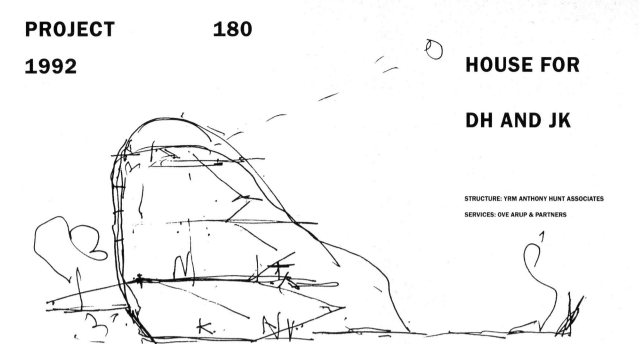

HOUSE FOR

DH AND JK

STRUCTURE: YRM ANTHONY HUNT ASSOCIATES

SERVICES: OVE ARUP & PARTNERS

LOCATED ON A 6M-WIDE END OF TERRACE SITE IN 19TH-CENTURY ISLINGTON IN LONDON, THIS FOUR-STOREY, 220M² HOUSE MAKES EXTENSIVE USE OF GLASS TO COMPENSATE FOR SHADING BY TREES AND A NORTH-FACING ASPECT. THE MAIN STREET FACADE IS CONSTRUCTED ENTIRELY FROM GLASS BLOCKS. THE TWO FLANK WALLS ARE OF LONDON STOCK BRICK. AN ASSEMBLY OF FLOOR DECKS IS SUSPENDED BETWEEN THESE CROSSWALLS IN A MANNER SIMILAR TO THAT PROPOSED FOR PROJECT 167. BEHIND THE GLASS-BRICK FACADE, A PLANAR GLASS ROOF UNDULATES AWAY TOWARDS THE SOUTH, SHADED BY FOLIAGE.

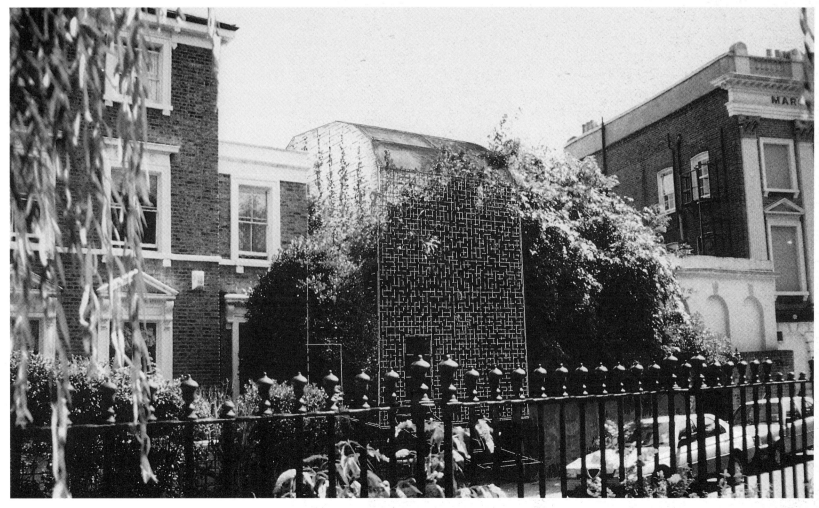

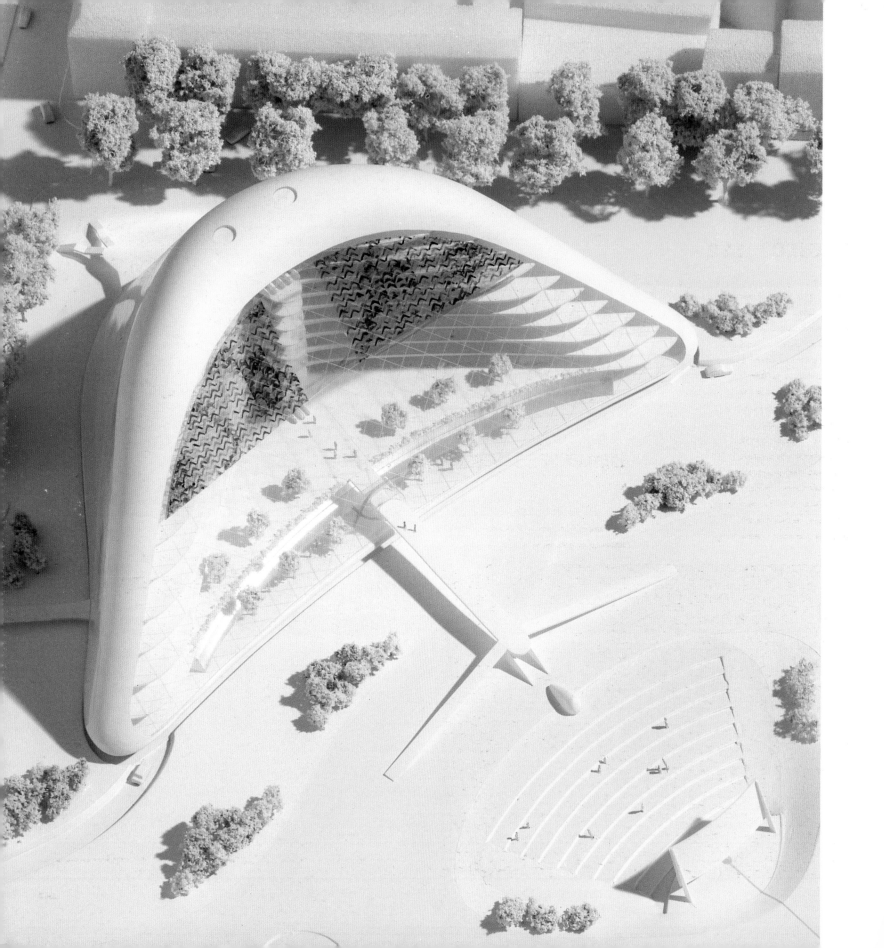

PROJECT 192

ONE OF THE MOST IMPORTANT DESIGN ISSUES CONFRONTING ARCHITECTURE TODAY IS THE CREATION OF A FORMAL LANGUAGE FOR THE ENERGY-EFFICIENT AND NON-POLLUTING TECHNOLOGIES THAT ARE NOW REQUIRED FOR OUR ANCIENT CITIES. THIS COMPETITION PROJECT FOR THE OFFICES OF THE DEPARTMENT OF THE ENVIRONMENT IN HAMBURG RECONCILES THE TRADITIONAL URBANISM OF THE CITY'S DECAYING ALTONA DISTRICT WITH THE MOST ENERGY-EFFICIENT ADVANCED BUILDING FORM.

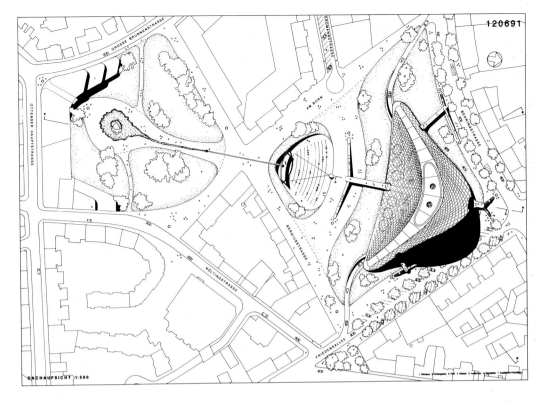

UMWELTBEHÖRDE HAMBURG

1991

STRUCTURE: YRM ANTHONY HUNT ASSOCIATES

SERVICES: OVE ARUP & PARTNERS

DUNE

GLASS MOUNTAIN

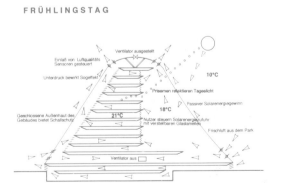

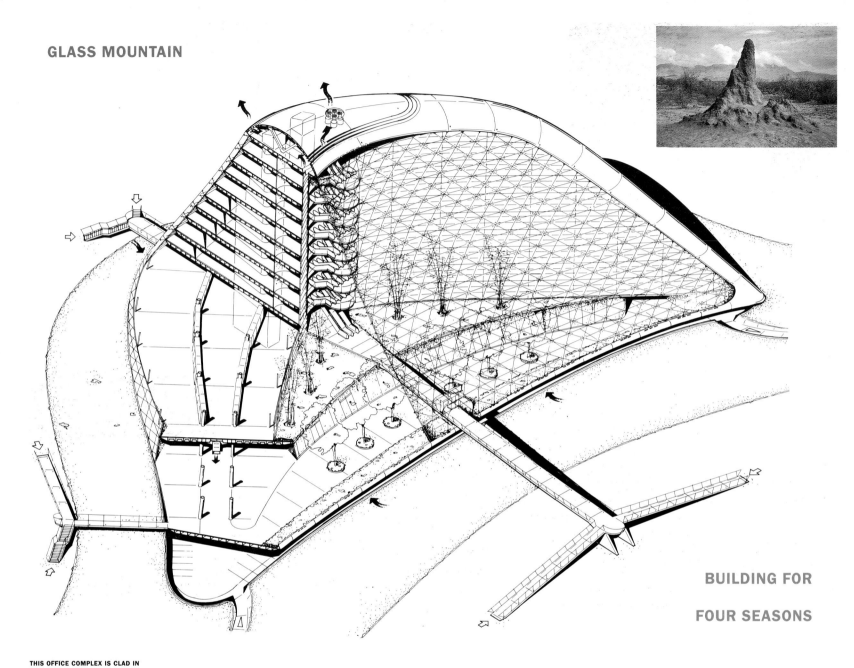

BUILDING FOR

FOUR SEASONS

THIS OFFICE COMPLEX IS CLAD IN TRANSPARENT GLASS AND HAS AN AERODYNAMIC SHAPE, WHICH MINIMISES ITS SURFACE AREA AND MAXIMISES ITS THERMAL EFFICIENCY. THE 40,000M² BUILDING ENVELOPE EMPLOYS LOW PRIMARY ENERGY MEANS OF CONSTRUCTION. IT EXPLOITS A LOW DRAG COEFFICIENT TO MINIMISE HEAT LOSS AND REDUCE OPERATING COSTS, AND IS ALMOST ENTIRELY HEATED AND COOLED BY AMBIENT ENERGY SOURCES.

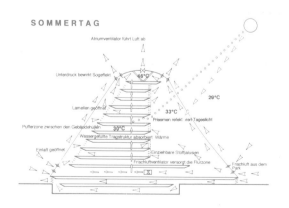

SOMMERTAG

Atriumventilator führt Luft ab

Unterdruck bewirkt Sogeffekt 46°C

29°C

Lamellen geöffnet

33°C

Prismen refektirarh Tageslicht

Pufferzone zwischen den Gebäudehüllen 30°C

Wassergefüllte Tragstruktur absorbiert Wärme

Einlaß geöffnet

Einziehbare Stoffjalusien

Frischluftventilator versorgt die Flurzone Frischluft aus dem Park

FRÜHLINGSTAG

Ventilator ausgestellt

Einlaß von Luftqualitäts Sensoren gesteuert

10°C

Unterdruck bewirkt Sogeffekt

Prismen reflektieren Tageslicht

18°C

Passiver Solarenergiegewinn

Geschlossene Außenhaut des Gebäudes bietet Schallschutz 21°C Nutzer steuern Solarenergiezufuhr mit verstellbaren Glaslamellen

Frischluft aus dem Park

Ventilator aus

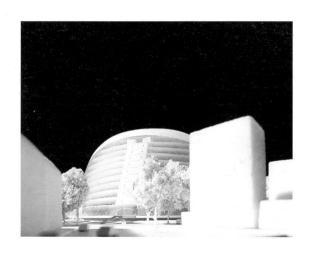

PLAN

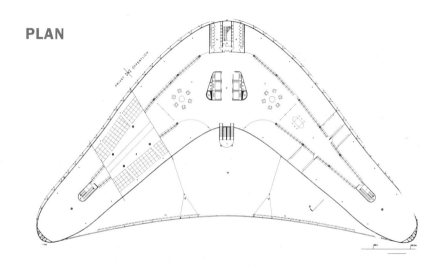

AERODYNAMIC SHAPE

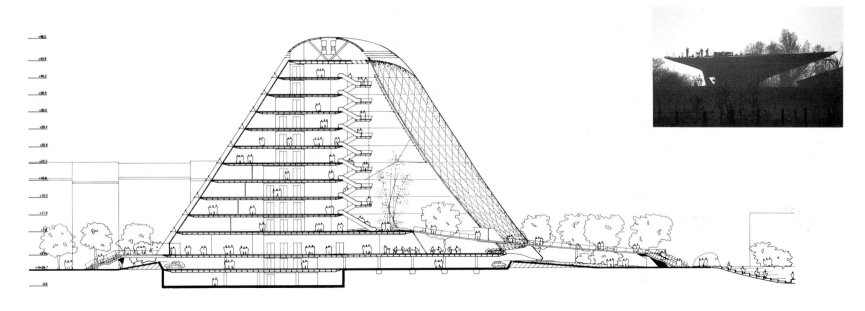

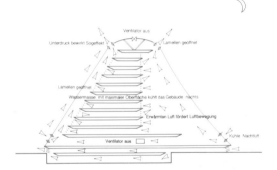

WINTERTAG

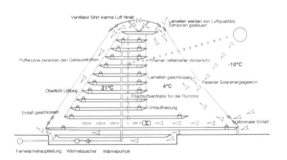

SOMMERNACHT

THE HEART OF THE BUILDING IS ITS ATRIUM: A DRAMATIC SOUTH-FACING SPACE ANIMATED BY THE MOVEMENT OF ESCALATORS AND PEOPLE, AND BY THE CHANGING LIGHT THROUGH ITS STAINED GLASS SCREEN. ALL OFFICE FLOORS OPEN ONTO THIS ATRIUM, WHICH FUNCTIONS AS PART OF THE CLIMATE-CONTROL SYSTEM. BELOW THE OFFICE FLOORS THERE IS A PUBLIC-ACCESS LEVEL WITH SHOPS, A RESTAURANT AND A TERRACE.

145

AN IMPORTANT ASPECT OF THIS
DESIGN IS THE INTEGRATED
LARGE-SCALE ARTWORK – A
STAINED-GLASS SCREEN BY BRIAN
CLARKE. THIS IS DESIGNED TO BE
READABLE BY DAY AND NIGHT
SO THAT IT GIVES THE BUILDING
A UNIQUE SIGNATURE IN THE
CONTEXT OF THE CITY. ANOTHER
IMPORTANT ASPECT IS THE
SUBTLE LANDSCAPING OF
THE BUILDING'S SURROUNDINGS,
ENABLING IT TO ORCHESTRATE
ITS OWN IMPRESSIVE TREE-
LINED PEDESTRIAN APPROACH
FROM THE RIVER ELBE, AS IT
PASSES THROUGH A SEQUENCE OF
SMALL PARKS SEWN INTO THE
EXISTING URBAN PATTERN.

NO
CORRIDORS

BRIAN CLARKE'S GLASS

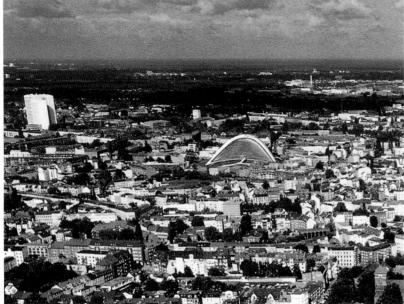

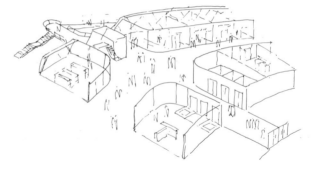

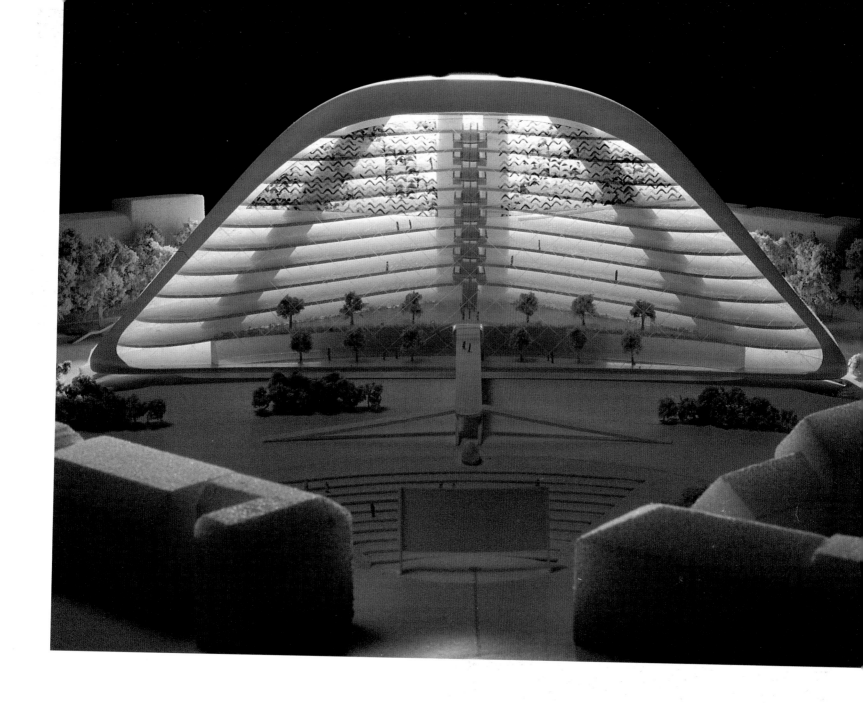

OUTLINE

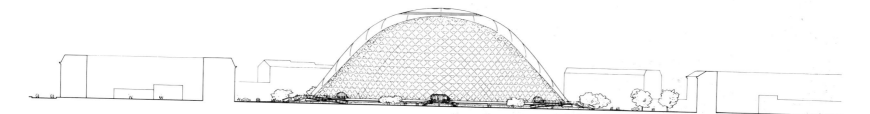

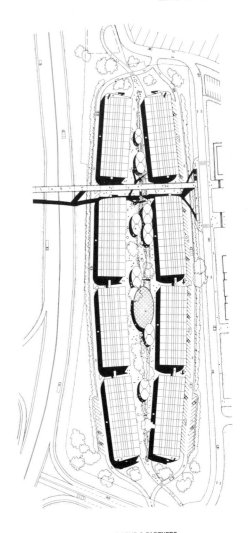

TECHNOLOGY PARK BRNO

PROJECT 199

1992

THIS IS A LIMITED COMPETITION ENTRY CARRIED OUT IN ASSOCIATION WITH THE RICHARD ROGERS PARTNERSHIP FOR A TECHNOLOGY PARK ADJACENT TO THE UNIVERSITY OF BRNO, ON THE OUTSKIRTS OF THE CITY OF BRNO. THE DESIGN FOCUSES ON THE CREATION OF A LINEAR PARK ENCLOSED BY AN ELLIPTICAL ARRANGEMENT OF OFFICE BUILDINGS. COMMUNICATION BETWEEN THE UNIVERSITY AND THE TECHNOLOGY PARK IS FACILITATED BY A NEW, PEDESTRIAN FOOTBRIDGE. EACH OF THE EIGHT 2,500M² STEEL-FRAMED OFFICE BUILDINGS HAS A MINIMAL SURFACE AREA, ENERGY-EFFICIENT SHAPE, AND EXPLOITS MAXIMUM USE OF NATURAL LIGHT AND AMBIENT ENERGY SOURCES.

WITH RICHARD ROGERS PARTNERSHIP

STRUCTURE: OVE ARUP & PARTNERS

SERVICES: OVE ARUP & PARTNERS

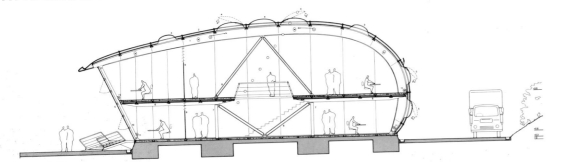

1992

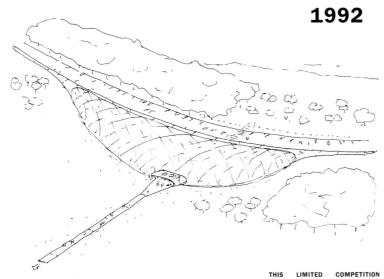

THIS LIMITED COMPETITION ENTRY SEIZES UPON THE SCALE OF THE LANDSCAPE SURROUNDING THE ANCIENT MONUMENT OF STONEHENGE AND ENDEAVOURS TO RESTORE ITS PRIMEVAL ISOLATION BY MAKING NO COMPETITIVE BUILDING INTERVENE ON SALISBURY PLAIN. THE VISITOR CENTRE ITSELF IS OF EXTREMELY LOW PROFILE, SET BETWEEN EXISTING BELTS OF WOODLAND.

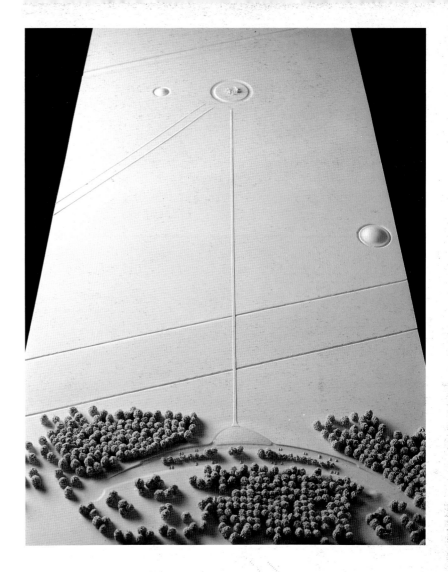

PROJECT 201

LANDSCAPE PLAN 1:1250

STRUCTURE: YRM ANTHONY HUNT ASSOCIATES

SERVICES: OVE ARUP & PARTNERS

LANDSCAPE: TOWNSHEND LANDSCAPE ARCHITECTS

STONEHENGE

VISITORS CENTRE

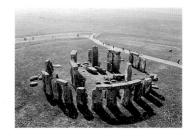

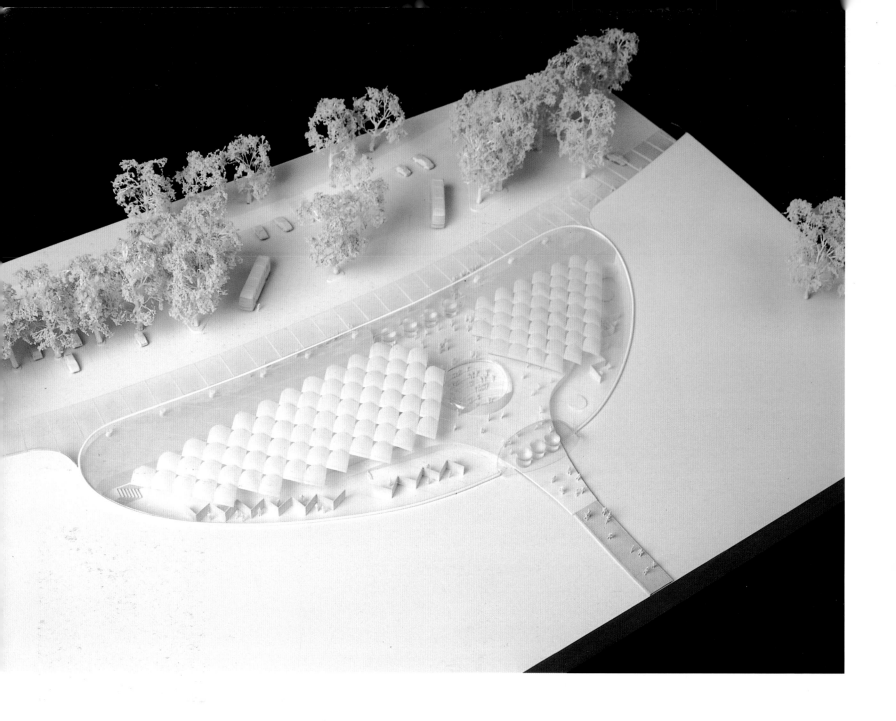

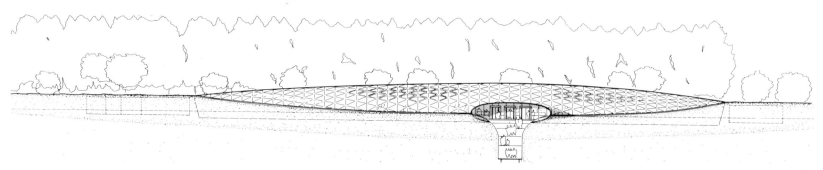

VIEWED FROM THE MONUMENT, THE CENTRE CAN BE SEEN AS NO MORE THAN A LENS SET INTO THE SIDES OF A GENTLY SLOPING EARTHWORK, LIKE A NEOLITHIC BARROW, THAT CONCEALS ALL VEHICLE MOVEMENTS AND CAR PARKING. STONEHENGE CAN BE OBSERVED AND APPROACHED FROM THE VISITOR CENTRE ON FOOT BY A METAL, MESH PATH, WHICH IS SUPPORTED JUST ABOVE THE GRASSED CHALK SURFACE OF THE PLAIN. THE ARCHITECTURE THUS BECOMES AN EXPRESSION OF THE RESPECT OF ONE CIVILISATION FOR THE AWESOME ACHIEVEMENT OF ITS DISTANT PREDECESSOR.

LOW PROFILE

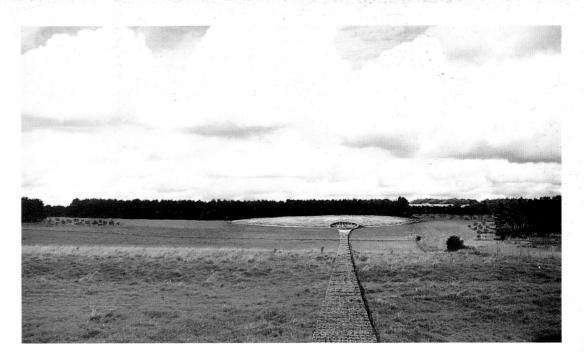

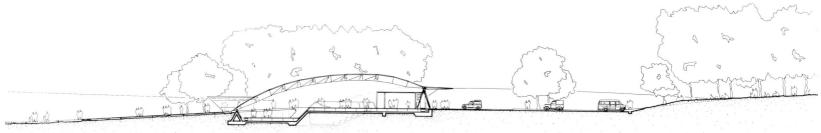

TRANSPARENT FORM

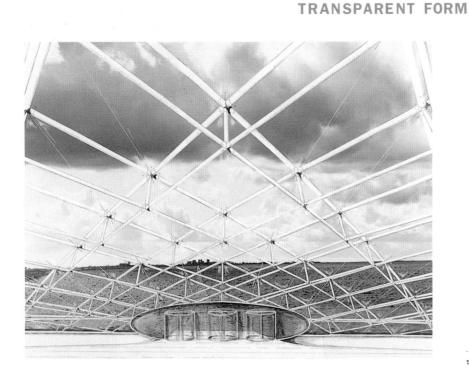

NEW PROJECTS

TOWER

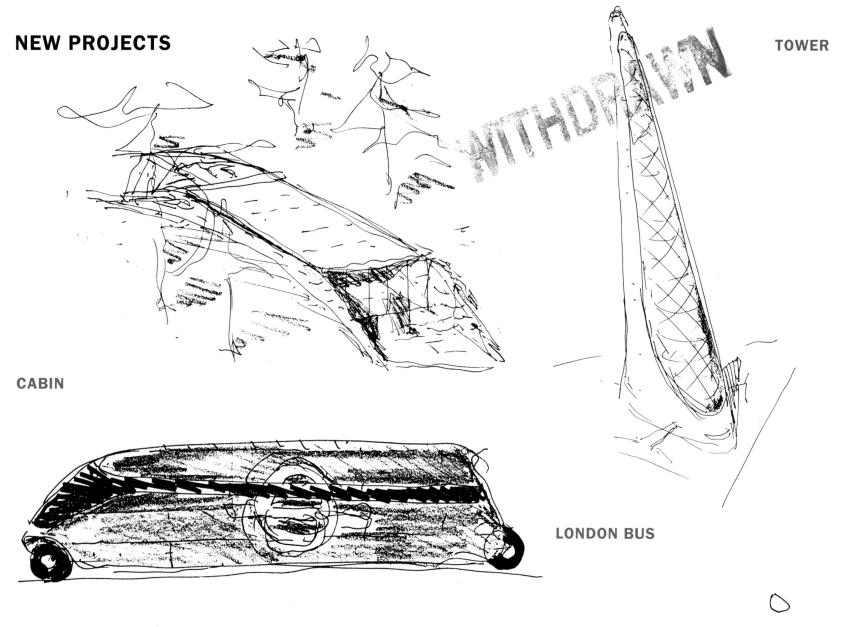

CABIN

LONDON BUS

BC STUDIO

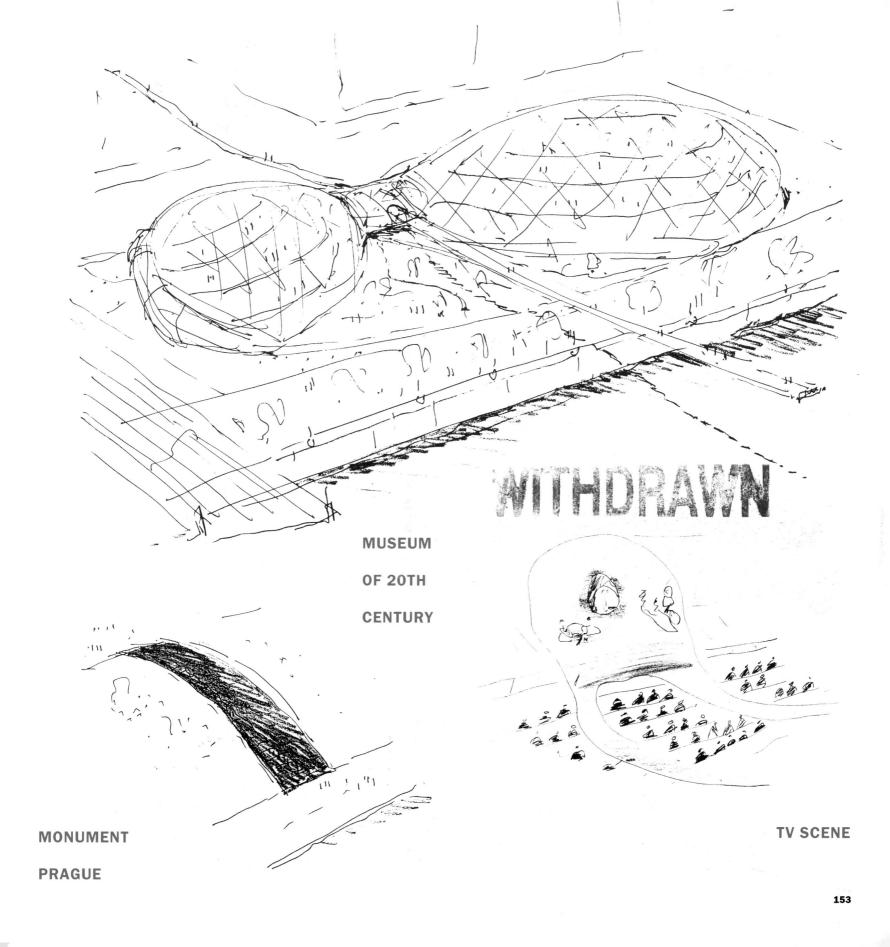

WITHDRAWN

MUSEUM
OF 20TH
CENTURY

MONUMENT

PRAGUE

TV SCENE

JAN KAPLICKY **PRAGUE 1937**

FUTURE SYSTEMS

1979

FOSTER ASSOCIATES

1977–83

LOUIS DE SOISSONS

1974–77

PIANO & ROGERS

1971–73

DENYS LASDUN

1969–71

PRIVATE PRACTICE

1964–68

AMANDA LEVETE **BRIDGEND 1955**

FUTURE SYSTEMS

1989

RICHARD ROGERS & PARTNERS

1984–89

POWIS & LEVETE

1983–86

YRM ARCHITECTS

1982–84

ALSOP & LYALL

1980–81

DAVID NIXON **BRADFORD 1947**

FUTURE SYSTEMS 1979

RICHARD ROGERS & PARTNERS 1979–80

FARRELL GRIMSHAW PARTNERSHIP 1978–79

LOUIS DE SOISSONS 1975–77

FOSTER ASSOCIATES 1972–74

CONSULTANTS

STRUCTURAL ENGINEERS
ATELIER 1
ELMS ROOKE PARTNERSHIP
OVE ARUP & PARTNERS
SAMUELY & PARTNERS
YRM ANTHONY HUNT ASSOCIATES

SERVICES ENGINEERS
OVE ARUP & PARTNERS
YRM ENGINEERS

LANDSCAPE ARCHITECTS
DEREK LOVEJOY & PARTNERS
TOWNSHEND LANDSCAPE ARCHITECTS

QUANTITY SURVEYOR
DAVIS LANGDON & EVEREST

MODELS

RICHARD ARMIGER

THE NETWORK

UNIT 22

CLIVE WILLIAMS

THANKS TO

RICHARD ARMIGER TOM BARKER MIKE BEAVEN ALVIN BOYARSKY BRIAN CLARKE JANA CLAVERIE PETER COOK CHRIS CORBIN RICHARD DAVIES DAVID DEXTER RAY ELMS DANICA FARRAN PAUL FINCH TONY FITZPATRICK BRIAN FORSTER MARCO GOLDSCHMIED JOHN GRILLI JONATHAN HARPER DEBRA HAUER THOMAS HOEGER TONY HUNT ROGER HYDE COLIN JARVIS DAVID JENKINS EVA JIRICNA JEREMY KING ALISTAIR LENCZNER STUART LIPTON CLYDE MALBY ANN MINOGUE FRANK NEWBY MARK NEWTON MARTIN PAWLEY KEN POWELL PETER RICE RICHARD ROGERS DAVID ROSEN ANDY SEDGWICK DON SHUTTLEWORTH WILF STEVENSON DEYAN SUDJIC NEIL THOMAS ROBERT TOWNSHEND JOHN WELSH JANE WERNICK

PHOTOGRAPHS

GEOFFREY BEECKMAN	PP 2 121 126 127 130 131 149 150 155
RICHARD BRYANT	PP 58 59 60 61
RICHARD DAVIES	PP 63 70 71 79 83 85 87 91 93 94 97 98 103
	104 105 106 111 113 115 122 125 140 142 145 147
MIROSLAV DUSIL	P 41
KEN KIRKWOOD	PP 46 47
TARAS KUSCYNSKYJ	P 43

BIBLIOGRAPHY

AA Files	UK	European	UK	
A + U	JAP	Evening Standard	UK	
Actuel	F	Face	UK	
Aktuelle Arkitekter	DK	Foundation	UK	
Ambiente	D	FP	JAP	
Apxitekton	CYP	Guardian	UK	
Arbitare	I	House and Garden	UK	
Arca	I	Houston Chronicle	USA	
Arch +	D	ID Magazine	USA	
Architects' Journal	UK	Ideal Home	UK	
Architectural Design	UK	Impact	UK	
Architectural Record	USA	Independent	UK	
Architectural Review	UK	Insight	UK	
Architecture d'Aujourd'hui	F	Intramuros	F	
Architektura CSR	CS	Japan Architect	JAP	
Architekture & Wohnen	D	LA Reader	USA	
Arquitectura Viva	SP	Modern Painters	UK	
Axis	JAP	Modo	I	
Bauwelt	D	Moniteur	F	
Blitz	UK	New Civil Engineer	UK	
Blueprint	UK	New Scientist	UK	
Bobedre	DK	New York Times	USA	
Building Design	UK	Observer	UK	
Building Services Journal	UK	Omega	AUS	
Building	UK	Parametro	I	
Business Review Weekly	AUS	Playboy	D	
Ceskoslovensky Architekt	CS	Progressive Architecture	USA	
City Limits	UK	Projekt Revue	CS	
Corriere Scienza	I	RIBA Journal	UK	
Cosmopolitan	UK	Scuola Officiana	I	
Cree	F	SD	JAP	
Design Review	UK	Storefront	USA	
Design	UK	Sunday Telegraph	UK	
Design Week	UK	Techniques & Architecture	F	
Designers' Journal	UK	Times	UK	
Detail	D	Ubermorgen	D	
Deutsche Bauzeitung	D	Village Voice	USA	
Die Welt	D	Viz	UK	
Domov	CS	Vogue Living	AUS	
Domus	I	Vogue	UK	
El Pais	COL	World Architecture	UK	
Elle Decoration	UK	World of Interiors	UK	
Esquire	UK			

SELECT PUBLICATIONS

AA Files	16	1987
AA Files	21	1991
A + U	128	1981
A + U	162	1984
A + U	219	1988
Arca	22	1988
Arca	26	1989
Arca	34	1990
Arca	35	1990
Arca	43	1990
Arca	52	1991
Arca	63	1992
Architects' Journal	5 August	1992
Architectural Record	6	1992
Architectural Review	7	1983
Architecture d'Aujourd'hui	237	1985
Blueprint	April	1991
Building Design	1 March	1991
Cree	February–March	1987
Daily Telegraph	9 March	1991
Esquire	6	1992
Progressive Architecture	2	1990
Vogue	3	1991
World Architecture	20	1992